ELSTREE

A CELEBRATION OF FILM AND TELEVISION

STUDIOS

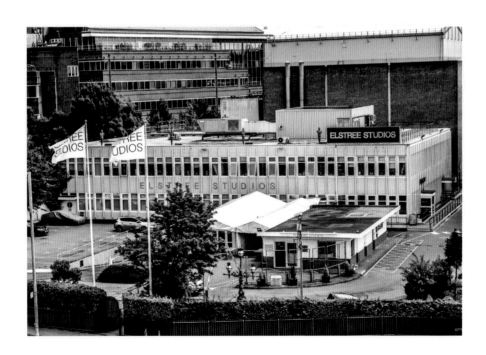

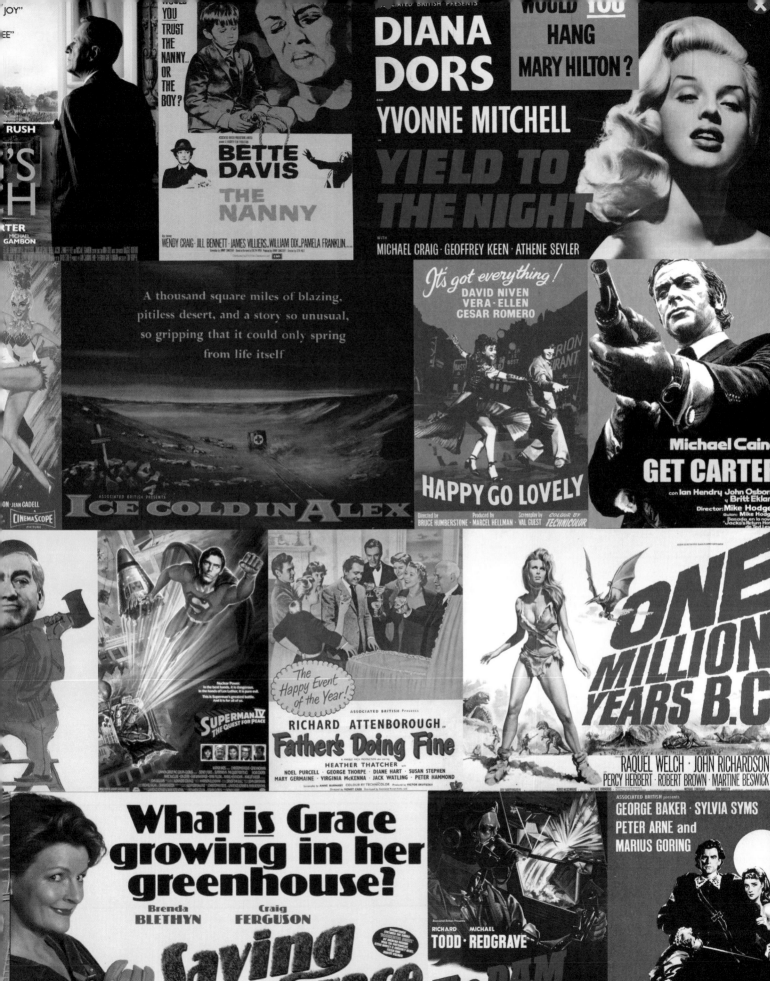

ELSTREE

A CELEBRATION OF FILM AND TELEVISION

STUDIOS

MORRIS BRIGHT
and
PAUL BURTON

Michael O'Mara Books Limited

This book is dedicated to all the people at Elstree Studios who have contributed so much to its ninety-year story.

First published in Great Britain in 2015 by
Michael O'Mara Books Limited
9 Lion Yard
Tremadoc Road
London SW4 7NQ

A CIP catalogue record for this book is available from the British Library.

Papers used by Michael O'Mara Books Limited are natural, recyclable products made from wood grown in sustainable forests. The manufacturing processes conform to the environmental regulations of the country of origin.

ISBN: 978-1-78243-381-1 in hardback print format

1 2 3 4 5 6 7 8 9 10

www.mombooks.com

Designed and typeset by Design 23

Printed and bound in China

CONTENTS

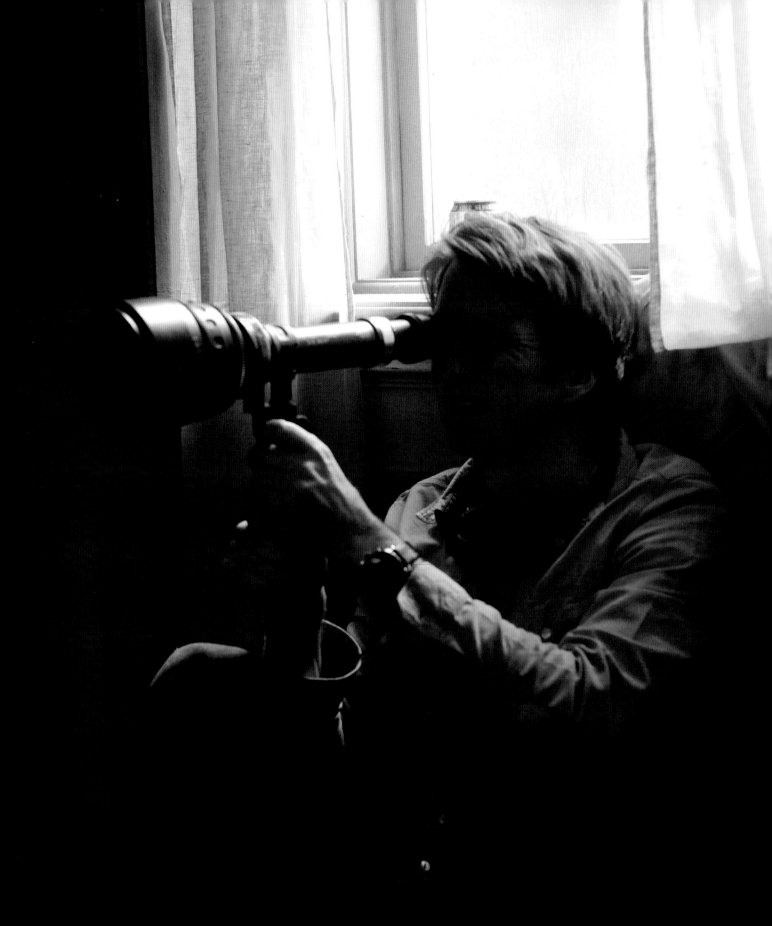

INTRODUCTION

Elstree Studios is a very special place to me. I knew the area well, having been a director on *EastEnders* at the BBC studio nearby, but as a film lover I was always very much aware of the history of film and television production at Elstree Studios and its extraordinary film heritage.

When I first came to Elstree with *The King's Speech*, the film had been turned down by most people – including all of the Hollywood studios. It was a hard film to put together. Independent film production is very stressful because the financing isn't secure until the deals are closed, which involves agreeing every detail down to whether an individual actor has a trailer or not.

We brought *The King's Speech* to Elstree because the studio space is priced sensitively for independent productions. This was hugely important as we had such constraints on our budget. Elstree offered us the ability to house production offices, costume and art departments all close to London, and allowed us to build the sets we needed, such as the interior of speech therapist Lionel Logue's mansion flat. Elstree was a great home, giving us stability through all that low-budget chaos.

I had known that I wanted to be a film director from the age of twelve. In the mid-1980s, acclaimed film critic Derek Malcolm used to host a show on BBC2 called *The Film Club*. As a child, I would religiously videotape the movies of what was, in effect, a curated season of films by those whom Derek thought were the greatest filmmakers. I owe much of my passion for cinema to watching that series of films – Bergman, Truffaut, Godard and Tarkovsky, as well as American cinema and the works of Scorsese and early Woody Allen. It was an amazing grounding in the grand masters and it had a huge effect on me.

LEFT: Tom Hooper directing on the set of *The Danish Girl.*

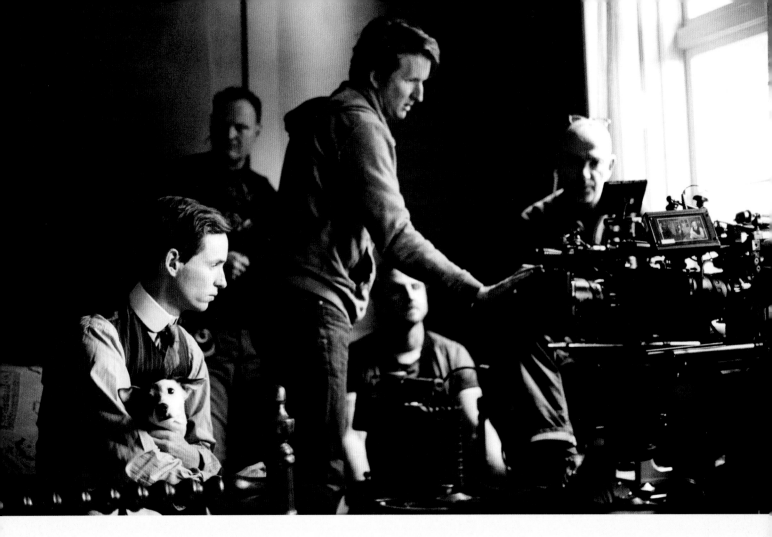

I remember recording the epic *Andrei Rublev* by Andrei Tarkovsky on what must have been a three-hour VHS video cassette. When I watched the film, right at the very end, as this black-and-white film shifts into colour, my cassette stopped and started rewinding. I burst into tears. I was very passionate about film from a very young age!

I started making short films when I was thirteen. I wanted to move from short films to making feature films in my early twenties and inevitably discovered that not only did the world not want twenty-two-year-olds directing movies, but that even less did they want to give them $15 million dollars to do so. I saw myself as a bit of an auteur and didn't work for a while. I knew I had to adjust my sights.

Looking back, it's ironic that I experienced those classics from *The Film Club* not on a cinema screen, in the format in which they were shot, but on television and as often as not in a

ABOVE: Hooper was keen to shoot *The Danish Girl* at Elstree after the success of *The King's Speech*.

different aspect ratio. So when people talked to me about the difference in making film and television, I always used to smile inwardly, thinking that most of the great films I've watched were on television. I just couldn't agree with the idea that films and television are made using different rules.

But how to get started? I tried everywhere to get into television. I visited *The Bill*, *Coronation Street* and each time I would be told the same thing, 'We liked your twelve-minute film … how long did it take to shoot?'

'Nine days,' came my reply.

And then they'd point out that on their schedules they were expected to film twelve minutes each and every day. 'How do we know that you can work that fast?'

And so I was caught in a catch-22 position because I couldn't prove how fast I could work unless someone gave me the chance. And no one would.

BELOW: On the set with Helena Bonham Carter, who played Queen Elizabeth in the 2010 multi-award-winning film *The King's Speech*.

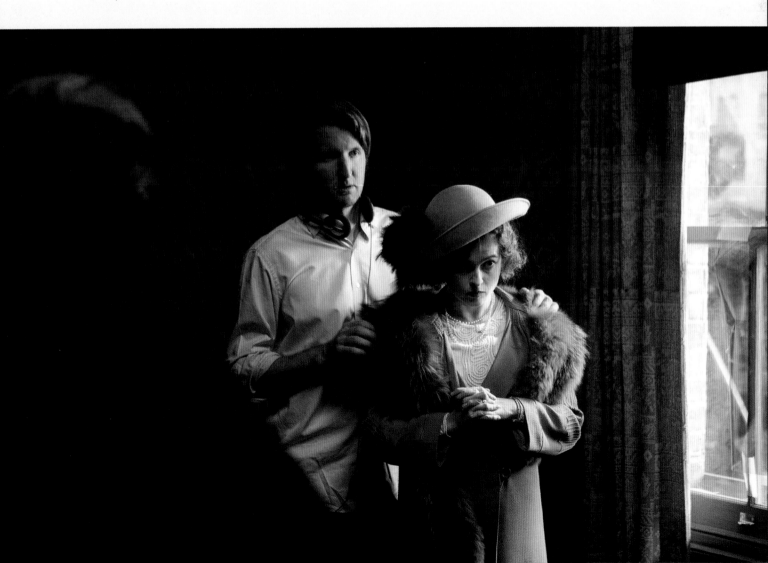

Until, that is, I met producer and director Matthew Robinson on the set of a late-1990s regional soap, *Quayside*. He was directing a block of episodes and we were discussing whether or not I might direct the next block, when suddenly he turned round and said, 'Here's the next scene I'm about to shoot. It's all yours. You've got an hour and ten minutes. There's three and half pages of it.' And with that he left the studio.

It took me completely by surprise. There was no warning. And it was a sink or swim moment for me. Yes, if I'd messed up he could have recovered the situation but this test would give us both the assurance that I could do it. Thankfully, I didn't mess up. And then I got offered the work: *Byker Grove, EastEnders, Cold Feet, Love in a Cold Climate, Prime Suspect*, leading to feature films *Red Dust* and *The Damned United*, and a developing relationship with HBO: *Elizabeth I, Longford* and *John Adams*.

I felt very nostalgic about Elstree Studios after the success of *The King's Speech*. I felt it had been a great home for us. So it was a joy to return with my new film, *The Danish Girl*, and make that connection again. On my return, it was wonderful to see that a huge banner image of *The King's Speech* had been erected above Stage 8. There's just one green screen shot in *The Danish Girl* – of Eddie Redmayne walking across a bridge – and the green screen was erected directly under *The King's Speech* banner!

It was very exciting on *The Danish Girl* to build our sets and shoot in The George Lucas Stage. To feel like you're connected with *Star Wars* gave me a buzz every time I turned up for work in the morning. We built two central sets for the film – the Danish apartment and the French apartment – in The George Lucas Stage.

The dream for any director is to have complete control over the look of a film. If it is possible to build all the sets needed, then studios are ideal as everything is created from scratch. *The Danish Girl* is the perfect example of where the interiors we were

looking for literally did not exist on location in the UK and we couldn't find them in Copenhagen. Constructing sets at Elstree allowed us full control over the palette and colour scheme and also allowed us to show the contrasts between the Danish and Parisian style when the film shifts between locations: yet the sets were just yards away from each other. *The Danish Girl* has strong concentrated performances from the leads Eddie Redmayne and Alicia Vikander, and to be able to be in this wonderful bubble where there's no exterior sound and real life doesn't invade, is incredibly important for the intricacies of the creative process. Directors and actors alike cherish this experience – yet another reason why studios remain such an integral part of filmmaking.

We're all in the business of storytelling. Buildings have stories to tell as well – and studio buildings more than most. This book is a great way of celebrating in words, and especially pictures, the extraordinary stories that the buildings at Elstree Studios have witnessed over its ninety-year history.

Britain's first talking picture, Hitchcock's *Blackmail*, was made here at Elstree, then *The Dam Busters*, *Star Wars*, *Indiana Jones*, *The Shining* … Elstree has been, and remains, the proud home to some of this country's finest films and television.

I have greatly enjoyed my times at Elstree and am delighted to be a part of both its story and its history.

Tom Hooper

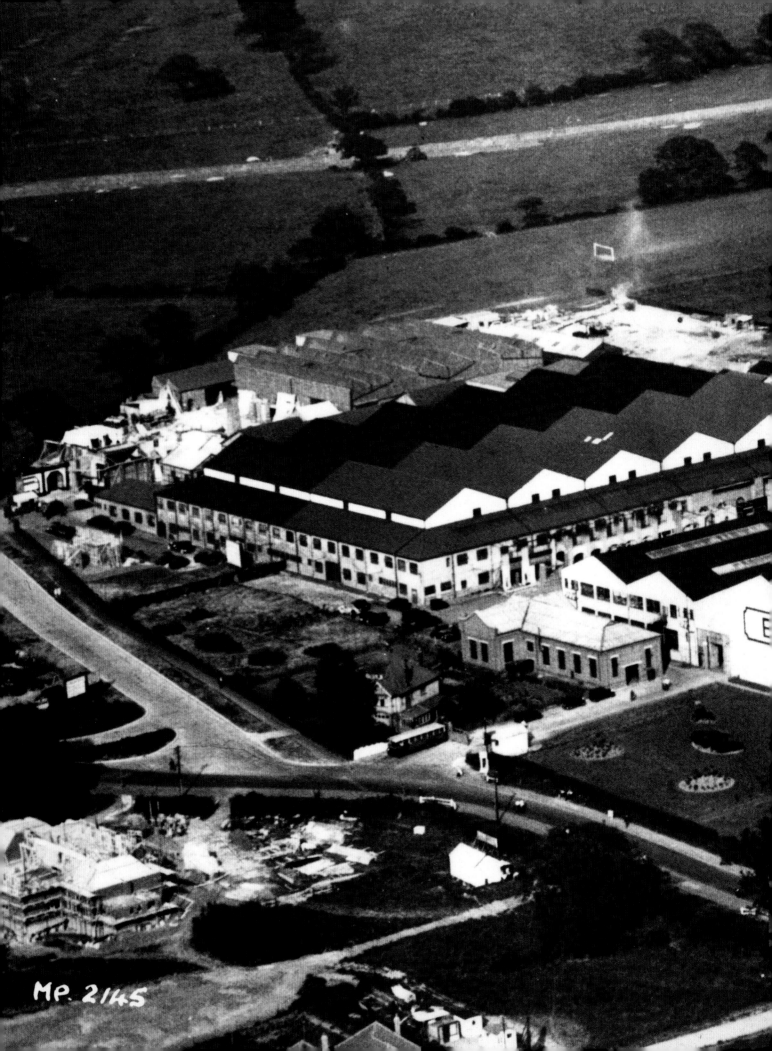

MP. 2145

ELSTREE

CHAPTER ONE

CALLING

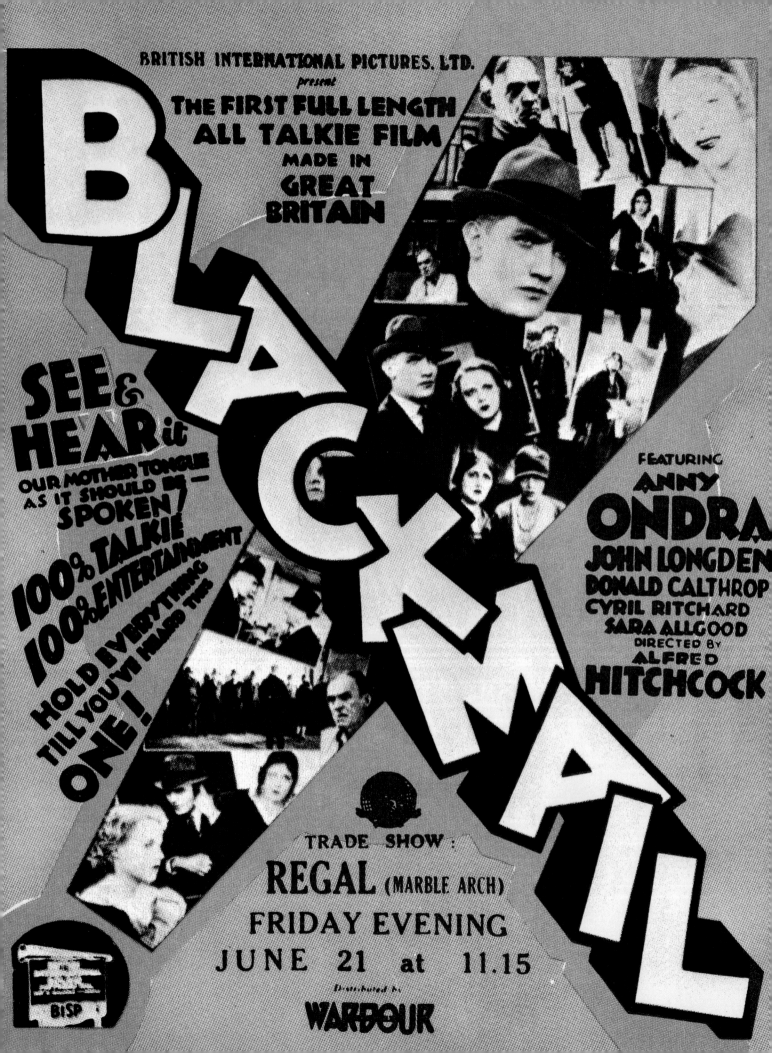

Elstree and Borehamwood in Hertfordshire live cheek by jowl just a stone's throw from London. Film and television production in the area stretches back more than one hundred years and indeed across more than one site in the town. Borehamwood first played host to film production in 1914 when Percy Nash, John East and Arthur Moss Lawrence's Neptune Studios was opened on the site of what in most recent times has been BBC Elstree, the home of current television staples *EastEnders* and *Holby City* and, formerly, of such series as *Top of the Pops* and *Grange Hill*. There were to be a further five studios that would come and go over the decades ahead, including MGM British Studios – often referred to as the 'Rolls-Royce' of film production – leaving just Neptune and Elstree Studios as the only production sites open in the town in the twenty-first century.

So what of the history of what we now know as Elstree Studios itself? Well, the First World War practically brought film production in Britain to a halt. Ironically, audience attendances at the time rose as the people sought refuge in the darkness of cinemas across the land to escape the misery of post-war life. American filmmaker J.D. Williams noted the sight of crowds queuing around the block outside the various picture houses in Britain and he decided there and then to do something about it. Searching for a suitable site, he chose the relatively smog-free Borehamwood in Hertfordshire in which to base his newly formed production company, British National Films, which he

ABOVE: The beautiful
Lillian Hall-Davis as
Rosemary Tregarthen
in the 1928 silent
adventure film, *The
White Sheik*, directed
by Harley Knoles.

formed with W. Schlesinger and Herbert Wilcox. By the end of 1925 two large stages had been erected and opened. The site was grandly titled British National Studios.

Madame Pompadour, which boasted Dorothy Gish, Antonio Moreno and Nelson Keys in the cast and charted the life and times of Louis XV of France's delectable mistress, was the first film to be made at Elstree Studios. However, by the time director Herbert Wilcox was on the studio floor with the seventy-minute silent film, complications had arisen in the business relationship between J.D. Williams and W. Schlesinger. Enter cinema-owner John Maxwell, who, on realizing that he needed a studio in order to satisfy the needs of his various cinema-related business interests, and, with the site at Borehamwood meeting with his approval, provided the finance required to complete Wilcox's then half-made project.

Maxwell was a Scotland-based solicitor. His first tentative steps into the film world were made in 1912 when he invested in a Glasgow picture house. By 1918, Maxwell's interest in the

ABOVE: A production still from *The White Sheik*.

industry had grown and seen him acquire twenty cinemas and co-found a successful film distribution company called Waverley Films. Waverley's managing director, Arthur Dent, had been obtaining titles from the London-based company, Wardour Films, and before long, Maxwell took control of that company too. Dent moved to London to become sales manager of Wardour for Maxwell, and the latter himself followed in 1925.

Having already had his place as the original saviour of Elstree Studios confirmed, Maxwell went on to merge British National Studios with his ABC cinema circuit, and changed its name to British International Pictures, which in time would become more commonly known within the industry as BIP Studios.

Herbert Wilcox was to spread his wings and join Nelson Keys in leasing three stages from Maxwell. The stages were built and located just next door to BIP, thus starting the British and Dominions Film Corporation (B&D Studios) in the process. A number of impressive titles would emerge from this part of the

site, most notably Alexander Korda's comedy, *The Private Life of Henry VIII*, which starred Charles Laughton, Merle Oberon, Elsa Lanchester and Robert Donat. As a result, a friendly rivalry would continue to exist between B&D and BIP.

John Maxwell was now the head of a company capable of film production, exhibition and distribution. In addition, Maxwell would also take over the old Welwyn Garden City-based studios of British Instructional Films (BIF), which remained as an overflow facility for Elstree Studios until 1950.

Fate was at that time on Maxwell's side, and the government's decision to create The Cinematograph Films Act in 1927 resulted in his role in the history of the studio being more than just its saviour. The Act was designed to promote British film production by ensuring that a quota of films each year had to be made in Britain, or funded by British money, in order to try to hold back

BELOW: Lillian Hall-Davis and Carl Brisson in the sporting drama, *The Ring*. Brisson played fairground boxer Jack Sander, while Hall-Davis played his love interest Mabel, whose romantic attentions turn to a professional boxer, Bob Corby, played by Ian Hunter.

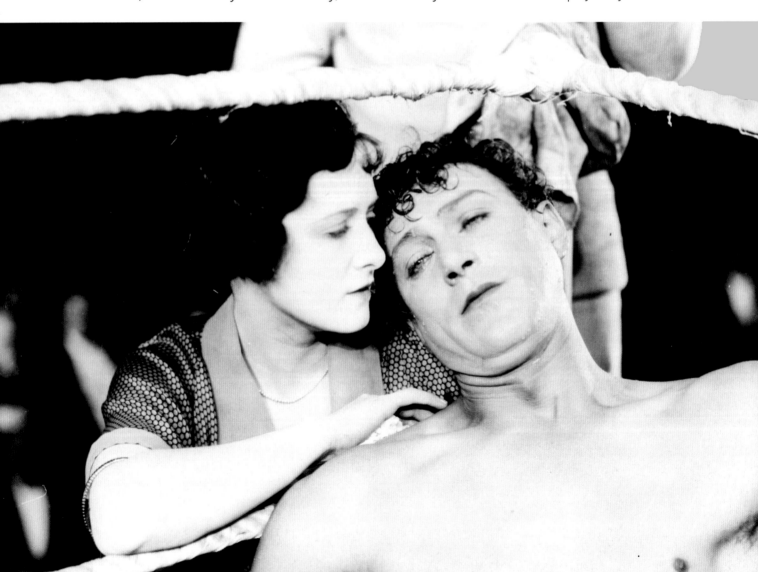

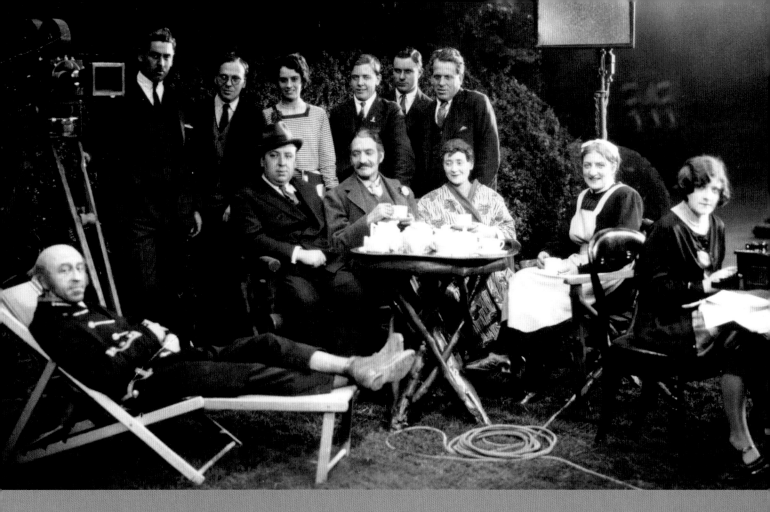

ABOVE: A publicity photo of Alfred Hitchcock (seated at table, left) and colleagues on the set of the 1928 film, *The Farmer's Wife*.

what seemed to be the dominance of the American film market. Cinemas were required to show a quota of British films alongside those from America. The Act saw production at film studios lift considerably and it was not unknown for two or three silent films to be shot in the same stage at the same time.

John Maxwell brought the then twenty-eight-year-old London-born filmmaker Alfred Hitchcock to Elstree during 1927, signing him to a three-year deal. His contract carried the condition that 'Hitch' would make twelve films. In return, the filmmaker was promised the princely sum of £13,000 a year – an enormous amount for the time. Hitchcock immediately rewarded Maxwell's faith in him by delivering the critically acclaimed silent film, *The Ring*. This picture, shot, edited and released within three months, focused on a love triangle set against the brutal sport of boxing, and was the only time the director was credited with the role of sole screenplay writer.

In December 1927, Lucy Baldwin, the wife of the then British

prime minster, Stanley Baldwin, was invited to visit the BIP Studios to go behind the scenes on Hitch's next movie for the studio, the silent romantic comedy, *The Farmer's Wife*. One of the high-points of her itinerary was meeting Alfred Hitchcock, who was already making a name for himself.

The stresses and strains of filmmaking were heightened for Hitchcock on *The Farmer's Wife* when cinematographer Jack E. Cox fell ill during production, leading to Hitchcock himself having to shoot many of the remaining scenes for the film, which was eventually released in 1928.

Hitch's next film at Elstree was another silent movie, the 1928 comedy *Champagne*, which tells the tale of a millionaire's wish to

ABOVE: Lillian Hall-Davis and Jameson Thomas in the 1928 film, *The Farmer's Wife*.

RIGHT: Betty Balfour celebrates in the 1928 'slight comedy', *Champagne*.

fix his daughter's frivolous ways by pretending to lose his wealth following an unlucky turn of fortune on the stock market. Critics were less than kind to Hitchcock about *Champagne* – and Hitch himself later declared that he didn't like the film, saying it 'had no story to tell'. Not all had gone smoothly during production of the film. Before filming started, the star, Betty Balfour – known at the time as 'Britain's Queen of Happiness' or 'Britain's Mary Pickford' – had refused the original version of the screenplay,

which was penned by Hitchcock. Additionally, in an effort to show who was boss – and at the very last minute – Hitch insisted that the extras (who had also appeared in *The Farmer's Wife*) were sacked, meaning that filming was delayed by a number of days while a search took place to find replacements.

With the silent film era almost at a close in Britain, Hitchcock went into production on *The Manxman* – a bittersweet love story and the last film he would personally shoot entirely as a silent picture.

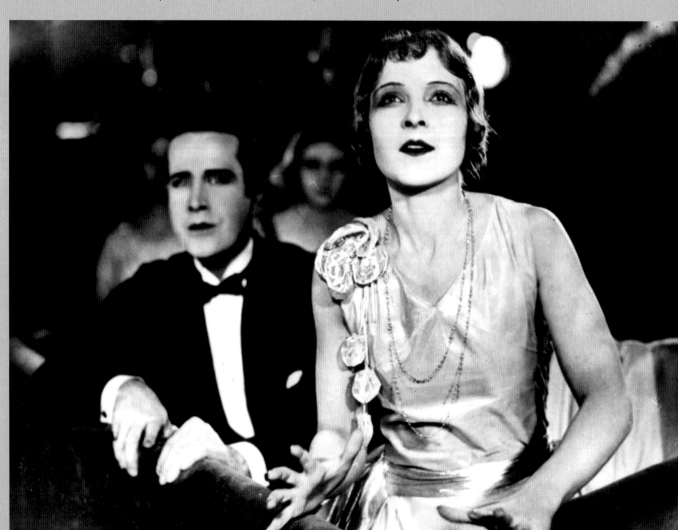

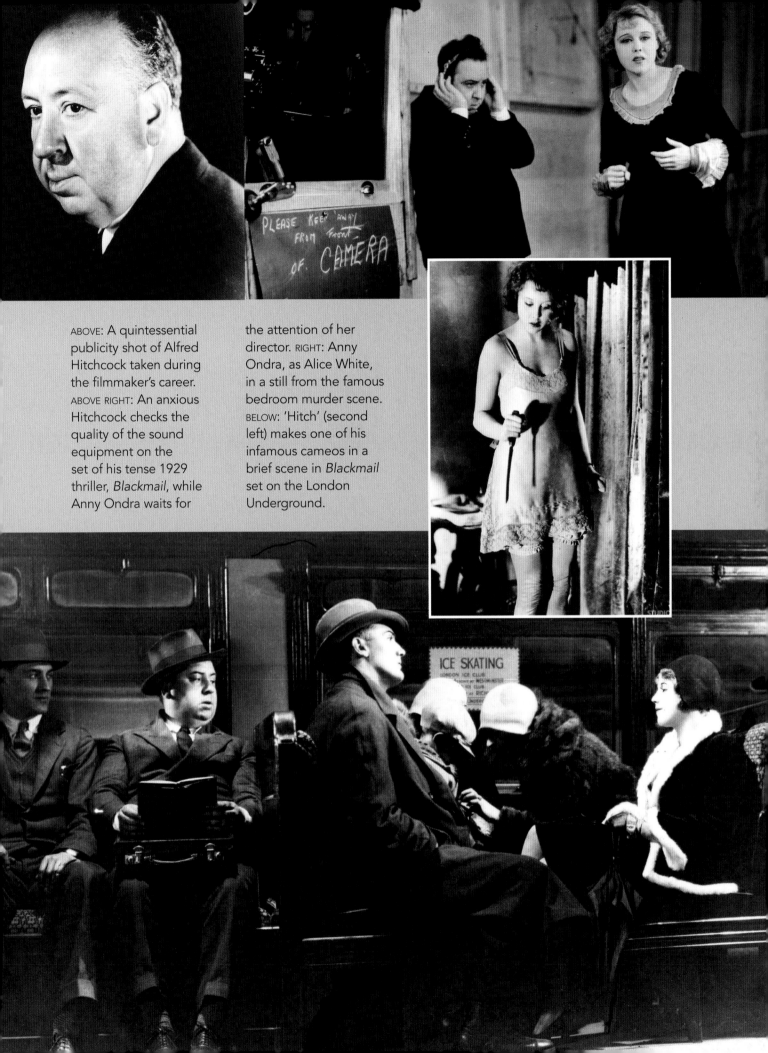

ABOVE: A quintessential publicity shot of Alfred Hitchcock taken during the filmmaker's career. ABOVE RIGHT: An anxious Hitchcock checks the quality of the sound equipment on the set of his tense 1929 thriller, *Blackmail*, while Anny Ondra waits for the attention of her director. RIGHT: Anny Ondra, as Alice White, in a still from the famous bedroom murder scene. BELOW: 'Hitch' (second left) makes one of his infamous cameos in a brief scene in *Blackmail* set on the London Underground.

Hitch filmed the location work on the Cornish coast, as opposed to the Isle of Man, where the story was set. The remaining scenes were filmed back at BIP.

Summarizing his silent film years much later, Hitchcock said, 'There was only one thing missing in the silent pictures, and that was sound coming out of the peoples' mouths. And sounds coming from the streets. In other words, there was no need to abandon the technique of the pure motion picture.'

One film that marked a highpoint in the era of British silent

BELOW LEFT: Helen Burnell and Jack Hulbert in a charming moment from the 1930 musical film revue, *Elstree Calling*.

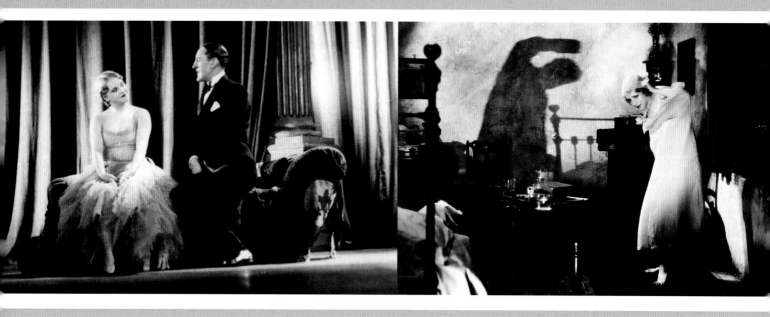

films, even though the 'talkies' were soon destined to overtake and end the silent days, was the 1929 crime drama, *Piccadilly*. Produced and directed by Ewald André Dupont and with a screenplay by Arnold Bennett, it is a tale of a divided London during the roaring 1920s, and its performances from a cast including Gilda Gray, Anna May Wong, Jameson Thomas and Cyril Ritchard, along with inspired cinematography by Werner Brandes, continue to impress to this day. Ambition, lust and jealousy abound and the subject of inter-racial sex and racial tensions are all tackled in a very direct way – all of which is surprising for a film of the time.

ABOVE: A tense scene in the 1930 film, *Murder*, which was co-written by Alfred Hitchcock, his wife Alma Reville and Walter C. Mycroft. The screenplay was based on a play called *Enter Sir John* by Clemence Dane and Helen Simpson.

It's worth mentioning that not only was Anna May Wong the first Asian-American star, but she was also one of the first non-white actresses to become famous on an international scale. Also worthy of note is that actor Charles Laughton made a small scene-stealing appearance as a dinner guest in an iconic sequence in the picture.

Credited as being the first full-length British 'talkie', Alfred Hitchcock remarked that his 1929 thriller film, *Blackmail*, was 'a simple yarn, a simple story', and both Hitchcock and playwright

BELOW: An iconic moment from *Number Seventeen*, a 1932 film that Hitchcock made under protest.

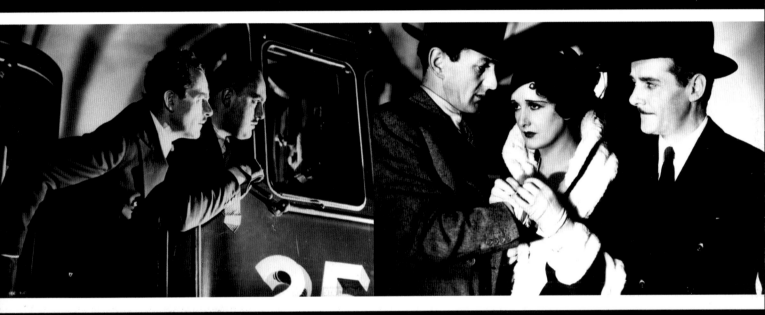

ABOVE RIGHT: John Stuart, Anne Grey and Donald Calthrop in *Number Seventeen*, which was based on a stage play by J. Jefferson Farjeon.

Charles Bennett collaborated to turn the latter's play into a workable screenplay. *Blackmail* tells the story of a police detective whose girlfriend kills an artist in self-defence with a bread knife when he attempts to rape her.

Blackmail includes a famous cameo appearance by Hitch. Said to be his longest cameo, we see the director reading a book and being distracted by an annoying young boy while taking a journey on the London Underground.

By this time, 'talkies' were becoming hugely popular, with some people seeing them as revolutionizing the industry and others still believing that they were merely a fad and would never catch on.

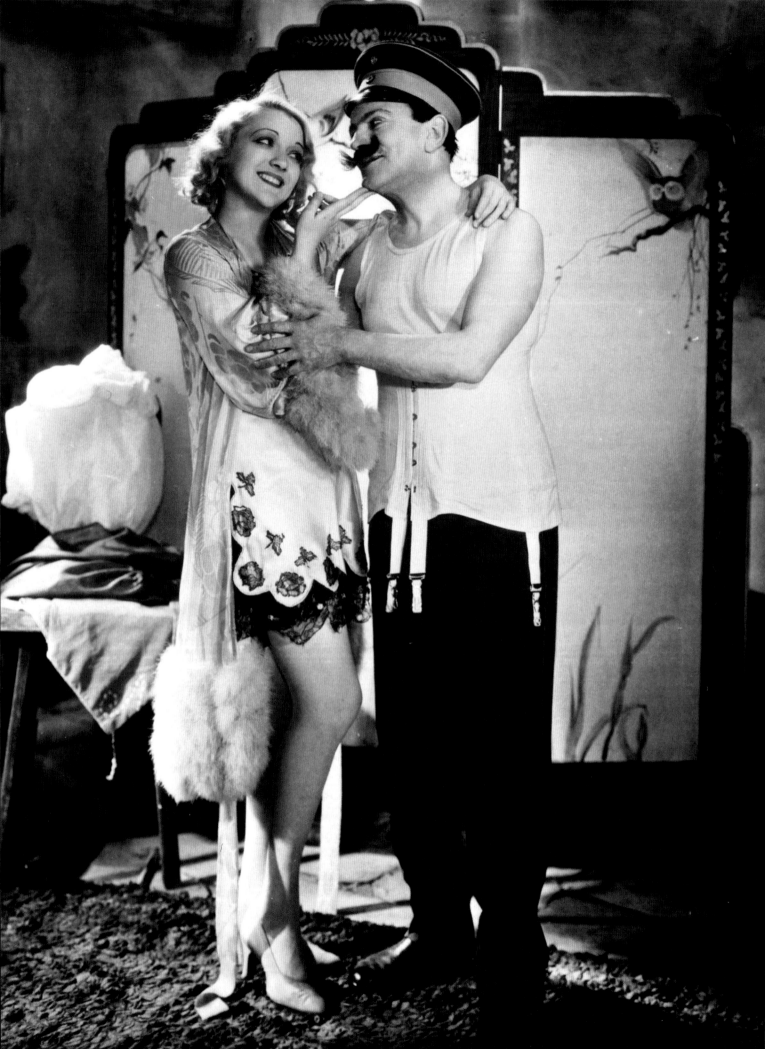

It was a time of great change in the movie business, and John Maxwell only allowed Hitch to make a part of the film with sound. Hitchcock was convinced that talking pictures were the future and continued – surreptitiously – filming with sound, so that when Maxwell eventually came around to the idea, Hitch only had to make minimal reshoots, having craftily shot a number of scenes in such a way that they could be easily adapted. Two versions of *Blackmail* were eventually released. One entirely silent for cinemas not yet equipped for sound, and another almost entirely with sound.

Nowadays, when we are able to watch film on an ever-increasing range of devices at the touch of a button or screen, it is hard for more recent generations to comprehend the profound and exciting effect the arrival of sound had back in the 1920s and 1930s on the world of cinema. For example, in the 'seduction scene' in *Blackmail*, a piano was added and, thanks to the ability to use sound, it became a feature of the scene.

It's well known that female star Anny Ondra, playing Alice, lip-synched all of her dialogue in the film and that it fell upon

LEFT AND BELOW: Two highlights from the 1932 film, *Josser in the Army*, which starred the Sunderland-born music-hall performer, Ernie Lotinga. Lotinga also made *Josser on the River* and *Josser Joins the Navy* at the studio.

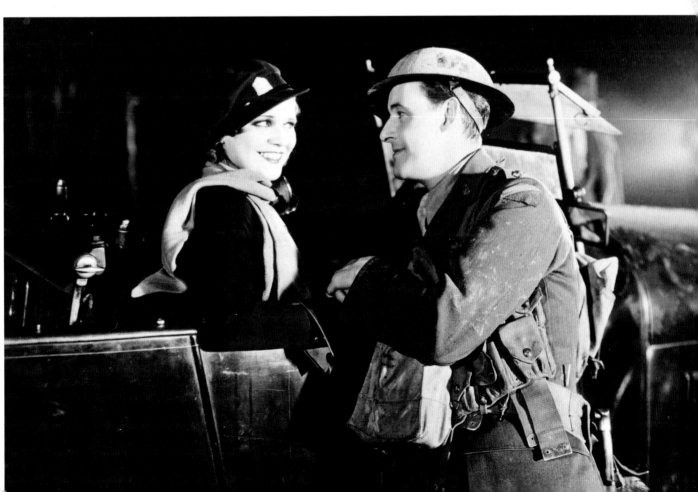

actress Joan Barry to deliver the dialogue, as Ondra's Czech accent was deemed unsuitable for her role as a cockney shop assistant. Due to the obvious technical limitations of sound post-production of the day, Barry (who would go on to appear in Hitchcock's film, *Rich and Strange*) was present on set and had to deliver the dialogue just off camera into a microphone. As you might expect, this had mixed results. Ondra spoke her lines without making any sound, while Barry attempted to synch her voice with Ondra's mouth movements. The arrival of the talkies was something of a disaster for this silent film star: as soon as movies were made with sound, Ondra's heavy accent meant the end of a promising career in Britain.

Viewed now, *Blackmail* is, perhaps ironically, at its most gripping when there is no dialogue being spoken. As always, it's Hitchcock's renowned touches that continue to make this

ABOVE: In 1933, the drama film, *Red Wagon*, which starred Charles Bickford, Anthony Bushell and Greta Nissen, emerged from BIP, which had for some time been unfairly nicknamed the 'porridge factory' owing to the prolific number of moving pictures of variable quality that rolled off the production line at the studio.

film so appealing. As the saying goes, less is often more, and the clever way in which Hitchcock leaves the murder in *Blackmail* to our imaginations, taking place as it does on a bed, behind closed curtains draped around the side, is still a very effective device. Alice manages to put her hand out, grab a bread knife off a nearby table and plunge it into her attacker. The murder

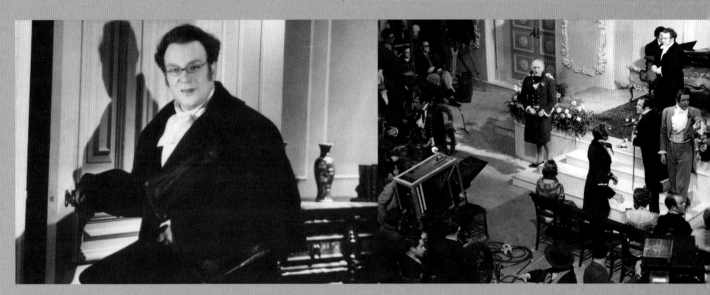

ABOVE: Richard Tauber as Franz Schubert in the 1934 musical drama, *Blossom Time*. The film was directed by Paul L. Stein, and based on Heinrich Berte's opera of the same name. Such was its popularity, readers of *Film Weekly* magazine voted *Blossom Time* 'The Best British Film of 1934'.

ABOVE RIGHT: A photograph taken during the filming of *Blossom Time*.

itself is only confirmed when we see the actor's hand fall through the curtain and rest, lifelessly, in mid-air.

What happened behind the undulating curtains during the murder scene was later put on record by then assistant cameraman, Ronald Neame. Hitchcock gave Neame a 16mm camera to record the action behind the curtains. Once processed, it revealed that a props hand ruffled the curtains during the scene to give the effect of a struggle, while another props hand added fake blood to the murder weapon. The actor dropped his hand through a gap in the curtains.

News of the advances in sound technology had not gone unnoticed by Buckingham Palace. The future King George VI and Queen Elizabeth were soon tiptoeing their way onto the stage floor at BIP in order to watch the action taking place on the primitive sound stages set up for the production of *Blackmail*.

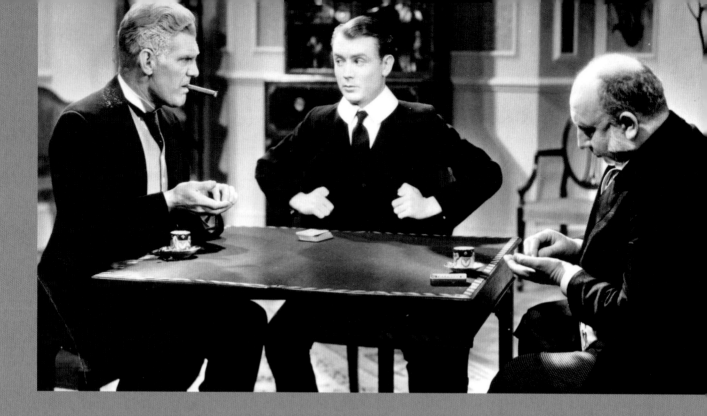

Hitchcock was fond of working late during filming, and the unit rarely finished for the day before 11pm. But, more demandingly for the cast, their movements on camera were now restricted in order that their voices could be effectively picked up. The crew, meanwhile, were faced with using the new RCA Photophone recording equipment that had been installed to bring the era of sound to BIP's Elstree Studios, and the hot and sweaty booths that were created to house the then noisy and bulky camera equipment.

Irish playwright Sean O'Casey's highly regarded play *Juno and the Paycock*, was given the big screen treatment in 1930, with

ABOVE: Will Hay and a young John Mills in a scene from *Those Were the Days*. Released in 1934, this was a screen adaptation of Sir Arthur Wing Pinero's play, *The Magistrate*.

LEFT: Will Hay in the comedy film, *Radio Parade of 1935*. Directed by Arthur B. Woods, the film sees Hay play William Garland, the director general of the National Broadcasting Group. Clifford Mollison and Helen Chandler co-starred.

Hitchcock in the director's chair. O'Casey's play was first staged in Dublin in 1924 and it was said that he was unsure about the idea of committing it to film. However, he visited Elstree Studios and met with Hitch during the filming of *Champagne*, and not only did they forge a great friendship but Hitch also persuaded O'Casey to write a new scene for the very beginning of the film adaptation. Barry Fitzgerald, Maire O'Neill and Edward Chapman all took lead roles.

ABOVE: Will Hay played the Reverend Richard Jedd, a country-based vicar who discovers he owns a share in a racehorse, in the 1935 comedy, *Dandy Dick*.

Although Hitchcock did not direct the 1930 film *Elstree Calling* (it was directed by Adrian Brunel) he did write most of the original material. The title boasted an eclectic collection of film, theatre and radio performers of the era in a series of 'sketches'. Most notable of those taking part was the host, Tommy Handley, who achieved greater fame during the Second World War when he appeared in the catchphrase-laden radio show, *It's That Man*

Again (ITMA). And if cinema-goers in Britain were still stunned by the advances in film that had brought them sound, they must have been equally amazed when *Elstree Calling* included certain items in colour – not the vibrant full-colour that we are used to now but rather muted tones over four out of nineteen of the sketches.

Starring Herbert Marshall, Norah Baring and Edward Chapman, Hitchcock's *Murder!* was first released in 1930. Two versions of *Murder!* were filmed. As well as in English, a German version – entitled *Mary* – was also shot, using German actors and actresses. Hitchcock later detailed how the shaving scene for the German version was technically more superior. 'We had the chance to hear the results before we shot the German version,' he enthused. 'The orchestra had been playing too loudly, and sometimes Wagner drowned out Marshall. When we shot Abel [Alfred Abel, who played Sir Jan Menier in the German version],

RIGHT: The delectable Adrienne Ames in the 1935 film, *Abdul the Damned*.

BELOW: Fritz Kortner as Sultan Abdul Hamid and Nils Asther as the dastardly Chief of Police in *Abdul the Damned*.

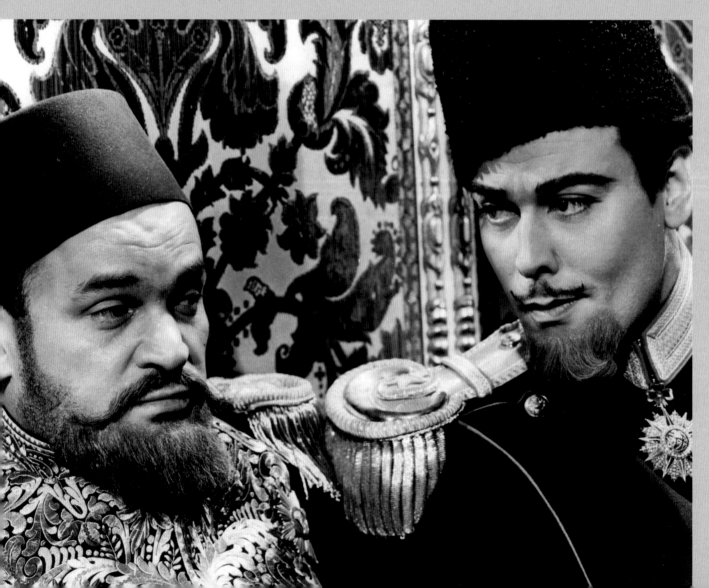

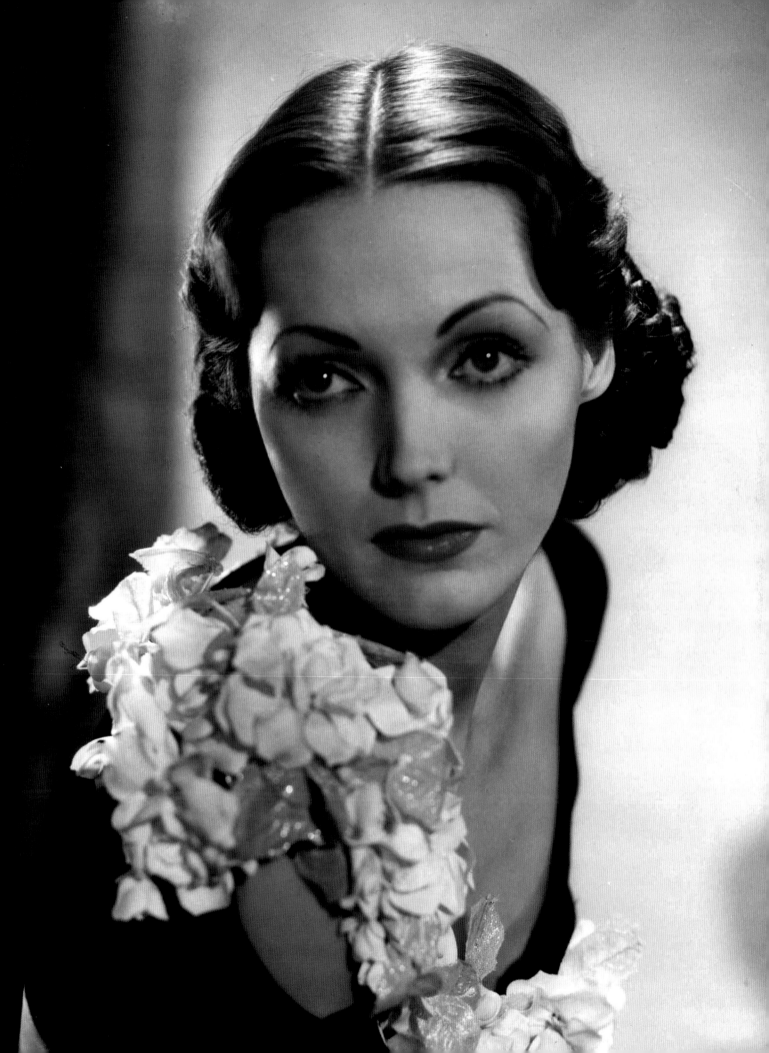

we had them play more softly; consequently it's more successful in this respect.'

As the industry, from cinema managers to film company owners, wrestled with the problems and costs that the 'talkie' generation brought, John Maxwell gave permission to Thomas Bentley to direct the first all-talking British film to be made and released in colour, *Harmony Heaven*, in 1930. Written by Randall Faye, Frank Launder and Arthur Wimperis, and starring Polly Ward, Stuart Hall and Trilby Clark, it was one of the first musicals to be made in Britain.

Two feuding families – the Hillcrists and the Hornblowers – class warfare and land ownership and development are the main themes of Hitchcock's 1931 film, *The Skin Game*. The film was an adaptation by Hitch and his wife, Alma Reville, of a play by John Galsworthy, and included Edmund Gwenn, Helen Haye and Jill Esmond in the cast.

In 1932, Hitch directed *Number Seventeen*, a film based on

a stage play by J. Jefferson Farjeon. On first look, Hitchcock didn't want to film the play, dismissing it as full of clichés. He had wanted to make a film version of the stage comedy *London Walls* by John Van Druten. However the studios – and John Maxwell in particular – had other ideas. Ironically, Hitchcock's colleague from *Harmony Heaven*, Thomas Bentley, was assigned *London Walls*, despite wanting to direct *Number Seventeen*. Whether this was part of a power game on the studios' part, to try to exert some control over Hitchcock, is speculative but the insistence of the studios won the day. Alfred Hitchcock and Alma Reville worked with Rodney Ackland to adapt Farjeon's play for the screen, and Hitchcock duly directed the film.

Starring John Stuart, Anne Grey and Leon M. Lion, *Number Seventeen* is a crime-thriller that features the events following a jewel robbery. The final scenes of the film used specially built model trains created by Bill Warrington, who went on to become

BELOW: A still from the film, *Royal Cavalcade*. Newsreel footage and re-enacted film sequences were to form the basis for the 1935 production, which was commissioned to mark the Silver Jubilee of King George V.

one of the most respected craftsmen in the business, and was still working at Elstree almost fifty years later as the special effects equipment supervisor on *Raiders of the Lost Ark*.

With *Number Seventeen* failing to reach the giddy heights of many of Hitchcock's previous films – and also going to prove the old adage that you're only as a good as your last film in the movie industry – Hitch found himself sidelined in favour of other directors. Worse still, it was made clear to him that he would only be producing other directors' films for the following year at least.

George Bernard Shaw granted Maxwell permission for his short play, *How He Lied to Her*, to be committed to celluloid for a 1932 release as *Arms and the Man*. Director Cecil Lewis

BELOW LEFT AND RIGHT:
Two production stills from the comedy film, *Housemaster*, which was released in 1938. Otto Kruger, Diana Churchill and Phillips Holmes took starring roles in this picture, which sees life at an elite public school turned upside with the arrival of three new girls.

had to be mindful that Shaw was not willing for a single word to be tampered with when he and Frank Launder wrote the screenplay. Launder would go on to write, produce and direct a prolific number of films with Sidney Gilliat, including the famous *St. Trinian's* series.

Lord Camber's Ladies, a 1932 comedy drama that stars Noel Coward's sometime co-star, Gertrude Lawrence, and renowned actor-manager, Gerald du Maurier, would turn out to be the only film Hitchcock would produce for BIP, as he left the studio in 1933 to work for rival studio Gaumont-British. This would, however, not be the end of his association with Elstree Studios.

Released in 1934, *Those Were the Days* saw a young John

Mills playing opposite popular music-hall star Will Hay. Hay, who was a keen amateur astronomer, returned to BIP to star in the comedy film, *Radio Parade of 1935*. Directed by Arthur B. Woods, the film sees Hay play the director general of the National Broadcasting Group, William Garland. A third Hay outing starring the bespectacled actor as a gambling cleric, *Dandy Dick* was filmed in 1935 and directed by William Beaudine.

Disaster struck in February 1936 when a serious fire resulted in the loss of the three-stage British & Dominion Studios, next door to BIP. Only timely intervention and the hard work of a team, including BIP studio manager, Joe Grossman, studio staff and, of course, the fire service, prevented the loss of the BIP Studios too.

Down but not out, Herbert Wilcox and British & Dominion moved production to Pinewood Studios in Iver Heath, Buckinghamshire. Fortunately, several buildings at the B&D site did survive and were later sold off to a number of film-related businesses. Today, plaques outside are the only physical proof that a profitable studio once stood and operated there.

In 1938, cinema-goers were treated to the comedy drama, *St Martin's Lane* starring Charles Laughton, Vivien Leigh and Rex Harrison. It was also released under the title of *Sidewalks of London*. Laughton and Leigh did not see eye-to-eye during the making of the film – perhaps explaining why Laurence Olivier's many visits to the studio during the production process were a welcome diversion for his then future wife.

Murder in Soho, a crime drama that stars Jack la Rue, Sandra Storme, Bernard Lee and Googie Withers, was to hit cinema screens in 1939, which also saw the welcome return of Alfred Hitchcock for his film adaptation of Daphne du Maurier's novel, *Jamaica Inn*, starring Charles Laughton, Leslie Banks, Robert Newton and Maureen O'Hara. Despite being a big success at the box office, *Jamaica Inn* is not considered by critics to be

BELOW: Charles Laughton and Maureen O'Hara starred in the 1939 costume drama, *Jamaica Inn*.

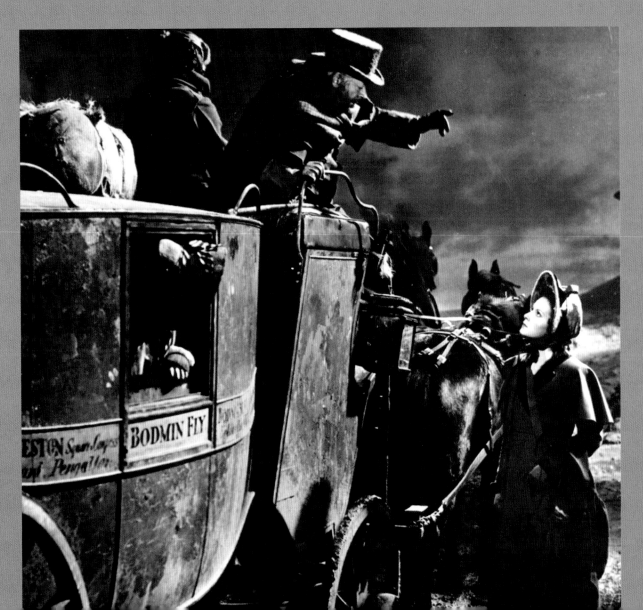

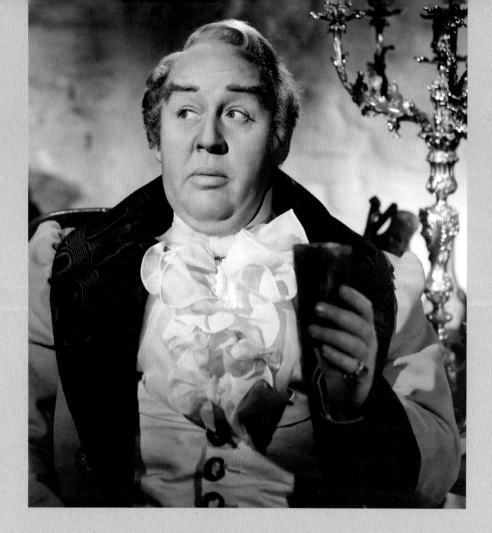

LEFT: Charles Laughton as Sir Humphrey Pengallan in the film adaptation of *Jamaica Inn*.

one of the director's best films. One imagines that the director didn't have the happiest of experiences, as Laughton reportedly interfered on a number of matters during production of the film.

With the end of the decade in sight, changes were imminent. It's estimated that at that point, approximately 200 films had been made at Elstree Studios. At the start of the Second World War, The Royal Ordnance Corps commandeered the studios with Brigadier G.W. Worsdell in charge. With their arrival, a 550-seater auditorium, named the Garrison Theatre, was built with the purpose of entertaining the many troops who would eventually be based near to the studio.

The site would not be confined to the purpose of entertaining and boosting the morale of the troops and the storing of essential supplies. Elstree played an even more important role in the six-year conflict, as various devices that aided the war effort were secretly created there. Representing BIP's interests, while the

RIGHT: A photograph from the 1939 gangster drama, *Murder in Soho*. When the film was released in America, under the title, *Murder in the Night*, it carried the tagline, 'The rapid-fire story of an underworld mobster with a social bee in his bonnet and a rod on his hip!'

site was unavailable for filmmaking, was the ever-reliable studio manager, Joe Grossman.

By the time of his death in 1940, John Maxwell had grown his cinema empire to more than 500 theatres – at that time the second largest cinema circuit in the world.

In their obituary of Maxwell, printed on 4 October 1940, *The Times* said, 'Maxwell brought to production vision, foresight, and culture and on the cinema side he believed in giving the public the best of pictures available, plus comfort and luxury.' He was considered by many in the United States, as well as in Great Britain, as the most outstanding personality in the British film industry.

After Maxwell's death, only time would tell what the future would bring for Elstree Studios once the war was over.

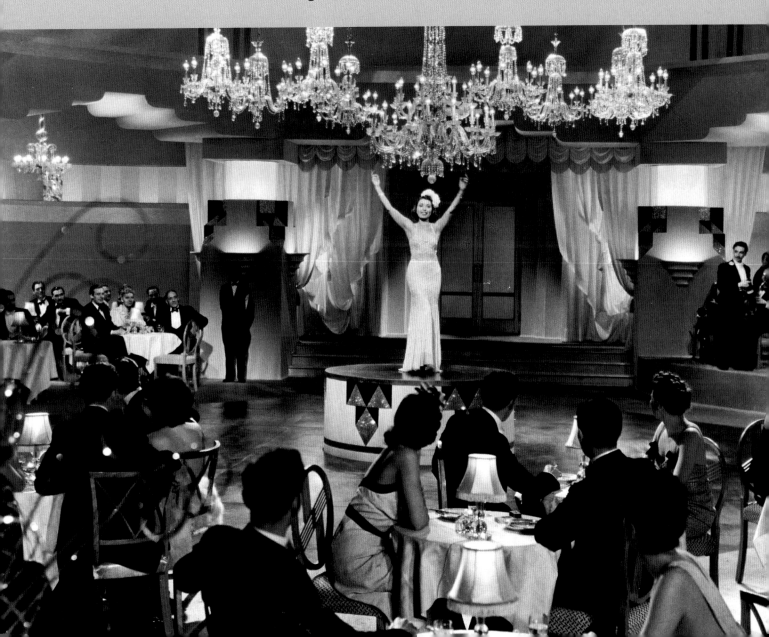

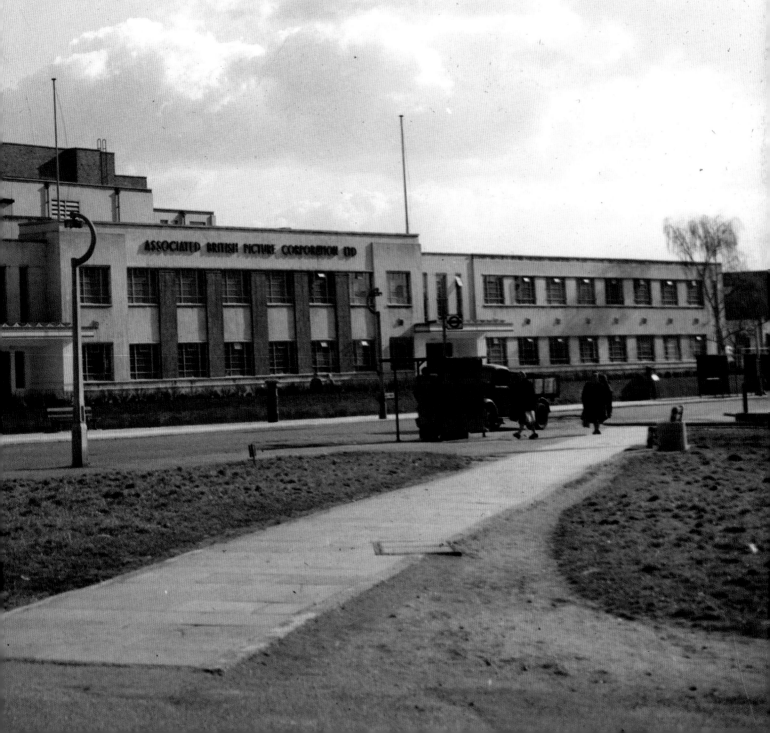

THE WIND

CHAPTER TWO

OF CHANGE

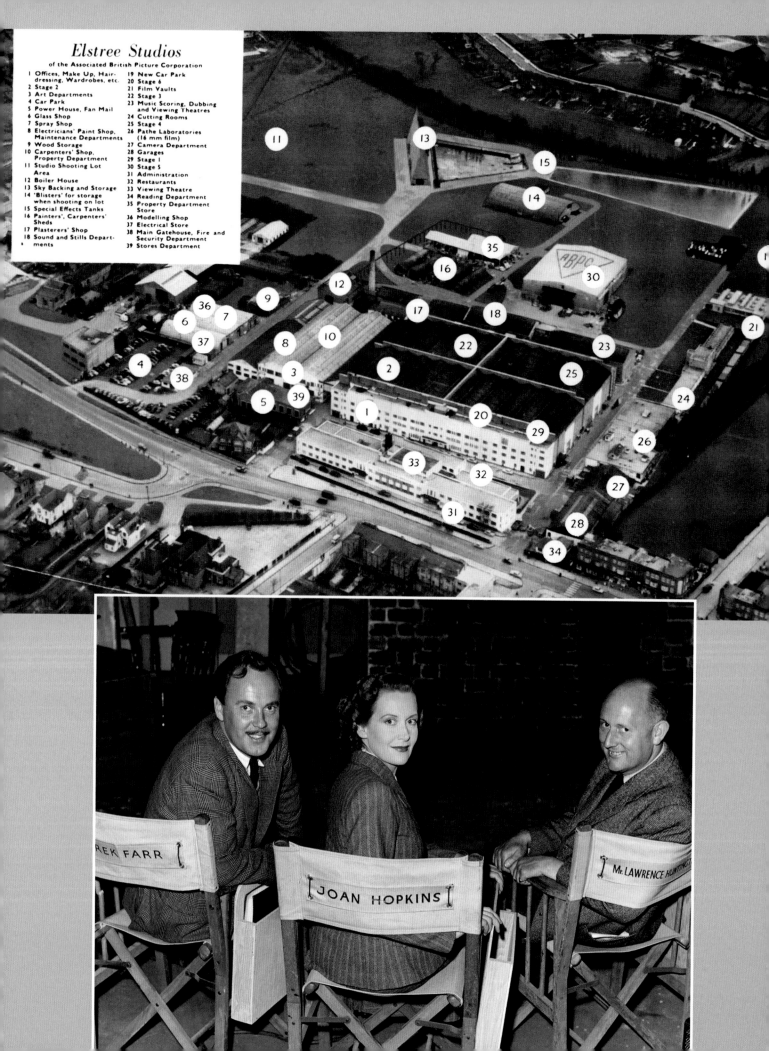

Elstree Studios
of the Associated British Picture Corporation

1 Offices, Make Up, Hair-dressing, Wardrobes, etc.
2 Stage 2
3 Art Departments
4 Car Park
5 Power House, Fan Mail
6 Glass Shop
7 Spray Shop
8 Electricians' Paint Shop, Maintenance Departments
9 Wood Storage
10 Carpenters' Shop, Property Department
11 Studio Shooting Lot Area
12 Boiler House
13 Sky Backing and Storage
14 'Blisters' for storage when shooting on lot
15 Special Effects Tanks
16 Painters', Carpenters' Sheds
17 Plasterers' Shop
18 Sound and Stills Departments

19 New Car Park
20 Stage 6
21 Film Vaults
22 Stage 3
23 Music Scoring, Dubbing and Viewing Theatres
24 Cutting Rooms
25 Stage 4
26 Pathe Laboratories (16 mm film)
27 Camera Department
28 Garages
29 Stage 1
30 Stage 5
31 Administration
32 Restaurants
33 Viewing Theatre
34 Reading Department
35 Property Department Store
36 Modelling Shop
37 Electrical Store
38 Main Gatehouse, Fire and Security Department
39 Stores Department

PREVIOUS SPREAD: The impressive administration block that was built by ABPC during their ownership and once stretched in front of the studio.

ABOVE LEFT: An aerial photo complete with studio guide that was issued by ABPC.

BELOW LEFT: Derek Farr and Joan Hopkins pose for a photo on the chairs with the director of *Man on the Run*, Lawrence Huntington.

t was all change for British International Pictures come the end of the Second World War. By now, Warner Brothers owned a greater part of the John Maxwell Estate, having bought, for £900,000, two million of the four million shares Maxwell's wife had inherited from her late husband. The purchase of an additional million shares – for £1,125,000 – during the summer of 1945 sealed Warner's ownership of the Elstree Studios site. Although the actual name of the studio wasn't changed to the Associated British Picture Corporation (ABPC) until after the war, John Maxwell's company had in fact already changed to that moniker in 1937. A new board, chaired by the late John Maxwell's son-in-law, Sir Philip Warter, subsequently made the decision to rebuild the studio. Meanwhile, back on the studio floor, Robert Clark, the newly appointed executive director of studios and production at Elstree tasked Robert Lennard, who had originally worked as a casting director at BIP before the war, with the job of finding the right actors and performers for a crop of new, post-war films.

September 1948 marked a milestone in the town of Borehamwood. With building work at the site finally completed, production commenced on the 1949 crime thriller, *Man on the Run*, directed by Lawrence Huntington and starring Derek Farr, Joan Hopkins, Kenneth More and a very young Laurence Harvey in his debut role.

This was quickly followed up by *The Hasty Heart*, which was to become the tenth most popular film at the British box office in 1949 and starred the then future US president Ronald Reagan,

together with Patricia Neal and Richard Todd. The film was set in tropical Burma at the end of the war but was shot over the course of a rather dull summer at Elstree.

Having previously decamped to Hollywood, Alfred Hitchcock made a brief return to his old Elstree stomping ground to act as both the producer and director of the crime thriller *Stage Fright*. This, sadly, did not mark the start of another intense period of British filmmaking for Hitchcock. Indeed, his next UK-made film would be Hitch's penultimate production, *Frenzy*, which was shot in

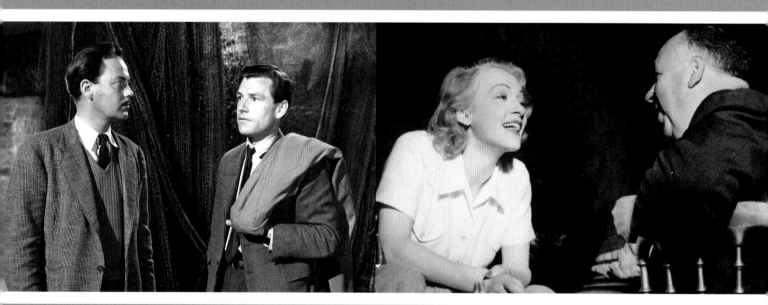

and around London and at Pinewood Studios and released in 1972.

Released in 1950, *Stage Fright* stars Marlene Dietrich, Jane Wyman (who had just won an Oscar for *Johnny Belinda*), Michael Wilding and Richard Todd, together with Alastair Sim, Sybil Thorndike, Kay Walsh, Joyce Grenfell and Ballard Berkeley.

Based on the novel *Man Running* by Selwyn Jepson, *Stage Fright*, which boasts many of Hitchcock's trademark long-takes, is set in the glamorous world of London's theatre land. Jane Wyman was by no means the only actress afforded the chance to impress in the film. Playing singer and accused murderess, Charlotte Inward, Marlene Dietrich was given the opportunity to

ABOVE LEFT: Derek Farr and Kenneth More in the 1949 film, *Man on the Run*.

ABOVE: Marlene Dietrich and Alfred Hitchcock engaged in conversation on the set of the 1950 crime film, *Stage Fright*.

perform Cole Porter's specially composed song, 'The Laziest Gal in Town', and Edith Piaf's iconic number, 'La Vie En Rose'.

Although the Second World War ended in Europe on 8 May 1945, the British were still coping with rationing and shortages for many years afterwards, including while *Stage Fright* was being made. Ever resourceful, Hitchcock found a solution, as Marlene explained. 'Hitchcock solved the problem by having steaks and roasts flown in from America and delivered to the best restaurants in London. And then after work, he would invite

BELOW: Richard Todd and Patricia Neal as Corporal Lachlan 'Lachie' MacLachlan and Sister Margaret Parker in *The Hasty Heart*.

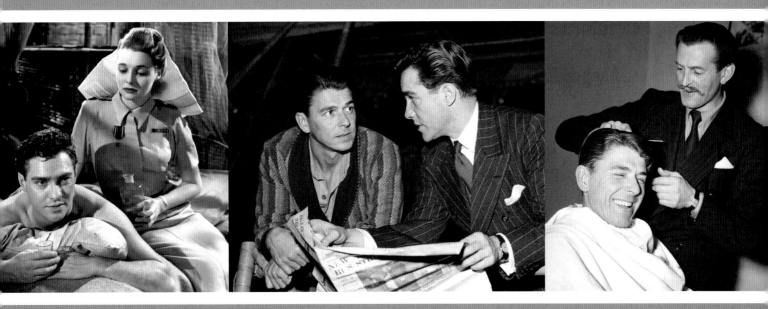

MIDDLE: Ronald Reagan and Richard Todd discuss the latest news while taking a break from filming.

RIGHT: Ronald Reagan has his hair cut for his role in *The Hasty Heart* courtesy of studio hairdresser, A.G. Scott.

Jane Wyman and me to a princely dinner. "Ladies must be well fed," he would say, as we gratefully polished off the delicacies. These dinners were the only contact we had with him outside the studio. He kept us at a distance. Like many geniuses he didn't like being idolized.'

Directed by John Boulting and produced by Ronald Neame, *The Magic Box* was one of the projects connected to The Festival of Britain. The film, which was shown just before the end of the festival in 1951, centred on the life and work of cinema pioneer, William Friese-Greene, played by Robert Donat. Roles in the production were taken by many of the leading stars of the day,

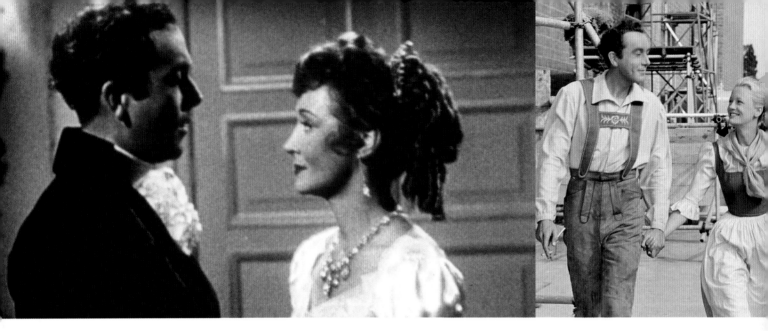

including Richard Attenborough, Bernard Miles, Eric Portman, Joyce Grenfell, Dennis Price, Margaret Rutherford and Glynis Johns. The film's makers also assembled an impressive list of screen talent to play cameo roles. These included Cecil Parker, David Tomlinson, Kay Walsh, Laurence Olivier, Jack Hulbert, Michael Denison, Michael Hordern, Peter Ustinov, Sidney James, Stanley Holloway, Thora Hird, William Hartnell and Googie Withers.

During the making of *The Magic Box*, Queen Elizabeth (later the Queen Mother) and Princess Margaret both visited the set and took great interest in talking to the director, cameramen and actors. Fascinating footage exists of Queen Elizabeth looking into the camera and also inspecting some of the models made for the film.

The comedy *Laughter in Paradise* was produced and directed by Mario Zampi and starred a host of well-known British acting talent, including Alastair Sim, Fay Compton, George Cole and Guy Middleton. A very young Audrey Hepburn also makes a brief appearance in the film, playing a cigarette girl. This was an early professional appearance on film for Hepburn. The filming of her scene was later recreated in *The Audrey Hepburn Story*, starring Jennifer Love Hewitt.

The plot of *Laughter in Paradise* sees dead millionaire Henry Russell (Hugh Griffith) informing four relatives in his will that they stand to inherit £50,000 if they each perform an outlandish task.

ABOVE LEFT: Dennis Price and Giselle Preville in ABPC's 1950 screen adaptation of the Ivor Novello musical romance, *The Dancing Years*.

ABOVE RIGHT: Dennis Price and Patricia Dainton take a walk near to the then main stage block at the studio during the making of *The Dancing Years*.

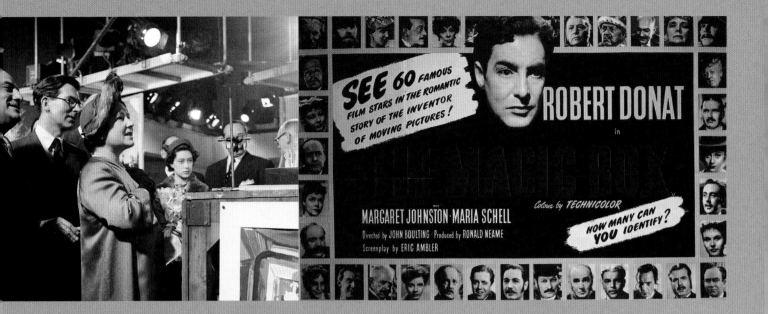

ABOVE LEFT: Her Majesty Queen Elizabeth (later the Queen Mother) and HRH Princess Margaret paying a visit to the set of *The Magic Box* (1951).

ABOVE RIGHT: Publicity material for *The Magic Box*.

The film was remade as *Some Will, Some Won't*, also at Elstree in the late 1960s, when it starred such household names as Leslie Phillips, Ronnie Corbett and Thora Hird.

In 1952, ABPC released a documentary film that paid tribute to the early years of the studio by means of extracts taken from forty-six films and through the eyes of the technicians who worked there. It shows scenes of films in production and the work of technicians, cameramen, sound engineers, craftsmen, actors and directors as they work as a team to bring a film together. Entitled *The Elstree Story*, the film was introduced by actor Richard Todd, who was Oscar-nominated for his role in *The Hasty Heart* and who would later go on to appear in *The Dam Busters*, also filmed at Elstree. Norman Shelley, Georgie Henschel, Kenneth Connor, Leonard Sachs, Peter Du Roch, Peter Jones and Warwick Ward all provided narration for the documentary.

By the time the documentary was made, Warwick Ward had switched roles from an actor in front of the camera to a producer behind it, but in *The Elstree Story* he is seen discussing his role in *The White Sheik*, back in 1928. He recalled that when the earlier film started production none of the artistes had seen a script. Indeed, the outline for the film, which they were given at the beginning, underwent constant changes before the production was finished.

Other studio personnel of the time who also contributed their recollections in *The Elstree Story* included E.B. Jarvis, who had

been cutting and assembling films since the studio opened; sound mixer Cecil Thornton, who had joined at the time *Blackmail* went into production; and camera operator Norman Warwick, who first started work at the studio as a boy of fourteen.

The Elstree Story was devised, produced and directed by Gilbert Gunn, who had to choose excerpts from the then

RIGHT: A selection of publicity photos from *Laughter in Paradise*. Top to bottom: Joyce Grenfell, John Laurie. Alastair Sim, Hugh Griffith and George Cole.

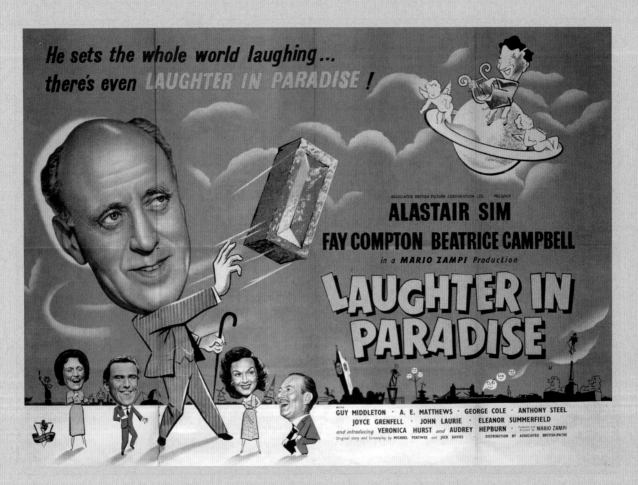

three hundred films in the studio vaults – seventy of which he considered he must see. Talks with the studio staff increased this list to 150. So he spent three months watching films in a preview theatre at the studio, while an assistant took notes. Some films had to be viewed more than once and Gunn was quoted in the film's press release as saying he believed that he viewed over one million feet of film to extract the required

ABOVE: The cinema poster for the 1951 comedy, *Laughter in Paradise*.

FAR RIGHT: Guy Middleton and a young Audrey Hepburn in *Laughter in Paradise*.

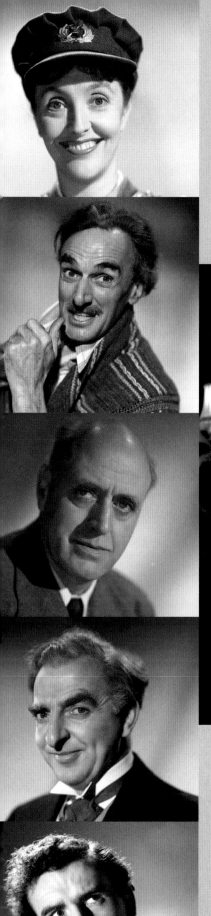

5,591-feet needed for the clips from the forty-six featured in *The Elstree Story*.

More than 100 stars appear in the film, which was distributed by Associated British-Pathé and sported the tagline: 'A story that will stir the pulses of the young and will re-kindle happy memories of the not-so-young!' The stars include many of the most iconic

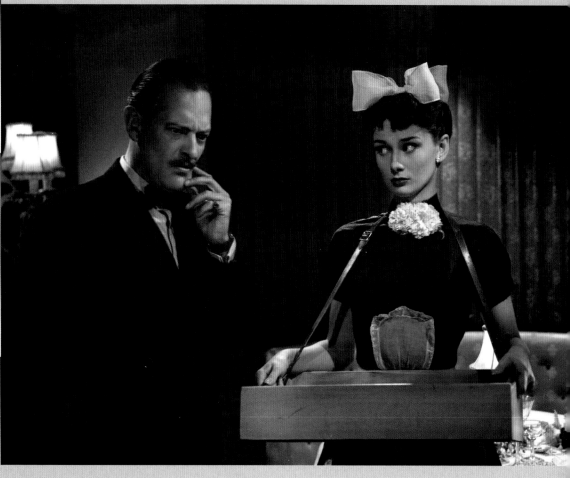

names in British filmmaking – Laurence Olivier, Ralph Richardson, Ann Todd, John Mills, Googie Withers, Douglas Fairbanks Jr., Margaret Lockwood, Maureen O'Hara, Michael Wilding, Patricia Roc, James Mason, Michael Denison and Vera-Ellen.

In 1953, British cinema-goers were given the opportunity to see Kenneth More, Bernard Lee, Andrew Ray (son of Ted Ray), Kathleen Ryan and Sidney James in the drama film, *The Yellow*

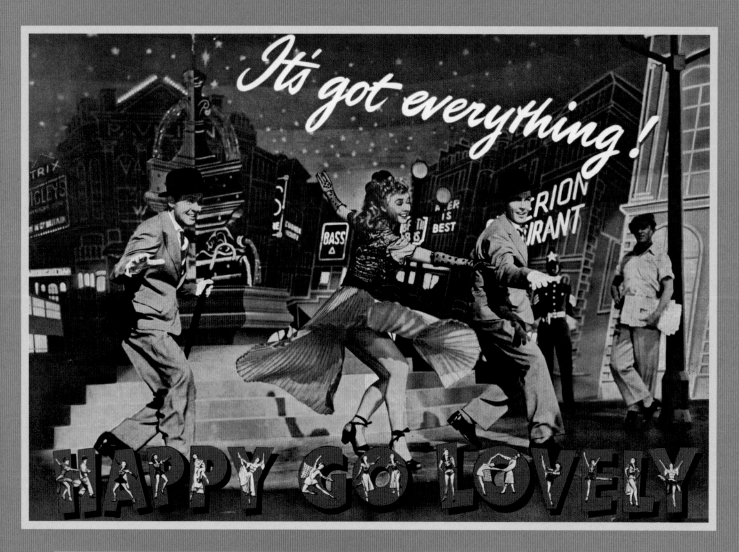

It's got everything!

HAPPY GO LOVELY

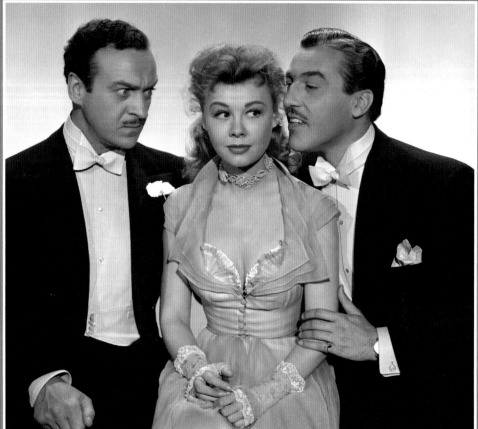

ABOVE: A publicity photo for the 1952 two-song musical, *Happy Go Lovely*.

LEFT: David Niven, Vera-Ellen and Cesar Romero starred in this romantic comedy, which had the tagline, 'Love … Fun … Youth … Set to Music!'

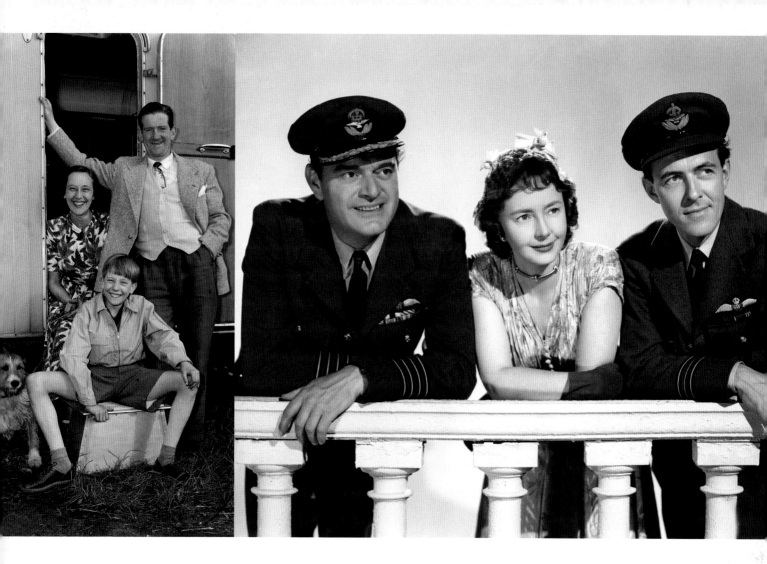

ABOVE LEFT: While he was making the 1953 film, *The Yellow Balloon*, Andrew Ray posed for a photo with his parents – comedian Ted Ray and his wife, Dorothy – and their dog.

ABOVE RIGHT: Jack Hawkins, Dulcie Gray and Michael Denison in *Angels One Five*, a war film directed by George More O'Ferrall, produced by John W. Gossage and set during the summer of 1940.

Balloon, which was directed by J. Lee Thompson, who co-wrote the screenplay with Anne Burnaby. Within a year the relatively unknown More, by now forty years old, was to become a big star following unexpected successes in the Rank films *Genevieve* and *Doctor in the House*.

Valley of Song continued ABPC's dedication to the gentle, quintessentially British comedy film. Set in the Welsh valleys, the film was directed by Gilbert Gunn and stars Mervyn Johns, Clifford Evans, Maureen Swanson and the London Welsh Association Choral Society. Future comedy great but then unknown jobbing actor Kenneth Williams makes a very short appearance, speaking just one line.

Will Any Gentlemen …?, a comedy of errors, which stars George Cole, Veronica Hurst and later Doctor Whos, Jon Pertwee and William Hartnell, had its original release in 1953.

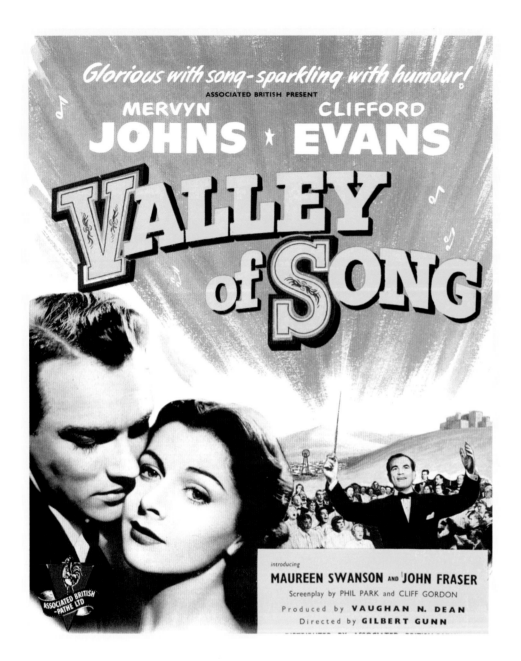

Directed by Michael Anderson, the film's cast also includes early appearances by *Carry On* film favourites, Sidney James, Joan Sims and Peter Butterworth.

George Cole returned to ABPC for the 1954 comedy film set in Ireland, *Happy Ever After*. Directed by Mario Zampi, the film also stars David Niven, Yvonne De Carlo and Barry Fitzgerald.

The Weak and the Wicked, first screened in 1954, was a women's prison-based drama directed by J. Lee Thompson. The cast included Glynis Johns, Diana Dors, Rachel Roberts and Irene Handl. Through a series of flashbacks, female prisoners recall the

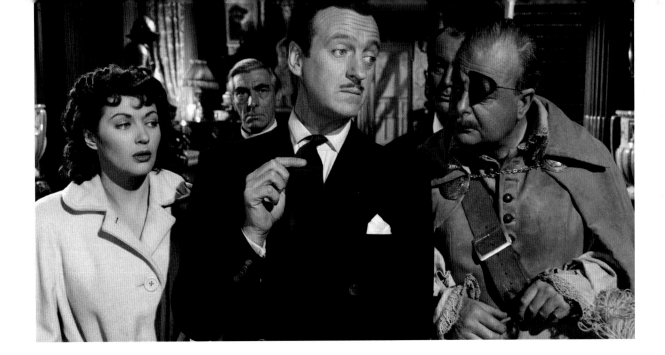

events that led them to be sentenced to serving time in prison. J. Lee Thompson also directed the 1954 marital comedy, *For Better, For Worse* starring Dirk Bogarde, Susan Stephen, Cecil Parker, Dennis Price and Thora Hird.

The 1954 musical *Lilacs in the Spring* paired stars Anna Neagle and Errol Flynn on celluloid for the first time. The film marked a return to the studio for its producer and director, Herbert Wilcox, who was married to Neagle.

Anna Neagle spoke well of her co-star, 'I love naturalness and simplicity and Errol Flynn has this to a charming degree,' she remarked. 'He has made so many friends on this picture with his sense of fun and his conscientiousness and he has been enormously co-operative. It's so unfair to judge people by what you read or hear and I must confess I was not prepared to find him such a hard worker.'

First released in the UK in 1955, and directed by Michael Anderson, *The Dam Busters* recreated the RAF's 617 Squadron's daring attacks on the Möhne, Eder and Sorpe dams in Germany during 1943. The film starred Richard Todd, Michael Redgrave, Ursula Jeans and Basil Sydney.

The story also charts how aeronautical engineer Barnes Wallis (played by Michael Redgrave) convinced the powers that be that his theory of making a bouncing bomb for the proposed attacks

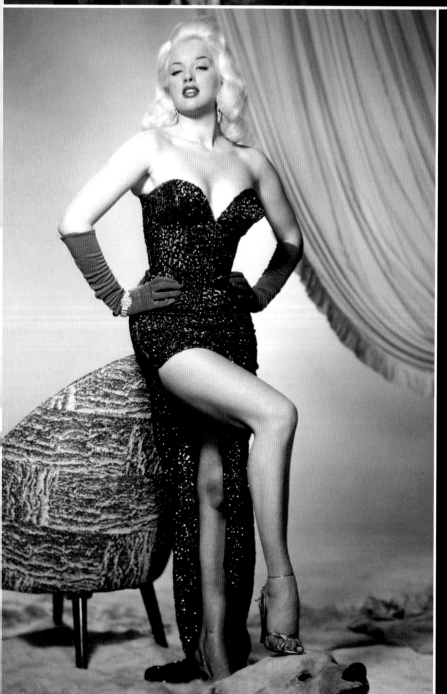

ABOVE: Jon Pertwee, Veronica Hurst and George Cole in *Will Any Gentlemen …?*

LEFT: England's Marilyn Monroe, Diana Dors, poses for a studio publicity photo.

RIGHT: *The Weak and the Wicked*, first screened in 1954, was a woman's prison-based drama directed by J. Lee Thompson and produced by Victor Skutezky.

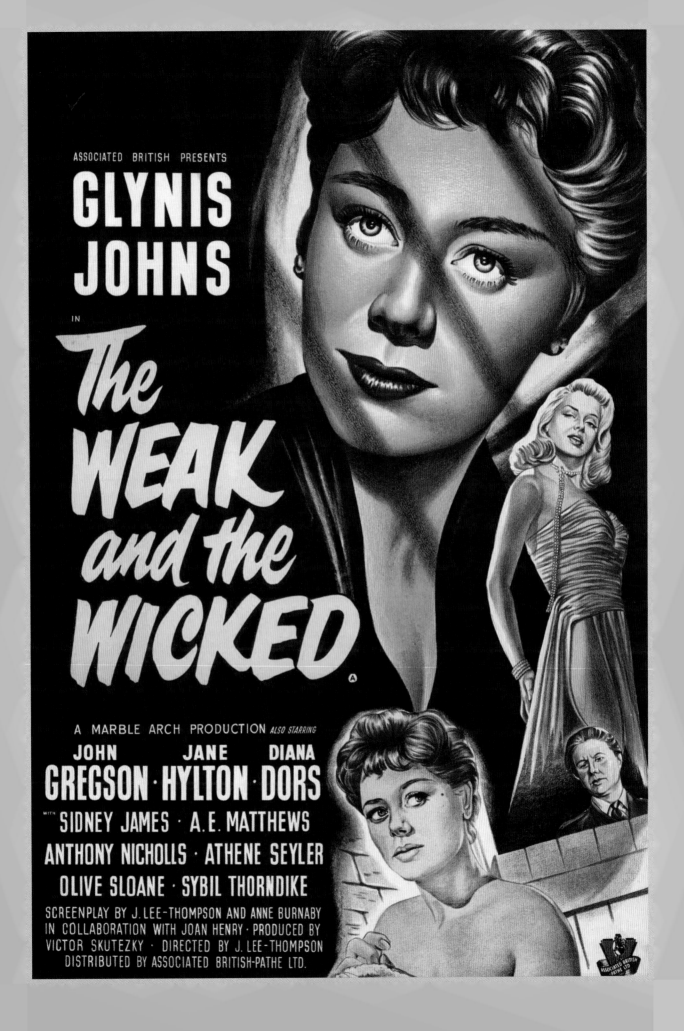

could become a practical reality, thus damaging the very heart of German industry.

Actor George Baker was cast as Flight Lieutenant David Maltby in the film. Baker was often to remind people that Maltby was 'the chap who actually hit the dam with his bomb and burst it'.

With its stirring and now iconic theme by Eric Coates, there's no doubt that *The Dam Busters* is a genuine classic British film – ABPC at their best. Indeed, it was the most popular film at the British box office in 1955.

The rise in popularity of television was slowly spreading across the country and eventually it made the film industry sit up and take notice. At first, ABPC was reluctant to embrace the new

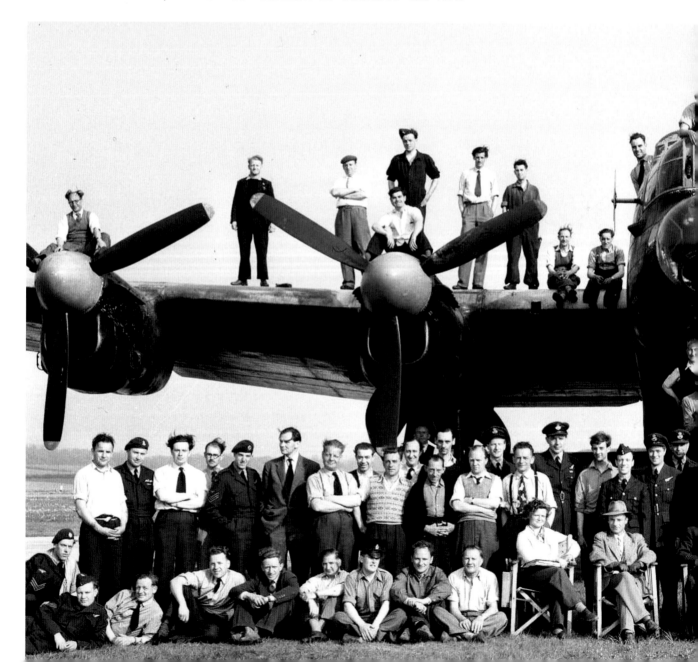

medium. Yet ironically, the Independent Television Authority (ITA) approached them with the idea of ABPC bidding to take on the new weekend ITV franchises for the Midlands and the north of England. Initially, the ABPC board showed the ITA the door. However, the demise of the Kemsley-Winnick Television consortium (the original successful bidders for those franchise areas), led to another approach by the ITA, which, this time, received a more positive response. The apparently sudden increase in enthusiasm was put down to the influence of certain members of ABPC's hierarchy. The agreement led to the formation of ABPC's television division – ABC (Associated British Corporation) – and eventually to the acquisition of the two franchises.

BELOW: A publicity photo featuring members of the cast and crew of the 1955 film, *The Dam Busters*.

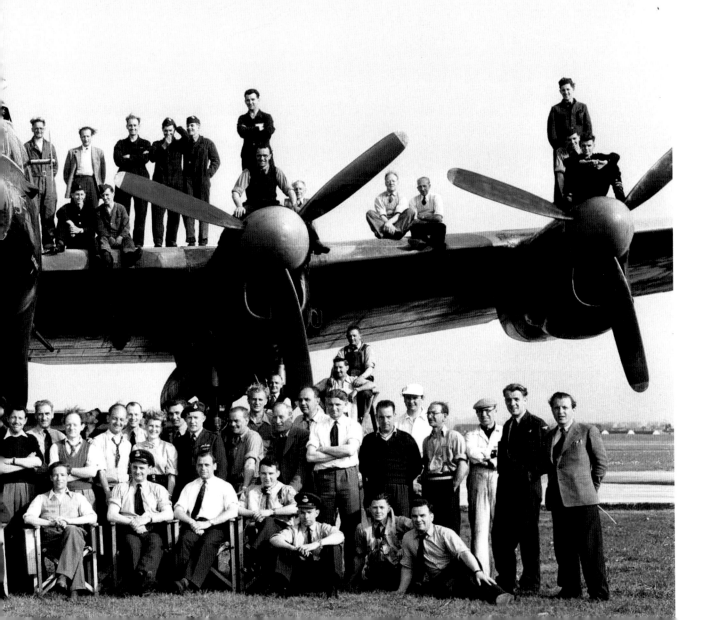

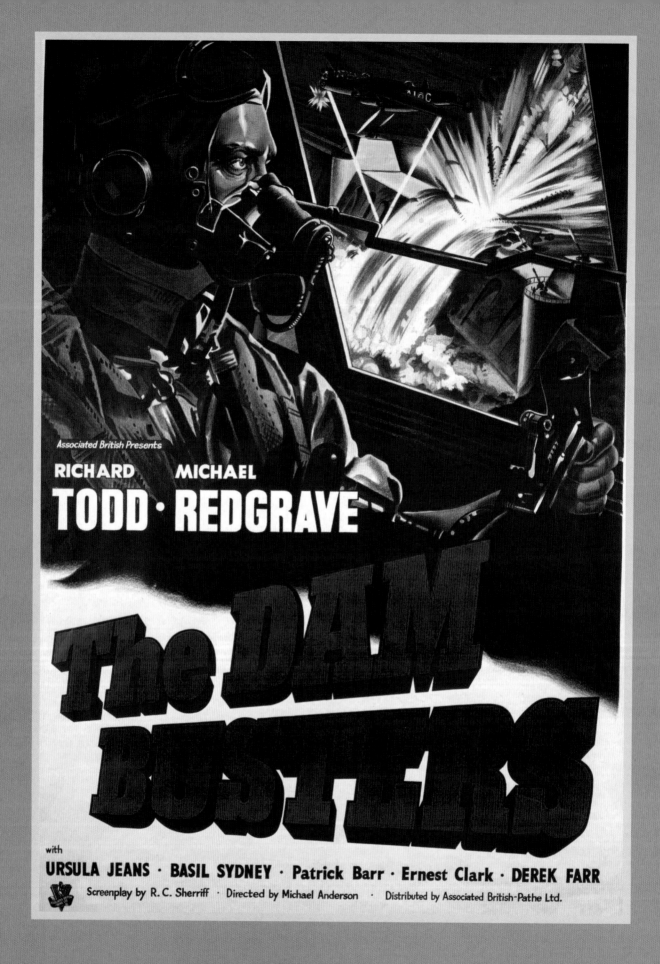

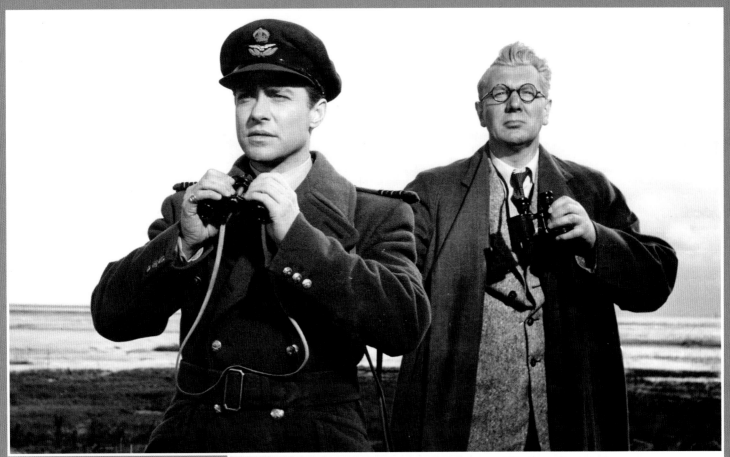

ABOVE: Richard Todd and Michael Redgrave as Guy Gibson and Barnes Wallis respectively in *The Dam Busters*, directed by Michael Anderson.

RIGHT: Michael Redgrave, as Barnes Wallis, attempts to persuade onlookers that his theories are viable.

LEFT: *The Dam Busters* is a film that many consider a classic of its genre.

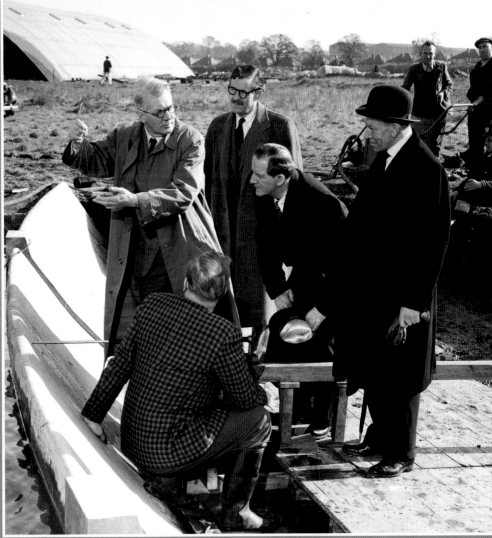

With the ink hardly dry on the contract, signed on 21 September 1955, ABC started to broadcast in the Midlands on 18 February 1956, and in the north on 5 May 1956. As well as making programmes at Elstree Studios, ABC also had main studio facilities created in former cinemas owned by the ABC cinema chain – the Astoria in Aston near Birmingham and the Capitol in Didsbury in Manchester. The Astoria was renamed the Alpha Television Studios. ABC was to share the studio with ATV. ATV, incidentally, would eventually base itself in the old Neptune studios on Clarendon Road in Borehamwood (later home to BBC Elstree and shows such as *EastEnders* and *Holby City*), just a stone's throw from Elstree Studios. ABC also made use of the Hackney Empire in London. Later, to further its television production capabilities, Teddington Studios in Middlesex, Warner's former film studios, was brought into full service – this time as a television facility. ABC and Rediffusion, London, were then asked by the Independent Television Authority (ITA) to form a venture to run the London ITV weekday franchise. Thus Thames Television was born and commenced broadcasting on 30 July 1968.

In late 1955, Michael Powell and Emeric Pressburger premiered their film *Oh … Rosalinda!!*, which is based on Johann Strauss's 1874 operetta, *Die Fledermaus*. Starring Michael Redgrave, Mel Ferrer, Anthony Quayle, Ludmilla Tchérina and Anton Walbrook, Powell and Pressburger had high hopes for a hit, but, although it became something of a cult classic much later, *Oh … Rosalinda!!* was not a commercial success.

The musical comedy film *It's Great to Be Young!*, first released in 1956, is believed to have been Britain's first teenage film musical. It also proved to be a box-office winner for ABPC. Directed by Cyril Frankel, and written by Ted Willis, it stars John Mills as an easy-going school music teacher, Mr Dingle, and Cecil Parker as a strict headmaster who ends up firing Dingle after he stands up for his students' rights. A young Richard O'Sullivan and Bryan Forbes both appeared in the film. 'I only did one day's filming replacing

BELOW: Ludmilla Tchérina as Rosalinda in a publicity photo for the 1955 filmic operetta, *Oh … Rosalinda!!*

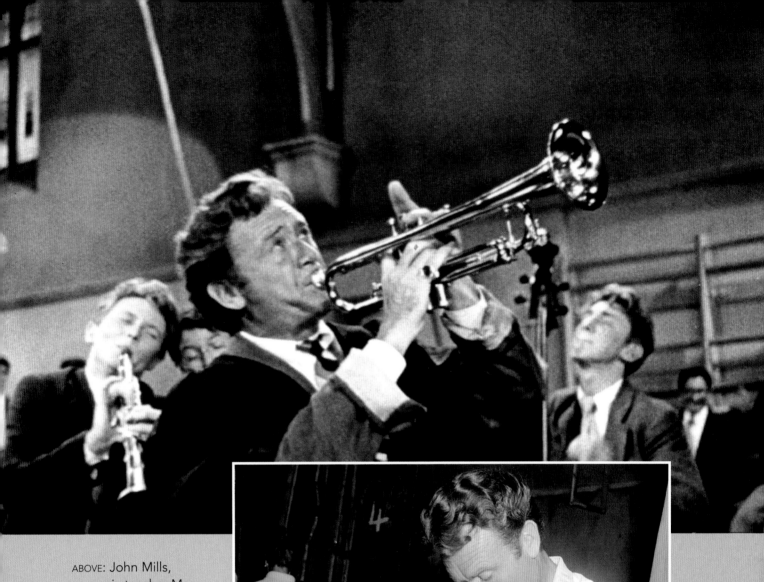

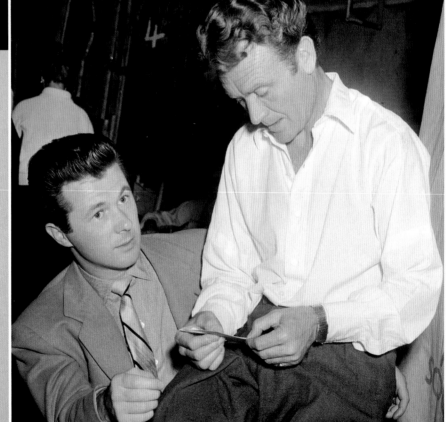

ABOVE: John Mills, as music teacher Mr Dingle, plays the trumpet with gusto in the 1956 teenage film musical, *It's Great to Be Young!*

RIGHT: Bryan Forbes and John Mills rest between takes during the filming of *It's Great to Be Young!*

another actor who had been fired!' Forbes later revealed. 'I think this was the first time I had worked at ABPC.'

Produced and directed by John Huston, with a screenplay by Huston and Ray Bradbury and based on Herman Melville's classic novel, the soon-to-be film classic, *Moby Dick*, was released in 1956. The cast included Gregory Peck as Captain Ahab, Richard Basehart as Ishmael, Leo Genn as Starbuck and James Robertson Justice as Captain Boomer. In the film, we follow Captain Ahab and his crew aboard the whaling ship *Pequod* seeking revenge on the 'great white whale' – Moby Dick – the whale that had almost killed Ahab in a previous encounter.

The production saw a new, large exterior water tank built on the backlot at Elstree, which was used to film many of the scenes with the whale. This tank was to benefit many film and television productions for many decades to come.

Also in 1956, the British crime drama *Yield to the Night* was made by ABPC. Directed by J. Lee Thompson, the film stars

RIGHT: Gregory Peck as Captain Ahab in the 1956 classic, *Moby Dick*.

FAR RIGHT: Director John Huston in a lighter moment on set.

BELOW RIGHT: An exterior water tank being built on the backlot at the studio for *Moby Dick*.

LEFT: Diana Dors as Mary Hilton in the 1956 crime drama, *Yield to the Night*. The film gave Dors the chance to shed her glamorous image and move away from many of the lighter roles she had played in her career, and prove what a proficient, serious actress she was.

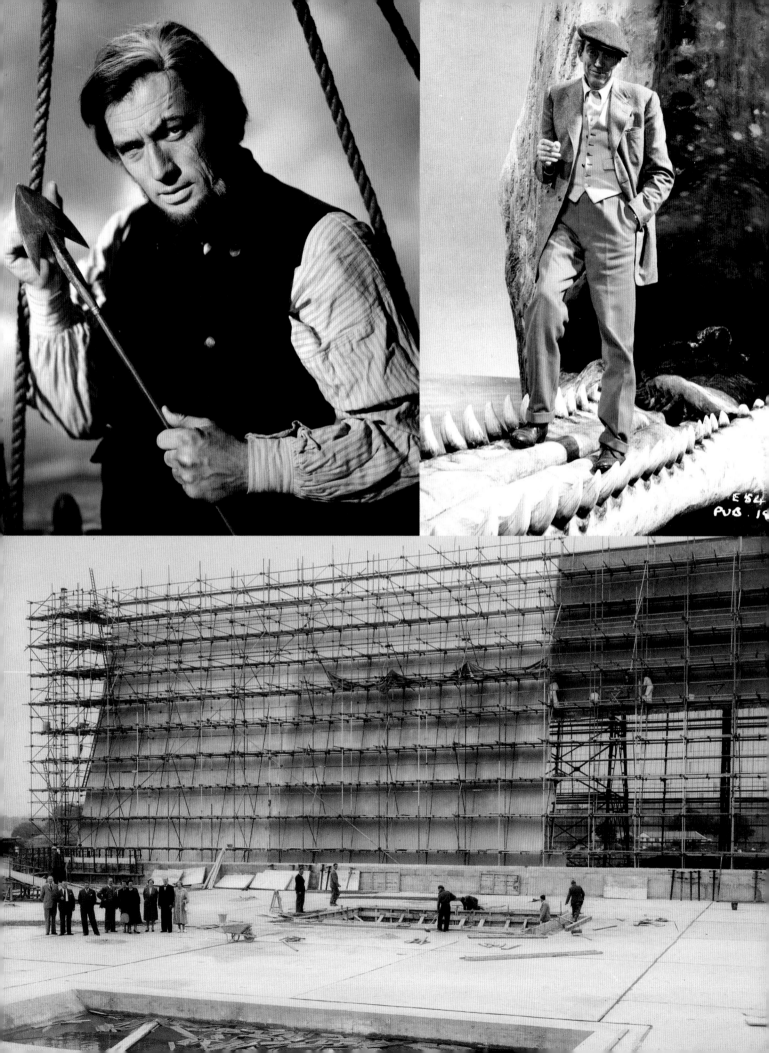

Diana Dors as Mary Hilton, a woman who leaves her husband, Fred Hilton (Harry Locke), for lover Jim Lancaster (Michael Craig). Hilton is later sentenced to hang for the murder of Lucy Carpenter (Mercia Shaw), Lancaster's lover. The film, which is told in flashbacks while Hilton awaits her fate, also stars Yvonne Mitchell and Geoffrey Keen.

Brief Encounter's Celia Johnson starred alongside Eric Portman, John Fraser, Rachel Roberts, Joyce Grenfell, Anthony Newley, Thora Hird and Hird's real-life daughter, Janette Scott, in the 1957 film, *The Good Companions*. The musical comedy follows the ups and downs of a touring concert party called 'The Dinky Doos'. ABPC's film version, directed by J. Lee Thompson, was an updated version of J.B. Priestley's original story, with music scored by Laurie Johnson.

Actress Janette Scott recalls being questioned about her wardrobe in the film. 'Robert Clark, head of production at the time, called me to his office while we were making *The Good*

FAR LEFT: Janette Scott performs in the 1957 musical, *The Good Companions*, directed by J. Lee Thompson.

LEFT: A shot taken in the studio grounds of Janette with her mother, Thora Hird, who also appeared in the film.

BELOW: Errol Flynn with his third wife, Patrice Wymore, in a scene from the 1955 musical, *King's Rhapsody*.

Companions. He questioned why I needed so many changes of clothes during the musical numbers when surely, "a jumper and a skirt would do!"'

Wardrobe budget issues aside, Janette Scott remembers ABPC as being an important part of her formative years. 'Elstree Studios was my home from nine years old until I was twenty. Avoiding lessons with various tutors, I knew every cutting room, wardrobe room and sound recording stage. I knew everyone and look back with great fondness. I remember Ronald Regan, while shooting *The Hasty Heart*, walking me to lunch and Gregory Peck kissing me at my fifteenth birthday party while he was working on *Moby Dick* at the time!'

Back in 1958, producer Peter Rogers and Gerald Thomas were planning a film that would ultimately go on to spawn the hugely successful *Carry On* film series. The first entry in the canon was *Carry On Sergeant*, which Rogers had originally scheduled to shoot at Beaconsfield Studios. However, due to a lack of stage space – Beaconsfield having been taken over by *Ivanhoe*, starring Roger Moore in his first big-hit small-screen role, Rogers decided to turn to the more expensive Pinewood Studios to base his new production. The film's funders, Anglo Amalgamated, were not best pleased at his decision. After all, Rogers' films were released onto the ABC circuit of cinemas, so they felt it appropriate to make the film at ABPC's Elstree Studios. Rogers' wife Betty Box, producer of the popular *Doctor* series of films, was already based at Pinewood and Rogers was eventually to get his way. Ultimately all thirty-one *Carry On* films were made at Pinewood Studios between 1958 and 1992.

John Mills returned to Elstree for the 1958 iconic film drama, *Ice Cold in Alex*, which also starred Sylvia Syms, Anthony Quayle and Harry Andrews. Directed by J. Lee Thompson the film is set during the Second World War and follows an eventful journey taken by Captain Anson (Mills) and MSM Tom Pugh (Andrews) from North Africa to Alexandria with two nurses. It's not long before they come to suspect that a passenger they pick up on

route, Captain van der Poel (Quayle), is a German spy.

Over the ensuing years, John Mills often spoke about the famous scene towards the end of that film in which, following a journey across the desert, his character, Captain Anson, finally gets to grips with that much-desired ice cold lager. The property master on the scenes filmed at Elstree Studios revealed that he had tried various liquid concoctions to try to replicate lager, but had sadly failed. J. Lee Thompson responded by announcing Mills would be faced with a real glass of lager. Due to various technical problems, there followed six takes – and six pints – before the shot was in the can. Mills was nothing short of drunk from the cold lager under the hot studio lights and members of the crew were required to put him to bed in his dressing room so he could sleep off the effects of the drink. No wonder Mills continued to claim for the rest of his life that it was the 'happiest and most enjoyable morning I have ever spent in any film studio'!

Sylvia Syms continues to be remembered for playing Sister

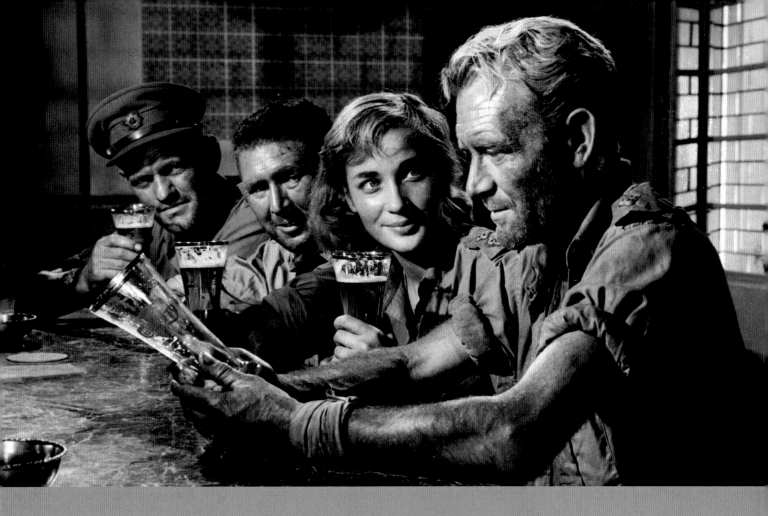

Diana Murdoch. 'Ice Cold in Alex is the film I'm always asked about, probably because it's always on television and everyone remembers that famous lager scene at the end. People love that film and it was a huge success, although the desert locations weren't fun because of all the flies. The actors, though, were marvellous: Anthony Quayle had been a war hero; John Mills was like my father and Harry Andrews was the sweetest man in the world.'

Nominated for four BAFTA's and released in 1959, *Look Back in Anger* stars Richard Burton, Claire Bloom, Mary Ure and Edith Evans. Directed by Tony Richardson, the drama film's screenplay was written by the author of the successful play, John Osborne, and Nigel Kneale. Burton, who was nominated for a Best Actor award at the BAFTA's, played the original angry young man, Jimmy Porter.

The 1950s ended on a high for the studios. Yet it would not be long before the Associated British Picture Company would face tough new challenges that would ultimately see big changes for both ABPC and Elstree Studios.

CHAPTER THREE

THE
SWINGIN'
SIXTIES

A new decade brought with it a Britain facing change and financial uncertainty. While the country was not in recession, it was on the verge of entering a decline. The population started to feel ill at ease and Prime Minister Harold Macmillan's declaration that 'most of our people have never had it so good' began to fall on deaf ears.

For the film industry the decade would bring its own challenges. Television, now beginning to make its mark with rising numbers of viewers, was taking chunks out of cinema attendances and, in turn, box-office receipts. Some films were able to buck the trend and indeed turn the popularity of certain television shows to their advantage. *Carry On Sergeant* shamelessly exploited the popularity of late 1950s Granada television hit *The Army Game*, even going so far as to employ some of its stars – William Hartnell, Norman Rossington and Charles Hawtrey – to appear in the low-budget, almost copycat, conscript-based comedy.

Top of the television ratings in 1960 was family sitcom *The Larkins* starring Peggy Mount as a harridan wife and her henpecked husband David Kossoff. The show was regularly watched in over 7.5 million households. Running for forty episodes over six years, it also found time for a big-screen outing called *Inn for Trouble*.

At Elstree, director Mario Zampi took BBC comedy *Whack-O!* starring the irascible Jimmy Edwards and turned it into *Bottoms Up!* – a broader, more slapstick big-screen outing. However, it would be the end of the decade and well into the 1970s when

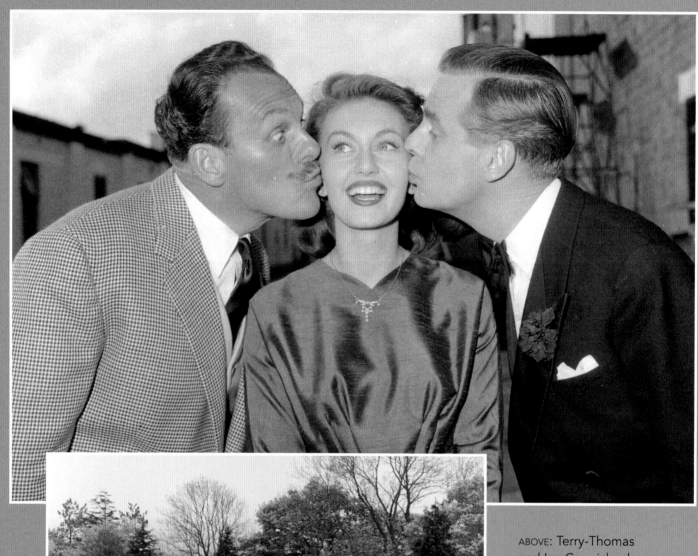

ABOVE: Terry-Thomas and Ian Carmichael both give their co-star Janette Scott a kiss on the cheek in the 1960 film *School for Scoundrels*.

LEFT: Ian Carmichael plays up for the cameras during a location shoot for *School for Scoundrels*. The location, a former private country club and, since the late-1960s a hotel, remains just a stone's throw from the studios.

Elstree would come into its own, seeing the production on its stages of many cinema versions of small-screen comedy classics such as *Up Pompeii*, *On the Buses* and *Are You Being Served?*.

For the Associated British Picture Company, which still owned more than 300 cinemas, the challenge was not to try and compete with television but to embrace the new medium. Studio sound stages could also be adapted for use by filming for television productions as well as big-screen features. That was the way forward. No room for one-upmanship here.

Ironically, it was to be two comedy actors renowned for their television work who would be filling the Elstree stages with mirthful goings-on over the next few years. The first was the diminutive curly red-haired Charlie Drake, remembered by a generation of viewers for his slapstick routines and cheeky catchphrase, 'Hello, my darlings!'

Drake was to make a quartet of titles at Elstree between 1960 and 1967. His first, *Sands of the Desert*, was directed by the man who also directed many of Norman Wisdom's big-screen antics,

BELOW: Charlie Drake and co-stars entertain Robert Mitchum when he visited their stage during a break from filming the 1960 comedy *Sands of the Desert*.

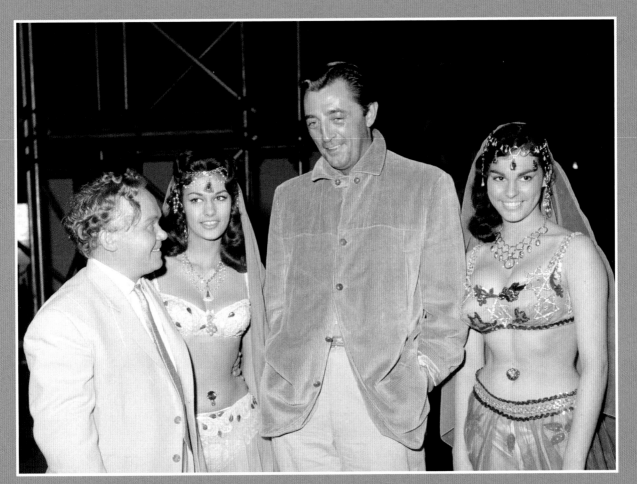

John Paddy Carstairs. In the film, Drake plays travel agent Charlie Sands who gets into the bad books of a sheik when he travels to the Arabian Peninsula with the intention of opening a new holiday camp. His second outing followed soon after, this time a naval comedy, *Petticoat Pirates*, in 1961, in which Drake played a lustful stoker who's out of his depth when the chief officer and a company of Wrens decide to lead a full-scale mutiny on a Royal Navy frigate in order to prove that they're as capable as their male counterparts.

Drake returned to ABPC to play expert, law-abiding locksmith, Ernest Wright, who ends up being exploited by the criminal fraternity in the 1963 film, *The Cracksman*, and then once more some four years later taking on the role of construction worker and amateur playwright Percy Pointer in a theatre-based comedy, *Mister Ten Per Cent*. None of Drake's films were great successes at the box office, however, and he returned to television, where his shows continued to attract high ratings and assured him continued personal fame.

BELOW: Charlie Drake finds himself in the dock in the 1963 comedy film *The Cracksman*, while Norman Bird tries to help the case run smoothly.

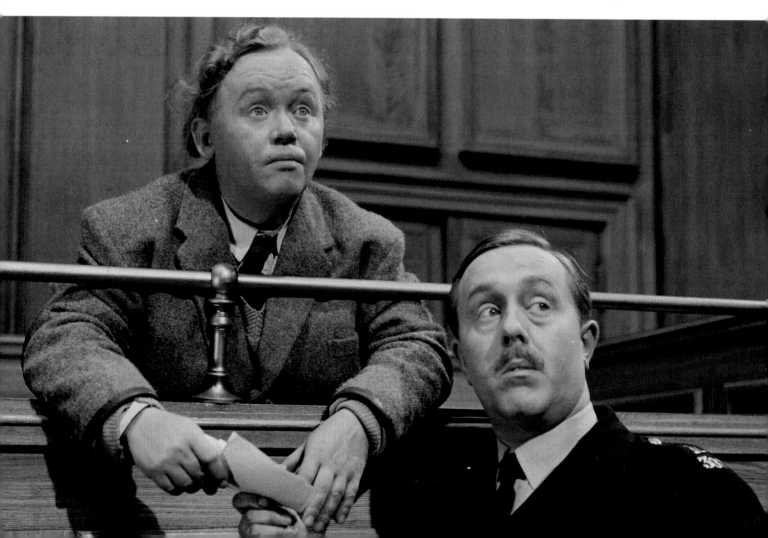

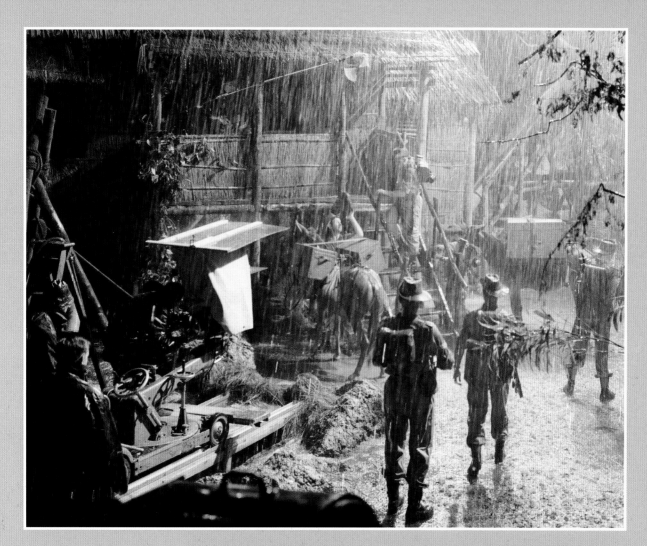

ABOVE: A behind-the-scenes photo taken in a stage at the studio doubling for the Burmese jungle in *The Long and the Short and the Tall*.

RIGHT: Laurence Harvey shares his thoughts with producer Michael Balcon during the making of the 1961 war film.

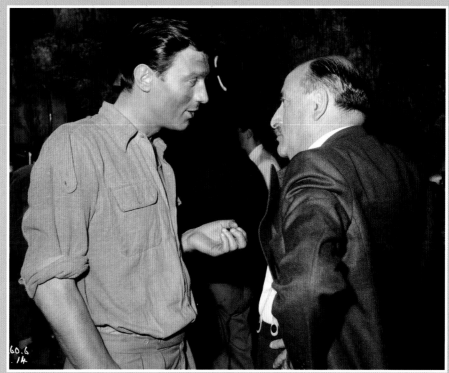

The second big name trying to make the move to big-screen success was radio and television star Tony Hancock.

In *The Rebel*, a 1961 comedy film directed by Robert Day, Tony Hancock stars as frustrated amateur artist, Anthony Hancock, who dreams of escaping the humdrum repetitive life of an office clerk to become an artist. The screenplay was written by Ray Galton and Alan Simpson who, over a seven-year period, had written over 100 episodes of *Hancock's Half Hour* for both radio and television.

'We decided we wanted to spread our wings a bit, and the

RIGHT: Tony Hancock and George Sanders take two dogs for a walk in the studio grounds.

BELOW RIGHT: Tony Hancock plays would-be successful avant-garde artist, Anthony Hancock.

only way to go now was the cinema,' said Alan Simpson. 'Ray and I had never written a screenplay and we had interest from ABPC to write a film starring Tony Hancock. So we got together with Tony and came up with the idea of *The Rebel*, which we originally called *One Man's Meat* – until the studio got hold of it and said, "No-way! That's a nonsense title."

'Ray and I came up with this idea of an avant-garde artist, who was a load of rubbish. But I suppose we were taking the mickey out of the so-called avant-garde art movement at the time.'

The Rebel is more than just a feature-length spin-off from a typical episode of *Hancock*, although there were similarities in

ABOVE LEFT TO RIGHT: Nanette Newman and Tony Hancock on set; Tony Hancock in a classic scene that cleverly summarizes the tedium experienced by the average office worker in the 1960s; with Irene Handl on set; the masterpiece 'Aphrodite at the Water Hole'; and a young Oliver Reed in thoughtful mode.

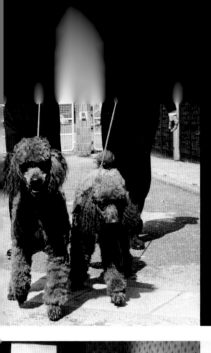

some of the casting. You'll notice that there are people who appear in the film who appeared in the television half hours,' Alan remarked. 'John Le Mesurier is a perfect example.'

But there was one casting in particular that excited Ray and Alan more than the others – that of George Sanders. 'George was a star, there's no other word for it,' exclaimed Alan. 'He was an immaculately dressed and beautifully spoken man; and what a charming lad he was too. He had written into his contract that he had a grand piano on the set at all times. And when he'd

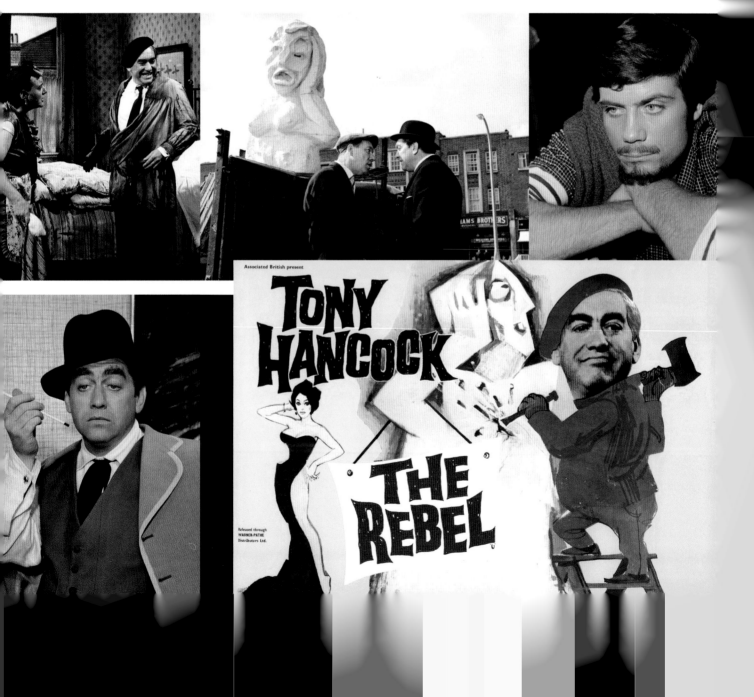

finished his shot he'd wander off, sit down at the piano and start warbling songs by Ivor Novello. He had a very good voice. Yet for some strange reason all the technicians and the electricians up on the rafters above our heads, and the scene shifters, took great exception and thought he was a big show off!'

Although Hancock was not destined to conquer the film world in quite the way he wanted to, *The Rebel* was a commercial success.

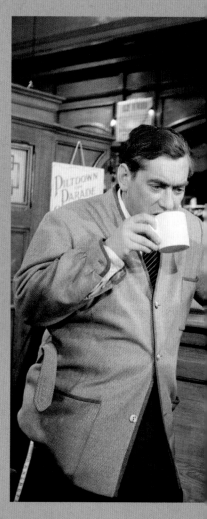

The Punch and Judy Man was Hancock's second and final film for ABPC at Elstree Studios. Having cast himself adrift from Galton and Simpson, the writers who had helped to make his shows appeal to the masses, Hancock decided to co-write the screenplay for *The Punch and Judy Man* with Philip Oakes. Directed by Jeremy Summers, the 1963 comedy is more bitter-sweet than gentle, and sees its star take on the role of an unhappily married Punch and Judy man in the fictitious British seaside town of Piltdown (in reality Bognor Regis in West Sussex) with his social-climbing wife, Sylvia Syms. Hancock's old colleagues John Le Mesurier, Mario Fabrizi and Hattie Jacques also appear.

Despite a great deal of promise and expectation, the film was not a critical success. Sadly, unlike Charlie Drake, there was to be no successful return to the small screen for Tony Hancock, whose personal demons got the better of him. Tragically, in 1968, while filming a sit-com in Australia, he took his own life. He was forty-four.

By 1960, with two No.1 hits already under his belt and a third imminent, Cliff Richard had become a big star name. Following in the footsteps of Tommy Steele, it was unsurprising that ABPC were keen to bring his brand of clean-cut, boy-next-door, sing-along fun to the big screen with hit musical films made at Elstree.

Released by ABPC in 1961, and with a budget of reportedly £230,000 – estimated to be almost £5 million today – *The Young Ones* was the first of a trilogy of musicals that Cliff Richard made for the company. Directed by Sidney J. Furie, the film was choreographed by Herbert Ross, and also starred Carole Gray, Teddy Green, Richard O'Sullivan, Melvyn Hayes, and Cliff's then

ABOVE: Tony Hancock and John Le Mesurier on the set of *The Punch and Judy Man*.

RIGHT: Mario Fabrizi and a friendly white dove in a scene from *The Punch and Judy Man* (1963).

LEFT: Tony Hancock plays with his fellow cast members during a break in filming *The Punch and Judy Man*.

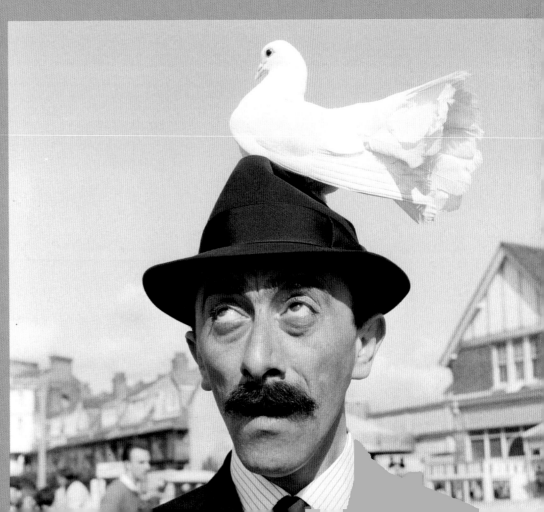

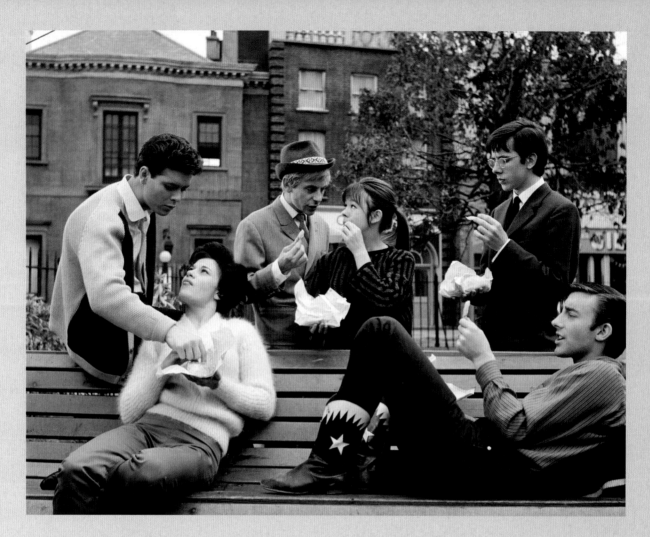

backing band, The Shadows. A 'town set', built on the backlot at ABPC and rehashed for numerous film and television productions afterwards, was used extensively for the exterior scenes set in London and close to and outside the youth club, while the disused Finsbury Park Empire doubled for many of the scenes set inside a run-down theatre.

'When *The Young Ones* was presented to me with such enthusiasm, and with the chance of having The Shadows write part of the music, it just seemed to me an opportunity I shouldn't miss,' Cliff Richard recalls.

'We had the time of our lives: we couldn't believe that at the end of the day we got paid. Now, as I look back, of course, had I been any kind of businessman I'd have made sure that when this film is seen over and over again I'd been on some kind of royalty. I could have retired by now! I don't get anything from the film but I do still relish the glory it brings me.'

ABOVE: Cliff Richard, Carole Gray, Melvyn Hayes, Annette Robertson, Richard O'Sullivan and Teddy Green in a scene from *The Young Ones* filmed on the exterior town set at the studio. Hayes remembered the film with gratitude. 'They were wonderful days,' he said. 'It was a joy to work at the studio.'

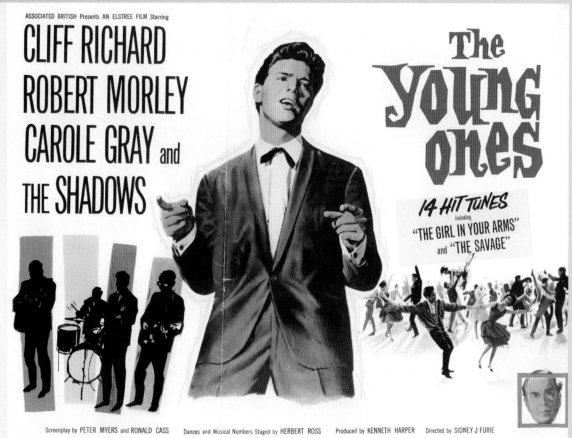

ASSOCIATED BRITISH Presents AN ELSTREE FILM Starring

CLIFF RICHARD
ROBERT MORLEY
CAROLE GRAY and
THE SHADOWS

THE YOUNG ONES

14 HIT TUNES
including
"THE GIRL IN YOUR ARMS"
and "THE SAVAGE"

Screenplay by PETER MYERS and RONALD CASS Dances and Musical Numbers Staged by HERBERT ROSS Produced by KENNETH HARPER Directed by SIDNEY J FURIE

A CinemaScopE PICTURE in Technicolor Distributed by ASSOCIATED·BRITISH-PATHE

RIGHT: Cliff Richard and Carole Gray share a cold drink during a break from filming the 1961 ABPC musical, *The Young Ones*.

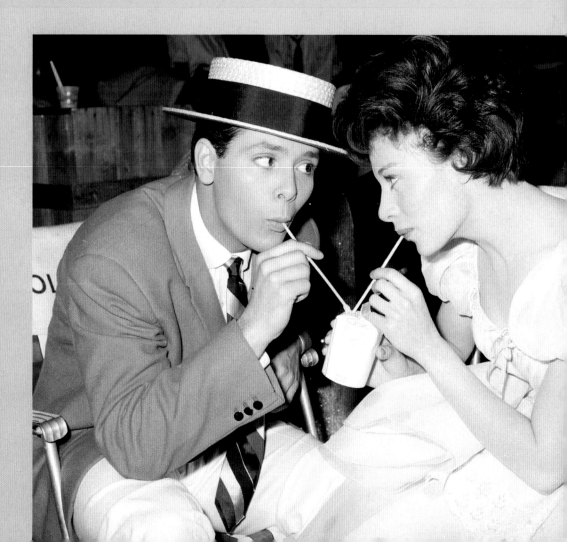

The release of the completed musical was to bring success for those involved. 'The Young Ones was massive,' Cliff remembers. 'The record was released on a Friday and on the Monday morning it was number one. There were queues around almost every cinema in the country to see the film.'

Before he went on to play James Bond on the big screen, Roger Moore played Simon Templar – a role originally offered to Patrick McGoohan – on the small screen in the action series, *The Saint*. A ladies' man not averse to combining business with pleasure, Templar was a character originally created by Leslie Charteris for a series of novels and was, essentially, a modern-day Robin Hood.

Distributed by Lew Grade's company, ITC, and originally shown in the UK on ITV, *The Saint* was shot on film and made at ABPC's Elstree Studios between 1962 and 1968. The first episode premiered on ITV in October 1962 and the action television series ran in total for an impressive 118 episodes and was sold to sixty countries. The first seventy-one episodes were filmed in black and white, with the remaining forty-seven episodes in colour. At its height, the show was being watched by more than 15 million viewers a week, thereby cementing Roger Moore's reputation as a huge star.

In an interview during the making of the series, asked why he was chosen to play the role of Simon Templar, Roger Moore joked, 'Because Sean Connery wasn't available! I tried to buy the rights,' he went on to explain. 'But I didn't have enough money at the time, or Leslie Charteris wasn't interested in selling to television, which put the price up. When I was approached, I was delighted to do it. I thought it was a character for a running television series that had a built-in premise. Part Superman and part natural hero. I think that people who have read the books know that *The Saint* was a crook – although we never say it on television. For this reason he has a double interest, he has another aspect to his character.'

A considerable number of actors and actresses shared the screen with Moore during *The Saint*'s production, many of whom would

LEFT: Suzanne Lloyd and Roger Moore pose for a publicity photo for one of the two episodes of *The Saint* in which she appeared.

BELOW: Annette André and Roger Moore in an intense moment from one of the six episodes of *The Saint* in which André appeared.

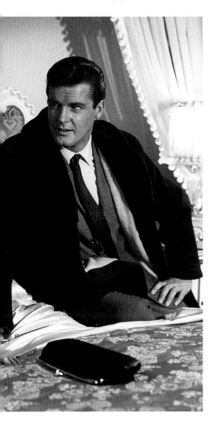

LEFT: Roger Moore and Angela Douglas pose for a publicity photo for an episode of *The Saint* called 'The Death Game'.

go on to become household names, including Warren Mitchell, Lois Maxwell, Ronnie Barker, Sylvia Syms, Oliver Reed and Shirley Eaton.

Annette André appeared in six episodes of *The Saint*. 'My film career pretty much started at Elstree Studios. My first television role was on *The Saint*. Roger Moore used to say to his business partner, Bob Baker, "Let's get Annette André in again for another episode." I think because he knew we'd always have a laugh.'

Canadian actress Suzanne Lloyd, who also appeared in *The Saint*, has clear memories of working on the long-running television series. 'I remember being treated well at the studio. The first time I was called Miss Lloyd came as a surprise, as first names are used in the States – it made me feel like someone special!'

For Suzanne, working with Moore was one of the biggest highlights of appearing in the series. 'Roger Moore was a delight,' she said. 'He was very professional and not at all temperamental. He saw to it that everyone was okay, but didn't make a fuss about it. The actors were professional and came in prepared, so we were able to move along at quite a speed. I only remember us going over time once.'

Angela Douglas appeared in an episode called 'The Death Game'. For Angela, the actor playing Templar was not only a colleague but a dear and close friend. 'We were all family friends. While we were filming my episode, Roger asked me to have lunch with him in his dressing room. I agreed and over a plate of chicken sandwiches and a cup of instant coffee he read me his fan mail!'

Angela still remembers the unique atmosphere that the studio had and continues to have. 'Compared to the other studios Elstree seemed a family affair,' she said. 'The crews would go from one film to another, and you were always aware of the ghosts of great talents past who worked there and brought the studio its distinction and reputation.' Angela would return to Elstree to appear in action television dramas, as well as in the perennial children's favourite *Digby, The Biggest Dog in the World.*

Released in 1963, *Summer Holiday* was the second Cliff Richard big-screen musical. The film was produced by Andrew Mitchell, who later would become managing director at Elstree, while the director was Peter Yates, who went on to direct such classics as *Bullitt*, *Eyewitness* and *The Dresser*. Joining Cliff and The Shadows for the ride were Lauri Peters, Melvyn Hayes, Una Stubbs, Jeremy Bulloch and Ron Moody.

As with *The Young Ones*, *Summer Holiday* was a huge success at the box office and, despite his initial concerns, Cliff later admitted that *Summer Holiday* is the one film out of his trilogy of ABPC musicals that he would happily take to a desert island. 'First of all I thought I acted better in it. The choreography seemed to have grown. The budget was bigger. And if you look at the two films side-by-side, *Summer Holiday* has a Cinerama look about it, whereas *The Young Ones* feels to me like a black-and-white movie in colour.'

Directed by Joan Littlewood, a theatre director renowned for her work in developing the left-wing Theatre Workshop, *Sparrows Can't Sing* was the film based on a play by Stephen Lewis, who was later to become known to millions starring in two long-running British sitcoms – as Inspector Blake in *On the Buses* and as Smiler in *Last of the Summer Wine*. The film starred James Booth as a

Original Story and Screenplay by PETER MYE

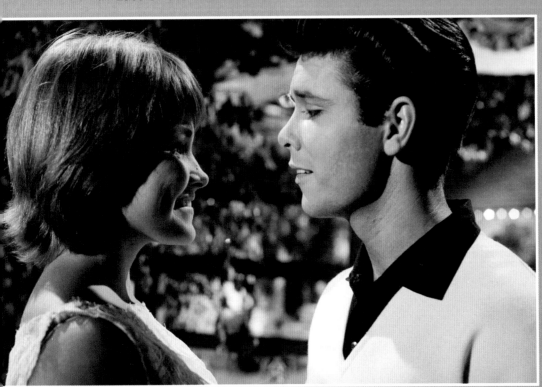

LEFT: Lauri Peters and Cliff Richard in a tender scene from *Summer Holiday*.

RIGHT: Cliff Richard, Melvyn Hayes and The Shadows performing 'Bachelor Boy' in an extra scene from *Summer Holiday*. Despite 'Bachelor Boy' being one of the most memorable songs of the film, the song and the scene it appeared in were last-minute additions. Distributors had felt the film was too short.

sailor who's been away at sea attempting, on his return to shore, to trace his wife, Maggie, played by Barbara Windsor in her first starring role.

Barbara Windsor was surprised at the outset that the 1963 film was made. 'I appeared on stage in the musical comedy *Fings Ain't Wot They Used T'Be* with James Booth. Everyone expected that it would be *Fings* that would be turned into a film. But Joan Littlewood decided to direct a big-screen version of the play *Sparrows Can't Sing* instead.'

Windsor's casting was not popular with the film's producers. 'They didn't want me to play Maggie Gooding. Up until that point I'd always played soppy birds on television, such as in *The Rag Trade*, and I'd had a theatre career. Joan told them that unless I was in the film, she wouldn't make it. In fact, her exact words were, "Either Bird's Egg does it or I don't make the film". She believed it would be funny with Jimmy Booth, a tall man, and me, a little woman, playing husband and wife. In the end, the producers gave in. I was lucky, Joan was pure theatre and she loved me from the minute we first met at the Theatre Royal, Stratford East.'

A desire for realism in the film meant that Littlewood was to ask Windsor to help her seek permission to use a certain location. 'I remember Joan saying that she needed a nightclub for the film.

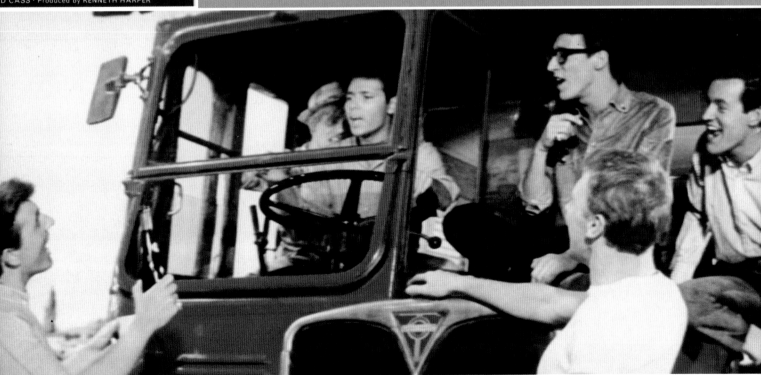

ABOVE: Barbara
Windsor and George
Sewell in a scene
from the 1963 film,
Sparrows Can't Sing.

I went to ask Charlie Kray if ABPC could use his brothers' club,
the Kentucky, which was on the Mile End Road. In the end, two
scenes were shot there, although I wasn't in them. The Krays loved
the experience and it gave them real kudos. It was a very funny
scenario!

'We had a big premiere for the film at the ABC Cinema,
directly across the road from the Kentucky. ABPC invited all their
contracted stars to attend. Princess Margaret and her husband
Lord Snowdon were due to attend, but she was ill on the day with
what is believed was a "diplomatic cold". However, Lord Snowdon
came on his own. It was a fantastic night and the film was received
extremely well. Roger Moore, Stanley Baker and Ronnie Fraser
all came to the Kentucky after the post-film reception at Stepney
Town Hall, for a party.'

The film was also a box-office hit across the Atlantic. '*Sparrows*
was an amazing success in America too,' remembers Barbara
Windsor proudly. 'I was even compared to the American actress,

comedian and singer, Judy Holliday – which I was so thrilled about! However, because of the cockney rhyming slang in the film, the distributor had to give out leaflets to the audience explaining the different expressions!'

By 1964, Ray Galton and Alan Simpson's iconic BBC sitcom, *Steptoe and Son*, was achieving weekly viewing figures of over 20 million. The suggestion that they should write a film for Harry H. Corbett was snapped up by ABPC. Called *The Bargee* the film was directed by Duncan Wood, who had also directed episodes of Galton and Simpson's sitcoms, *Hancock's Half-Hour* and *Steptoe and Son*. Corbett was cast as a bargee called Hemel Pike, a Casanova of the canals, a lothario of the locks, with girlfriends dotted along the route of the Grand Union Canal. Exceptional performances are given from the cast, which includes Eric Sykes, Ronnie Barker, Julia Foster, Miriam Karlin, Derek Nimmo and Richard Briers.

Harry H. Corbett's actress daughter, Susannah Corbett, offered firm views on the film. 'The cream of anyone who could hold a comedy line appeared in the film. It did well at the box office, but the critics weren't keen on it. I think it was edited quite a bit to get it reduced from an X certificate [at that time over-sixteens only] to an A certificate [where children could watch if accompanied by an adult], because of some of the darkness of the subject matter, and I believe my dad was disappointed about that. He wouldn't watch it after it was made, but then once something was in the can, it was done as far as he was concerned.'

LEFT: Julia Foster played Christine, one of Hemel Pike's girlfriends in *The Bargee*, seen here in an off-camera moment when Roger Moore visited the set.

Cliff Richard's third and final film for ABPC was *Wonderful Life*, released in 1964. In it, Cliff played Johnnie, a love-struck stuntman, and the cast included Susan Hampshire (who played Cliff's love interest), Una Stubbs, Melvyn Hayes, Richard O'Sullivan, Gerald Harper and The Shadows. The production was directed by Sidney J. Furie, and choreographed by Gillian Lynne. Lynne would go on to choreograph the West End musicals *Cats* and *The Phantom of the Opera*. As with the first two films, *Wonderful Life* features some enjoyable numbers including 'A Girl In Every Port', 'On the Beach' and 'All Kinds of People'.

The year 1964 was to see ABPC announce its biggest profits ever. With the swingin' sixties now well and truly underway, ABPC Elstree Studios was looking to expand, as television along with film productions, shared the lot.

ABOVE: A relaxed pose of Una Stubbs taken during the filming of *Wonderful Life*.

RIGHT: 'The best piece of filming in *Wonderful Life* is twenty-one minutes long,' Cliff once stated. 'And it's us impersonating various stars, from Charlie Chaplin up to Sean Connery's James Bond.' The entertaining sequence, filmed in both Gran Canaria and at ABPC's Elstree Studios, included the song 'We Love a Movie' and paid tribute to the history of cinema up until that point.

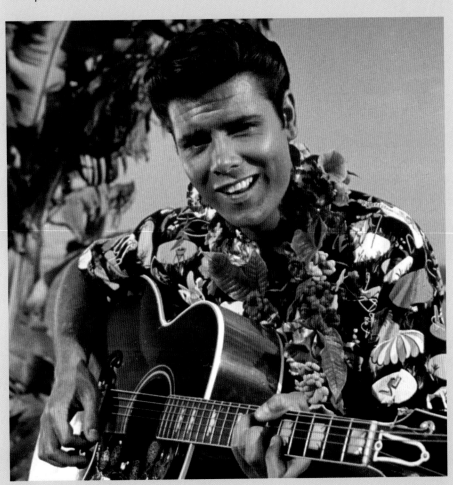

ABOVE LEFT: Barbara Windsor and Ronald Fraser in still from the 1964 comedy, *Crooks in Cloisters*.

LEFT: Bernard Cribbins up to no good as 'Squirts' in *Crooks in Cloisters*.

RIGHT TOP: Diane Cilento with her then-husband Sean Connery, soaking up the atmosphere on the set of the 1964 comedy film, *Rattle of a Simple Man*.

RIGHT MIDDLE: Harry H. Corbett and Diane Cilento pose in their costumes for a publicity photo for *Rattle of a Simple Man*.

RIGHT BELOW: Michael Medwin and Roger Moore share a joke during the latter's visit to the set of *Rattle of a Simple Man*.

Barbara Windsor returned to Elstree in 1964 for *Crooks in Cloisters*, filmed at the studios and on location in Cornwall. Directed by *The Saint*'s Jeremy Summers, the comedy tells the story of a small gang of crooks who, after carrying out a train robbery, end up retreating to an old monastery on a Cornish island. 'I loved making *Crooks in Cloisters*,' says Windsor. 'It took about six weeks to shoot.

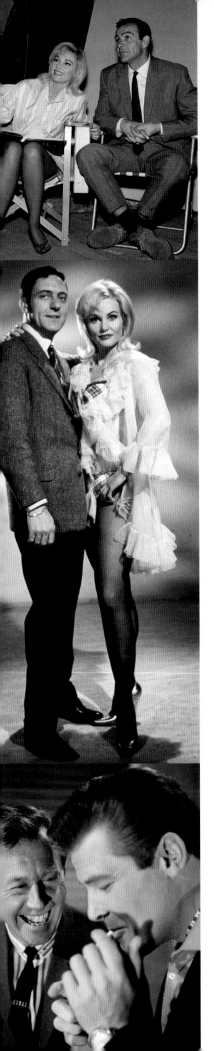

Ronnie Fraser and Bernard Cribbins were wonderful. Ronnie was hysterical. Everyone was great, my kind of people!'

As was often the case with low-budget comedies of the time, initial plans to shoot abroad were reined in: 'ABPC originally told us that we were going to film on location in the South of France,' says Windsor. 'But in the end we filmed in Cornwall! While we were on location Bernard Cribbins would take me out fishing at four or five in the morning.'

Back at Elstree, there was time to socialize after a day's shoot: 'There was a wonderful pub in Borehamwood called The Red Lion. It was across the road from the studios. All the stars working at ABPC and MGM down the road used to go there. I can remember being a little star-struck when I saw Gregory Peck. The whole area was like a little British Hollywood at the time.'

Despite all the films that she made afterwards, Windsor was to remain certain of one thing, 'Crooks was joyous to make – the most fun I've ever had on a film!'

With a screenplay by Charles Dyer, and based on his stage play of the same name, Rattle of a Simple Man was the last film made by the veteran director, Muriel Box. The 1964 comedy drama created another ideal opportunity for actor Harry H. Corbett to prove that there was more to him than just playing Harold Steptoe. Starring alongside Corbett was a stellar cast including Diane Cilento, Michael Medwin and Thora Hird.

'It's terrifying working in films,' Harry H. Corbett once confided. 'It's not a question of me hating the medium, but I hate the situation in which I have to work at present. I formed a way of life in acting that requires rehearsal, polishing. I can't give an instant characterization, just like that, and that's what I'm required to do. I'm expected to walk into the studio at 8.30 in the morning and give an instant characterization.'

'We had a lot of laughs but I'm afraid just at the time he (Harry) was going through a hard patch,' Diane Cilento recalled. 'Everything was going a bit pear-shaped. The play had been done

and it had been quite a success but it had to be changed round for the film. I was made an Italian! I think it was a rather good film. We took a lot of trouble with it, we did try very hard, but plays notoriously don't translate well onto the screen.'

Some seven years after Jack Hawkins had taken on the title role in the police drama *Gideon of Scotland Yard*, filmed at nearby MGM Borehamwood, a twenty-six-part action television series based on the novels by John Creasey was shot at Elstree across twelve months from the middle of 1964, with John Gregson now in the lead role. *Gideon's Way* was originally broadcast by ITV in the Midlands from 18 March 1965. Its producers were Robert S. Baker and Monty Berman, while the directors included John Moxey, Cyril Frankel, Roy Ward Baker and Leslie Norman. Edwin Astley was on hand to provide the theme tune and score. Alexander Davion and Daphne Anderson starred alongside Gregson, while George Cole, Rosemary Leach, Gordon Jackson, Megs Jenkins, Anton Rogers, Annette André and John Hurt also made appearances.

Made by ABPC's TV off-shoot company, ABC, and shown in the UK on ITV, *The Avengers* was an action television series created by Sydney Newman and originally made as a multi-camera production at Teddington Studios. It moved to Elstree Studios in the mid-sixties for the fourth, fifth and sixth series runs, after the American Broadcasting Company purchased the rights to broadcast the programme. This resulted in classier production values, not least shooting with a single camera on 35mm film, and colour episodes. The desire to please America was paramount due to the vast income it brought ABPC/ABC. In total, eighty-three episodes of *The Avengers* were made at Elstree Studios. The first Elstree episode originally broadcast by ITV on 2 October 1965.

From the second series of *The Avengers*, all of the episodes had centred on the crime and mystery-solving exploits of city-sort, bowler-hatted British agent John Steed, played by the suave Patrick Macnee, and his assistants, which, for the three series

ABOVE: Linda Thorson as Tara King in *The Avengers*.

RIGHT: Diana Rigg as Emma Peel, prepares to film a scene for *The Avengers*.

made at Elstree, were Emma Peel (Diana Rigg) and Tara King (Linda Thorson).

Julian Wintle, Brian Clemens and Albert Fennell produced the Elstree episodes, while directors included Roy Ward Baker and Sidney Hayers. A glittering array of supporting cast members included Terence Alexander, Eunice Gayson, Patrick Newell, Carol Cleveland, Charlotte Rampling, Patrick Cargill, Peter Bowles and Kate O'Mara.

Suzanne Lloyd has particular reason for remembering her time working on the series. 'First, I was stabbed in the leg during a fight scene with Diana Rigg. The director was pushing the fight very hard. The knife drew blood. It hurt more than it was dangerous. Then I was almost knocked out during a fight scene! I saw orange and black dots in front of my eyes. Patrick Macnee was a sweetheart and the producers could not have been more wonderful. Diana was great … a fine actress. I loved the show and was thrilled when I returned to the States to find it had such a strong following.'

Late 1965 saw the UK release of the Bette Davis film, *The Nanny*. Directed by Seth Holt, the thriller was made by Hammer Films. Davis played an English nanny who finds herself caring for a ten-year-old boy, recently discharged from a mental institution. Wendy Craig, Jill Bennett, James Villiers and William Dix also appeared in the film, which became a huge success at the box office on both sides of the Atlantic.

In the mid-sixties the studios across Elstree and Borehamwood were as busy as ever, yet this was in no small part due to the boom in television production. Cinema attendances were continuing to drop, with more people staying at home to get their entertainment fix from the small screen. In just two years, between 1964 and 1966, cinema admissions had dropped by a quarter from over eight million a week to six million.

ABPC, aware of the change in viewing habits, was keen to ensure it was keeping up with the trends and not only restructured the company to allow both a film and separate

ABOVE: New buildings being constructed as part of Elstree Studios' expansion programme in the sixties.

television arm but also to develop further the Elstree site.

To increase facilities at the studios, ABPC built three new stages – 7, 8 and 9, in order to meet the demand for space from long-running television productions, including *The Saint* – along with a new administration building, restaurant, bar, cafeteria, kitchen, an underground car park and an ancillary block. The ancillary block included a preview theatre, hair and make-up rooms and dressing rooms. All were constructed at the same time as part of an ambitious £1 million expansion project.

On the 29 September 1966, ABPC quite rightly boasted about the improved facilities in the trade magazine, *Kinematograph*. The editorial stated that Stages 7, 8 and 9 provided:

'... an additional 21,500 sq. ft. of stage space with working height of 35 ft. and are designed for compactness and production convenience; two incorporate under-floor water tanks. Lighting includes the latest Mole-Richardson Dual Purpose Grid with Monopole and Cradle facilities. Ventilation is of the latest Telescopic Trunking type, a system which distributes air by remote control giving six air changes each hour. Talk Back facilities with provision for the use of electronic aids to film making are also incorporated in the new stages block.'

In July 1966, the then-wife of King Hussein of Jordan, Princess Muna al-Hussein, visited the studio, together with her sister-in-law, Princess Basma. It was reported that King Hussein was lunching at 10 Downing Street with Prime Minister Harold Wilson. During the tour, Her Highness was introduced to Yul Brynner, Britt Ekland, Steve Forrest, Roger Moore and Charlie Drake – all of whom were busy working on productions at the studio at the time.

And still the new series kept coming. Monty Berman, Robert S. Baker and Terry Nation (best-known for creating the Daleks in the science-fiction television series, *Doctor Who*) were involved in the creation and development of the ITC-distributed action television series, *The Baron*, first shown in the ATV Midlands region from 28 September 1966. The team of experienced directors who worked on the run included Leslie Norman, Jeremy Summers and Cyril Frankel. Although this thirty-episode, one series is not as well-remembered or repeated as much as other examples of

LEFT: A publicity photo of Raquel Welch taken to promote Hammer's 1966 fantasy film, *One Million Years B.C.*, directed by Don Chaffey.

the genre, it nevertheless boasted an impressive cast, including Steve Forrest, Bernard Lee, Kay Walsh, William Franklyn, Moira Redmond and Edward Woodward.

With a budget of £400,000 – over £7 million today – *One Million Years B.C.* saw the glamorous Raquel Welch venture to film at the studio in Borehamwood and on location in the Canary Islands, playing Loana, in a remake of the 1940 movie of the same name. Directed by Don Chaffey, this successful Hammer fantasy film, which owes more to escapism than generally believed facts, is set in a world of cavemen and dinosaurs. While scenes shot on the backlot at ABPC included a replica of a lava-spewing volcano, it was down to American visual effects legend, Ray Harryhausen, to busy himself in his own studio in Slough on the stop-motion animation required for the dinosaur footage.

Oscar-winner Bette Davis found herself back at the studio in a film version of the hit play *The Anniversary*. Roy Ward Baker directed the film after the previous director was said to have been fired on the orders of its star. Davis plays Mrs Taggart, a role originally played by Mona Washbourne in the 1966 West End stage version. Taggart is a manipulative mother of three grown-up sons who each year gather to celebrate her wedding anniversary – despite the fact that her husband has passed away. Davis was in

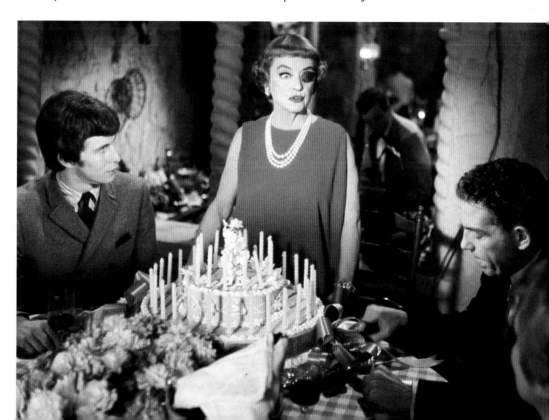

sparkling form, complete with dour masculine costume and eye patch, which was said to have affected both her balance and her behaviour during filming. Sheila Hancock, Jack Hedley and James Cossins also starred.

Created by Dennis Spooner, and lasting just a single series of thirty episodes, the action television series *The Champions* was first shown by ITV on 25 September 1968. Monty Berman produced, while directors of the series included Cyril Frankel, Leslie Norman and Robert Asher. The catchy theme tune was composed by Tony Hatch. The trio of main characters, played by Stuart Damon, Alexandra Bastedo and William Gaunt, were agents for a Geneva-based, United Nations law enforcement organization called Nemesis. As with other action television series made at Elstree Studios, *The Champions* included guest appearances from a number of well-known faces including Felix Aylmer, Kate O'Mara, Burt Kwouk, Imogen Hassall and Philip Madoc.

Made forty years before American sci-fi thriller series *Heroes*, what gave *The Champions* a different angle were the super human abilities of the main characters, bestowed upon them by a secret civilization in Tibet.

'I clearly remember the film test that I did with both Stuart Damon and William Gaunt for *The Champions*,' Alexandra

ABOVE: Stuart Damon, Alexandra Bastedo and William Gaunt in discussion in a scene from an episode of the action television series *The Champions*.

RIGHT: Donald Sutherland appeared in several adventure series made at Elstree in the 1960s, including a cameo in *Gideon's Way*.

Bastedo recalled. 'I was really pleased when I found out that all three of us had got the lead roles. Working on *The Champions* was a pleasant experience and we were treated very well, but it was hard work, and the schedule was pretty relentless. Often we would work six days a week from 7.30am and not be home and finished much before 8.30pm. But I did learn a great deal from working on the series. And we had very good lighting cameramen, which is why it looked so wonderful.'

The next Elstree action television series was *Department S*, created by Dennis Spooner and Monty Berman and on ITV, firstly in the ATV region, from March 1969. As with *The Baron* and *The*

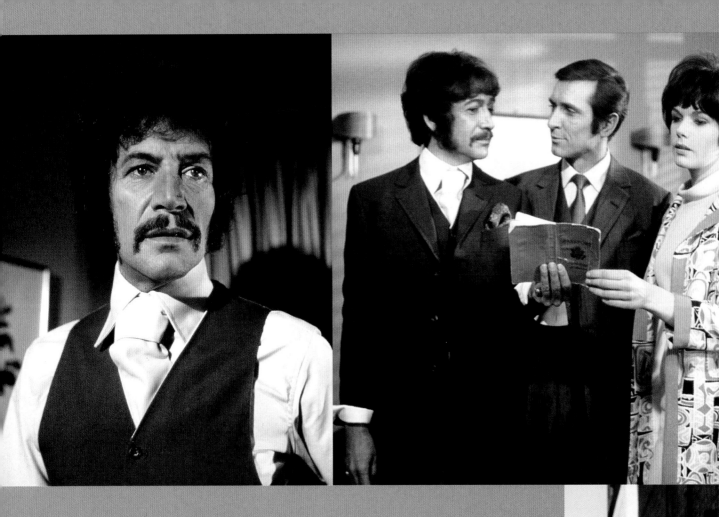

Champions, only one series, in this case of twenty-eight episodes, was made. Peter Wyngarde starred as eponymous author Jason King, ably assisted by Joel Fabiani and Rosemary Nicols.

'I was offered the role of Jason King while I was appearing in a play called *The Duel* in London,' Wyngarde explained. 'I wasn't particularly keen on the idea of starring in a long-running series, and did my best to avoid the attentions of Monty Berman *et al*. However, they managed to corner me at a dinner party, and I ended up agreeing to appear. I remember signing the contract on a paper napkin!'

Wyngarde once gave an insight into how he saw the role and what parts of his own persona he used as inspiration. 'I decided Jason King was going to be an extension of me,' he said. 'I was inclined to be a bit of a dandy – I used to go to the tailor with my designs.' Then there were his views on his drinking and eating habits. 'King had champagne and strawberries for breakfast, just as I did myself.'

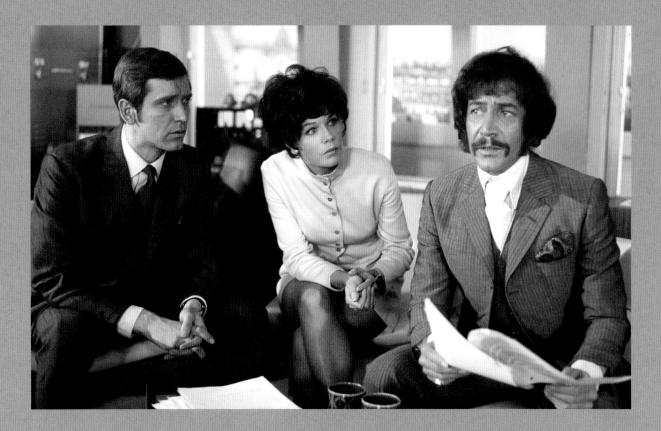

ABOVE LEFT: Peter Wyngarde, who played the flamboyant part-time fiction writer, part-time crime solver Jason King in the action television series *Department S*.

ABOVE MIDDLE AND RIGHT: Peter Wyngarde, Joel Fabiani and Rosemary Nicols starred as the brainy trio behind the programme.

LEFT: Rosemary Nicols poses for a publicity photo on the lot at the studio during a break from filming *Department S*.

It didn't take long before the cast became aware of the viewers' reaction to the series. 'The very first episodes we recorded were actually on air while we were still in production,' Wyngarde explained. 'So we were beginning to get feedback as to how popular *Department S* was becoming. We were getting lots of fan mail, and it got to the point where I couldn't go out on the street without being recognized. It was quite frightening!'

Combining crime, action, drama and more than a dash of humour, *Randall and Hopkirk (Deceased)* was an action television series with a supernatural twist – one of the title characters who appeared in the series was dead. Created by Dennis Spooner and Monty Berman, it was originally broadcast by ATV on the ITV network from September 1969. As with *The Champions* and *Department S*, it ran for a single series.

Produced by Monty Berman, *Randall and Hopkirk (Deceased)* employed directors including Cyril Frankel, Ray Austin and Roy Ward Baker. Appropriately, Edwin Astley composed a haunting

theme tune for the series, which was retitled *My Partner the Ghost* when it was shown in America.

Starring Mike Pratt and Kenneth Cope as private detectives Jeff Randall and Marty Hopkirk, the series opened with the death of Hopkirk in an episode called, 'My Late Lamented Friend and Partner'. Over the twenty-six-episode run, Marty would assist his partner with solving a variety of crime cases from beyond the grave while keeping an eye on his attractive young widow, Jeannie (Annette André). Ivor Dean, who had played Chief Inspector Claud Eustace Teal in episodes of *The Saint*, played the recurring character of Inspector Large in this series. Keith Barron, Valerie Leon, Brian Blessed, Joyce Carey and George Sewell also had guest roles.

The area of the backlot at the rear of the studios hosted the graveyard set where the character of Marty Hopkirk was supposedly buried. The 'town set' was once again used for exterior scenes in several episodes. In fact, various studio buildings around the site, including the ancillary block behind Stages 7, 8 and 9, doubled as factories, offices, police stations and even a prison. Both exterior water tanks, which ABPC had in operation at that time, and the underground car park were also used. Meanwhile, the exterior of Jeff and Marty's office was located at Springfield Road, in Harrow, in a building that has since been demolished.

Annette André proudly explained how much of an asset her working relationship with her colleagues was to the series. 'Mike Pratt, Ken Cope and I had a laugh when we made the series. We used to sit and talk in a dressing room or in the studio bar after filming and had many long discussions about the work itself and mulled over ideas for future episodes. We got on well with Dennis Spooner, the creator, who seemed to welcome ideas. Occasionally I think he used them. And it was through Mike and Ken that I got more to do in the show. In those days the women were used mostly for decoration!'

Annette still thinks back to the times she worked at Elstree

RIGHT: Kenneth Cope, Annette André and Mike Pratt in a publicity photo for the action television series, *Randall and Hopkirk (Deceased)*.

BELOW: The stars take a leisurely break – in a hearse – during filming. The series was broadcast in America under the title *My Partner the Ghost*.

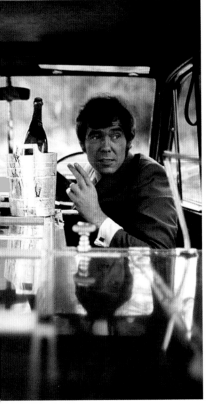

Studios. 'I have very nostalgic memories of the studio. I remember the stages, the dressing rooms and the long, thin, white administration building that used to stretch along the front of the site. I also remember the restaurant where we often had lunch. Elstree had a very homely feeling. It was not as daunting as Pinewood. And although it wasn't as glamorous as some studios, there was a relaxed atmosphere. I remember the camaraderie. If we had any spare time, we'd go and watch some of the other productions being filmed at the studio. Sometimes I used to take my lovely Afghan dog to the studio and I'd take her for walks on the backlot.'

With the sixties almost at an end, takeover rumours were rife at Elstree. The decade was changing and it looked very much like the good ship Elstree would soon have a new captain at the helm. A new era beckoned and with new ownership would come new challenges.

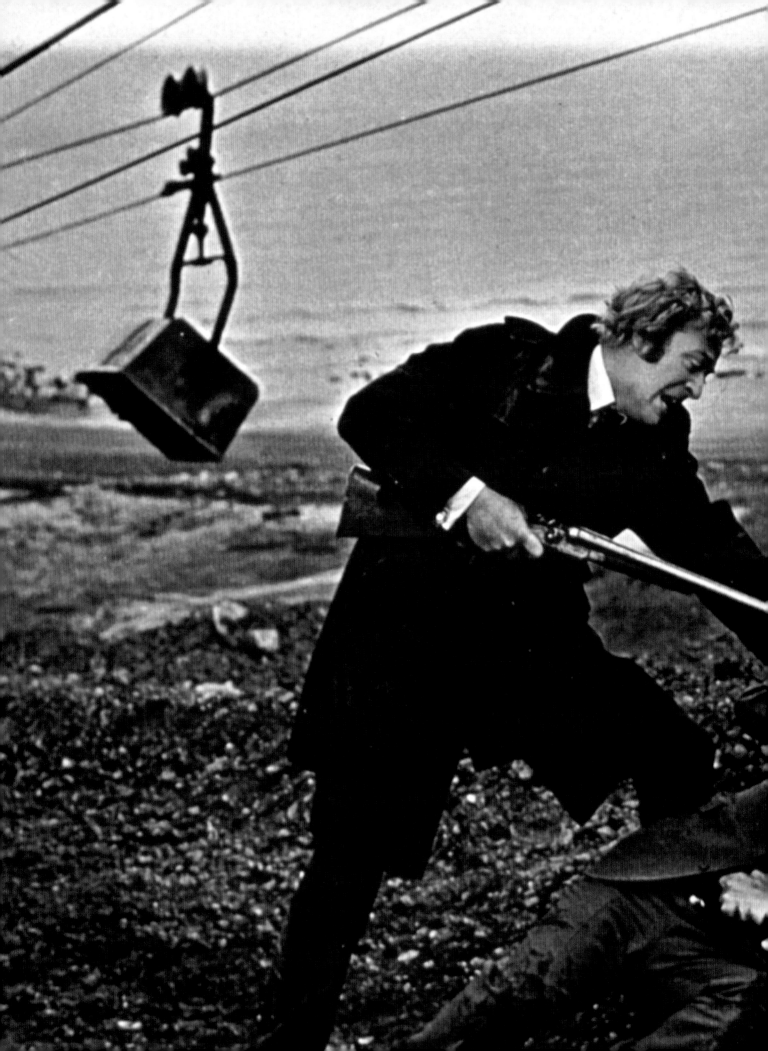

HIGHS
CHAPTER FOUR
AND LOWS

The behind-the-scenes battle for the Associated British Picture Company studios at Elstree was complete by February 1969.

Founded in 1931, EMI (Electrical and Musical Industries) was a British multinational company specializing in electronics and systems manufacturing. In the 1960s the company won a special place in the hearts of producers and broadcasters for its colour television camera – a vital constituent of production for the industry. In 1973, the company received the Queen's Award for Technological Innovation.

Not satisfied with creating the kit needed to shoot television, EMI wanted a slice of the action. Their takeover of ABPC gave EMI access to valuable assets, such as Elstree Studios, a chain of 270 cinemas and a fifty-one per cent share in the London region ITV-franchise-holder, Thames Television. Nat Cohen and Stuart Levy's film company Anglo-Amalgamated was also merged into EMI. Originally, back in 1962, ABPC had purchased a fifty per cent stake in Anglo-Amalgamated. The increase led to a controlling share of seventy-four per cent in 1967.

The takeover was to lead to a change in name for the studio, now to be known as EMI-Elstree Studios. EMI's purchase also led to the formation of a film production and distribution arm. Indeed at the time of its break-up in 2012, EMI was the fourth largest business group and one of the biggest record companies in the world.

Actor and filmmaker Bryan Forbes was approached by the Chairman and Chief Executive of ABPC, Bernard Delfont, to run

PREVIOUS SPREAD: Michael Caine, as Jack Carter, and Ian Hendry, as Eric Paice, in a scene filmed on location for the 1971 crime film, *Get Carter*.

LEFT: Christopher Lee as the Prince of Darkness, Count Dracula, in *Scars of Dracula*. Directed by Roy Ward Baker and produced by Aida Young, *Scars of Dracula* was made by Hammer Films in Stages 8 and 9 and released in 1970. The stellar cast also included Patrick Troughton, Dennis Waterman and Jenny Hanley.

Elstree Studios. 'I was dining with my wife Nanette Newman one night at the old White Elephant restaurant in Curzon Street, when Bernie came to the table and told me his company, EMI, had bought Elstree. He knew nothing about running a studio, and asked if I would put together a paper listing what I thought should be done. I wrote thirty pages, which I think startled him, and he offered me the job. I subsequently discovered that prior to our meeting he had more or less promised the job to Nat Cohen, the Managing Director of Anglo-Amalgamated. I always felt that by reneging on that offer he ensured Cohen bore a grudge against me.'

Forbes agreed to take on the role of Managing Director and Head of Production at Elstree Studios. Nat Cohen was not forgotten by Bernard Delfont, however, and found himself appointed to the EMI board. 'Once I took over, I was alarmed at the state of the studio, which was run down. Morale was at a low ebb among the staff, the place was filthy – including the office I inherited. I calculated that the studios wanted some £800,000 spent on it to bring it up to a decent standard. In the event, I was only allowed to spend £80,000, which meant I could just about put a lick of paint on it and mend the broken toilets!'

Fortunately, the filmmaker had more interesting diversions to take his mind off the refurbishments and problems at board level. EMI was anxious for him to get the studio up and running and to announce a programme of films as soon as possible. When

TOP RIGHT: Roger Moore as Harold Pelham, in the £400,000 psychological thriller, *The Man Who Haunted Himself*. Moore later said that this was one of his favourite roles.

MIDDLE RIGHT: Peter Sellers and Sinéad Cusack in the 1970 film, *Hoffman*. Sellers played businessman Benjamin Hoffman, a dramatic character role, which he was said to have ended up despising. Directed by Alvin Rakoff, the screenplay was by Ernest Gébler and based on his novel *Shall I Eat You Now?*

MIDDLE BOTTOM: Michele Dotrice in the 1970 film, *And Soon the Darkness*. Also starring Pamela Franklin and Sandor Elès. Directed by Robert Fues, written and produced by Albert Fennell and Brian Clemens.

BOTTOM RIGHT: Managing Director Bryan Forbes indulges in a spot of photography while on location for *The Go-Between*, one of the films that Bryan Forbes commissioned for the studios during his tenure.

LEFT: Julie Christie and Alan Bates relax between filming scenes for the 1971 film, *The Go-Between*.

news of his appointment became known he was bombarded with submissions, some 400 scripts and ideas in his first month alone. Forbes started reading scripts the first week he arrived and employed a team of readers to work through them all. His rule for passing a script was simple: if two readers agreed they liked it, then Forbes himself would be passed a copy. By this method he was able to put together the studio's first slate of films, which included *The Go-Between*, *The Railway Children*, *The Tales of Beatrix Potter*, *And Soon the Darkness*, *The Man Who Haunted Himself* and *Hoffman*.

In the early spring of 1970, nearby MGM-British Studios faced closure. A string of losses was further exacerbated by its American backers withdrawing their support for the business. The prospect of just one surviving studio left in Elstree and Borehamwood – after all that had been before – filled many with dread and concern for the very future of the British film industry.

For Bryan Forbes, still battling the challenges at the studio and within EMI due to changes within the company, the news was a mixed blessing: 'As the new decade beckoned, the nearby MGM-Borehamwood Studios closed. However, it was announced that MGM would pay a yearly subsidy to EMI-Elstree in return for the use of its facilities. EMI subsequently merged with MGM and I was made Chief Executive of the joint company. I had to inform the

MGM-Borehamwood Studios – probably the best in Europe at the time – that it was to close in two weeks' time and that everybody would be laid off. I tried to prevent it, but was overruled.'

With the merger came another name change, this time to EMI-MGM Elstree Studios. A further announcement was made that MGM would finance a modest number of films as part of the new agreement. MGM-EMI Distributors Ltd was formed in order to distribute these new titles.

As the sixties had begun at Elstree with a stream of comedy

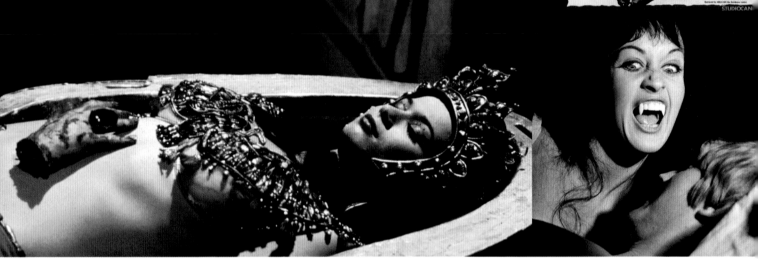

films bringing laughs to the nation, the early seventies, with its more liberal attitudes to nudity on screen, was to take on an all together darker tone, as a new-found penchant for horror saw the stages of Elstree filled with vampires, monsters, semi-clad nymphs and lashings of fake blood and gore.

At the helm of many of these cheap and not-quite-so-cheerful productions was, of course, Hammer Films. *Taste the Blood of Dracula* marked the return of everyone's favourite vampire, Christopher Lee, who had starred in the first Hammer horror take on the Dracula story back in the late fifties. The biting horror film also stars Geoffrey Keen, Ralph Bates, Roy Kinnear and Hammer

ABOVE LEFT: Valerie Leon as evil Egyptian queen, Tera, lies in her tomb in the 1971 Hammer horror film, *Blood from the Mummy's Tomb.*

ABOVE: Anouska Hempel attempts to get bitingly close to Christopher Matthews in the 1970 film, *Scars of Dracula.*

BELOW LEFT: Prior to donning the Darth Vader suit, Dave Prowse played a monster in the 1970 horror film, *The Horror of Frankenstein*.

BELOW MIDDLE: Kate O'Mara as Alys in *The Horror of Frankenstein*.

Films' regular Madeline Smith, who still has vivid memories of her times at the studio. 'I first went to Elstree to make *Taste the Blood of Dracula*. I remember there being a huge poster for *The Man Who Haunted Himself*, which starred Roger Moore. This was during Bryan Forbes' era as managing director. Bryan was very much Queen Bee at the time. He was brought in to put things right. Dear old Bryan was always around, but he never interfered. At the time, the studio seemed to be busy with horror films, which were quick and easy to make. It was thriving, although it

ABOVE RIGHT: Ralph Bates as Dr Henry Jekyll and Martine Beswick as Sister Hyde in Hammer's, *Dr Jekyll and Sister Hyde*.

RIGHT: Christopher Lee as Count Dracula gives Patrick Troughton as Klove a hard time in *Scars of Dracula*.

had a decaying air about it. It felt that the glory days had gone. I remember always being first in the rather small make-up room, which always seemed to be frozen!'

Peter Cushing, Ingrid Pitt, Madeline Smith and Kate O'Mara graced the 1970 film, *The Vampire Lovers*, a horror production with a lesbian twist from Hammer – 'the studio that dripped blood'.

Bryan Forbes brought the studio considerable box-office success when he gave Lionel Jefferies, who owned the film rights to E. Nesbit's novel, permission to direct his own screenplay of what has turned out to be one of the most enduring of family films, *The Railway Children*.

Starring Dinah Sheridan, Jenny Agutter, Sally Thomsett and Bernard Cribbins, *The Railway Children* sees a mother and her children parted from her husband when he's falsely imprisoned. Dinah Sheridan recalls the casting for the film. '*The Railway Children* came about after a totally unexpected phone call from Lionel Jeffries – an actor I had always admired but never worked with. He asked whether I knew of E. Nesbit's book and if I would consider playing the mother. It was arranged that we would meet with the producer, Robert Lynn, to discuss the film over lunch.

'At the restaurant, Lionel asked if I knew a young actress called Jenny Agutter. No, I didn't. At that moment, Bob Lynn wrote something on a card and slid it along the table so that Lionel and I could read it: "She's sitting on your right!" There, indeed, was

ABOVE LEFT: Gary Warren, Jenny Agutter, Dinah Sheridan and Sally Thomsett take a break from filming *The Railway Children* to engage in a game outside the former Stage 1 at the studio.

a charming young lady giving an interview over her lunch. Lionel jumped up with such joy that he knocked his chair over, but he managed to blurt out to her, "We're making a film of *The Railway Children*. Would you like to play the part of Bobby?" Jenny went crimson with both embarrassment and pleasure, and immediately said, "Oh, yes!"'

The enduring success of the film was very much down to the director's vision. Lionel Jeffries had never directed before, but, as an established and accomplished actor, he was sensitive to the reactions of other actors. He was full of interesting and new ideas, such as having the music written before the film started shooting. Johnny Douglas composed a theme tune for each character. When any of the actors were preparing for a scene, Jeffries would play their particular themes while they prepared, so the emotion was there.

With Bryan Forbes' 'revolving fund' ceasing to revolve and thus with less money to spend on productions, 'rather than fire people' Forbes pulled together a small budget and made the 1971 tearjerker, *The Raging Moon*, writing and directing the film himself within his managing director's salary, while still running the studio. Nanette Newman, Forbes' wife, and Malcolm McDowell acted in the film for scale and deferments. The cast of the film, which was released in America under the title *Long Ago Tomorrow*, also featured Norman Bird, Bernard Lee and Geoffrey Bayldon.

Although not a box-office success, the film received two Golden Globe nominations, for Best Foreign Film, and Best Song, 'Long Ago Tomorrow'.

On 22 March 1971, Bryan Forbes' resignation was announced. Asked whether, on reflection, he regretted taking the managing director's post at Elstree Studios, Forbes was frank. 'No, but I deeply regret I wasn't given the wherewithal and support to continue. We might have had a really viable British film industry instead of lumbering from one crisis to another. I won some battles and lost others, but on the whole I feel I lifted Elstree Studios a notch and gave the staff a feeling of pride again.'

Forbes' resignation was followed by the appointment of Ian Scott, a chartered accountant who had previously worked for Associated British Pictures. Scott would himself only stay for two years before going to work for Thames Television. Taking his place would be Andrew Mitchell who had joined ABPC back in 1955 and who had been associate producer on several Elstree productions, including Cliff Richard's trilogy of big screen musicals. Andrew

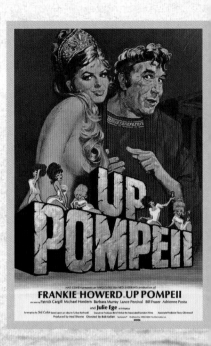

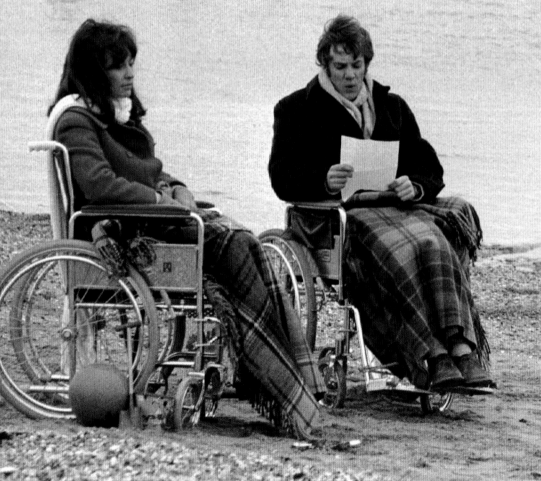

MAIN PICTURE: Nanette Newman and Malcolm McDowell in a scene filmed on location for the 1971 film, *The Raging Moon*.

ABOVE: Julie Ege and Frankie Howerd get a little closer in *Up Pompeii*. The film's producers, Ned Sherrin and Terry Glinwood, had a lucky break when it came to acquiring scenery. Glinwood found much of what they needed at nearby MGM Borehamwood, which had recently closed. The scenery had been used for the 1970 star-studded film *Julius Caesar* and Glinwood was able to obtain Roman columns, statues and busts for, in Sherrin's words, 'a song', and then sold them on for roughly the same price once *Pompeii* wrapped.

Mitchell would eventually be given a posthumous honour: that of having the oldest surviving studio administration building named after him.

The great comedian and writer Barry Cryer once described the career of comic actor Frankie Howerd as 'a series of comebacks'. After periods of mass popularity on radio in the late forties and then a huge drop in comedic fortunes by the late fifties, it was Peter Cook's sixties offer of a season at The Establishment Club in London, boosted by a successful turn on television's *That Was the Week That Was* that led to two years on stage with *A Funny Thing Happened on the Way to the Forum* – a kind of *Carry On Up the Coliseum*. And it was to be *Carry On* scriptwriters Talbot Rothwell and Sid Colin who would provide Frankie Howerd with his biggest television hit, with fourteen episodes of Roman bawdiness, *Up Pompeii* in 1969 and 1970, spending eight weeks in the Top 20 programmes and averaging over 13 million viewers a show.

The opportunity to capitalize on such popularity and bring *Up Pompeii* to the big screen was too good to miss. BBC hit *Till Death Us Do Part* had already made the successful transfer. And so it came to pass that Frankie Howerd as Roman slave Lurcio, toga over his shoulder and laurels in his hand, arrived at Elstree Studios.

The success of *Up Pompeii* led to two sequels. The first, *Up the Chastity Belt* was also released in 1971, and saw Frankie Howerd playing both sons of Eleanor of Aquitaine – King Richard the Lionheart and luckless serf Lurkalot – in a series of medieval comic misadventures also directed by Bob Kellett. As with *Up Pompeii*, this film is a perfect star vehicle for Howerd, joined by Graham Crowden, Bill Fraser, Anna Quayle and television game show *Golden Shot* hostess Anne Aston.

Although *Up the Chastity Belt* was written by Sid Colin, the veteran writers Galton and Simpson also made a valuable contribution to the final screenplay. 'Writing for Frank was enjoyable, and we wrote a lot for him,' said Alan. 'He was a very funny man. Very original. Ned Sherrin was very happy for us to do

what we could with the screenplay. We didn't really rewrite it, we doctored it slightly. Of its time, it was very funny film.'

The second sequel, *Up the Front*, was set during the First World War and directed by Bob Kellett in 1972. In it, Howerd plays Lurk, a cowardly boot-boy whose servile life is made that much worse by the bullying butler, played by veteran actor Bill Fraser. The film also included appearances by Zsa Zsa Gabor as Mata Hari and Stanley Holloway as the Great Vincento – a role meant for Vincent Price, who was busy filming elsewhere at the time.

After spending thirty weeks in the Top 20 programmes of the week, including taking the No.1 spot more than once, it was understandable that *On the Buses* was to be the next small screen hit to try its hand on the big screen. Hammer Films, best known for its horror output, shrewdly saw the potential for making a spin-off film of the sitcom at Elstree.

Hammer producer Roy Skeggs wasn't so sure of the film's prospects: 'The budget for *On the Buses* was very low because Hammer didn't really know how it was going to do at the box office. I budgeted £100,000, which was pretty tight. The bosses came back and said "too expensive" and I had to cut it back to £80,000 by reducing the number of weeks' filming from five to four! I lost the director straight away. I brought in Harry Booth, a television director who was used to shooting fast. The film came in on time and £900 under budget.'

BOTTOM LEFT: Michael Robbins, Anna Karen, Reg Varney, Bob Grant, Doris Hare and Stephen Lewis pose for a publicity photo outside the former Stage 5 at the studio.

BELOW RIGHT: Jack (Bob Grant) and Stan (Reg Varney) hatch a devious plan in *On the Buses*, while Arthur (Michael Robbins) and Olive (Anna Karen) look on.

ABOVE: Julie Christie in the award-winning 1971 film, *The Go-Between*.

Skeggs was production supervisor on the film and found innovative ways of keeping the costs down as Reg Varney, who played the lead, Stan Butler, recalled: 'Because we were taking the film out onto the road rather than being confined to a television studio, I had to learn how to drive a bus and get a passenger vehicle licence.

'Each morning at Elstree Studios they'd put all the cameras and lights and everything they needed for the day's filming onto the bus and then I would follow the location managers in their car up the road into Borehamwood, where they'd unload and we'd start shooting. Cheaper than hiring the usual lighting and equipment van and we always made the best of the daylight hours too, to keep lighting costs down. We were never more than a mile or so away from the studios, so if the weather turned bad we could get back and film something inside without wasting any shooting time.'

The bus depot building featured in the films was in actual fact the then current Stage 5 at Elstree Studios. The interiors of the Butler's home were also filmed in the same stage.

By the time the film was in the can, edited and ready for distribution, the producers got cold feet. There was no premiere and the film was slipped quietly into cinemas in London. Skeggs recalls: 'I had reservations about its chances of success. We put it on in the Edgware Road and in Finchley – forty people in one and twenty came to see it in the other. We cancelled the celebration dinner. And then when it went to Yarmouth that week it broke records. It caught the imagination and word of mouth helped it become a big hit.'

Although *On the Buses* was slated by the critics it played to capacity audiences. The film was held over for up to three weeks at some cinemas, and became the highest grossing film in the UK in 1971, beating the James Bond film, *Diamonds Are Forever*, at the box office. By the end of the following year, the film had amassed over a million pounds in combined box-office receipts around the world. Not bad for a film that cost £79,100!

Unsurprisingly, *On the Buses* became the first of a trilogy of

spin-off films, and creators Ronald Wolfe and Ronald Chesney kept the winning main cast members from the small screen incarnation for the outings – Reg Varney, Doris Hare, Michael Robbins, Anna Karen, Bob Grant and Stephen Lewis.

The Go-Between, another of the films that Bryan Forbes had commissioned during his tenure at Elstree Studios, was a romantic drama directed by Joseph Losey. Set during the summer of 1900, boarding school pupil Dominic Guard becomes a message carrier for two lovers, played by Richard Gibson and Julie Christie. *The Go-Between* went on to win the top award, the Palme d'Or, at the Cannes Film Festival in 1971, while the British Film Institute voted it the 57th best British film of the century.

BELOW: Christopher Gable and Twiggy in the 1971 film *The Boy Friend*. Despite its light-hearted plot, director Ken Russell felt this was one of the most difficult films he had ever made.

It was back to horror for Hammer Films, with *Blood from the Mummy's Tomb*, directed by Seth Holt. As well as Andrew Keir and James Villiers, the film stars *Carry On*/*Pink Panther*/Bond and Hammer starlet Valerie Leon in the dual role of Margaret/Tera. The film received a general release on the ABC circuit with *Dr Jekyll and Sister Hyde*, in late 1971.

At the start of the filming, the role of Julian Fuchs was recast and given to Andrew Keir. This followed the departure of Hammer veteran, Peter Cushing, to attend to his dying wife, Helen, the loss of whom, Cushing admitted, he never got over. Then, director Seth Holt suffered a fatal heart attack on-set at Elstree Studios during production. He was just forty-eight.

The idea for *Dr Jekyll and Sister Hyde*, directed by Roy Ward Baker, was conceived during an informal lunchtime meeting in the restaurant at Elstree Studios. Set in Victorian London, Dr Jekyll is played by Ralph Bates while the role of Sister Hyde, originally slated for Kate O'Mara, went to Martine Beswick. In a strange take on the Dr Jekyll and Mr Hyde story, here Jekyll is able to drink a potion and turn into a woman. The story also incorporates events inspired by the real-life activities of Jack the Ripper and Burke and Hare.

Ken Russell's musical comedy film *The Boy Friend* was first released by MGM-EMI in the UK in 1971. The film, based on

ABOVE: Three shots from *Digby, the Biggest Dog in the World*. From left: Jim Dale with a challenging co-star; Richard Beaumont with the eponymous Digby; Spike Milligan co-starred at his eccentric best.

Sandy Wilson's stage musical, stars Twiggy – who went on to win two Golden Globes as most promising newcomer and best actress in a musical – for her role as assistant stage manager, Polly Browne, along with fine support from a large cast including Barbara Windsor, Brian Murphy and Bryan Pringle. The original version of *The Boy Friend*, which had music provided by Peter Maxwell Davies, ran to 137 minutes. Felt to be too long for its international audiences, some twenty-five minutes were cut for its American release.

Following on from the box office successes of the *Up Pompeii* and the *On the Buses* trilogies there would be almost no stopping the output of small screen comedy hits given large screen outings at Elstree during the 1970s. From the sweet and gentle romance of a couple in their twilight years in *For The Love of Ada*, starring Wilfred Pickles and Irene Handl, to the everyday ups and downs of life for a successful divorced novelist with two feisty daughters in *Father, Dear Father*, starring Patrick Cargill, the stages at Elstree were full to brimming with small screen comedy talent aiming to hit the big time. Prolific sitcom producer and director William G. Stewart recalls bringing *Father, Dear Father* from television to cinema. 'I wasn't first choice for director. They had someone else in mind, but Patrick said: "If they want me, it's got to be Bill". I had a tremendous cast – all of whom had appeared in the television episodes. It was a big cast for a spin-off film.'

The director still remembers the thrill of working at Elstree. 'I was very, very happy entering Elstree Studios. I had always

been a movie fan and I thought about all the directors, including Hitchcock, who had made films there before me. I thought I was top of the film world! I shot the film multi-camera because I didn't like the idea of filming it with just one camera. I hadn't made a film before, although I had directed a great deal for television.'

The children's film, *Digby, the Biggest Dog in the World*, hit cinemas in 1973. Directed by Joseph McGrath, the film stars Jim Dale, Spike Milligan, Angela Douglas, Norman Rossington, Milo O'Shea, Dinsdale Landen and Victor Spinetti.

For lead actor Jim Dale, the film was a delight: 'One of my happiest memories of *Digby* was working with director Joe McGrath. He loved improvisation and gave me many opportunities, especially during the workmen's café scene. Everything you see on screen was invented on the spot. The sugar spoon chained to the counter near the sugar bowl so it couldn't be stolen. Taking that gag to the extreme with knives and forks attached by short chains to the tabletops, just wide enough apart to fit a plate full of food between, but too short to meet together to cut the food, leading into a juke box playing a Samba while some drivers did complicated choreographed hand movements trying to eat with said knives and forks. A "bunny-girl" in short skirt with a tray around her neck handing out tomato ketchup, mustard and vinegar bottles as if she were in the Ritz Carlton. An electric fan on a high shelf with long waving streamers attached to it to show it was working, then me holding a scalding mug of tea up to it to cool off, not noticing when someone pulls the fan's plug out of the socket, resulting in all the streamers floating down into my mug of tea. And, of course, I remember my girlfriend in the film was the delicious, delovely Angela Douglas. To this day she is still one of my dearest friends.'

However, 1973 also brought bad news for Elstree Studios. MGM announced that it would no longer be able to pay its yearly subsidy to the studios, blaming changes in the cinema-going habits of the public for a downturn in its profits and an unwillingness to invest. MGM subsequently became a member of Cinema International

Corporation (CIC), which took over international distribution of their film titles. Other founding members of CIC were Paramount Pictures and Universal Studios. Despite the blow, Elstree picked itself up once again and moved forward, with the studio name reverting back to EMI-Elstree Studios, while the distribution arm became EMI Film Distributors Ltd.

The coffers, though, were running low, and EMI boss Bernard Delfont gave the studios one year's grace before closure. By the end of 1973, the roster of permanent studio staff of 479 had been slashed to 256.

Like John Maxwell before him, studio MD Andrew Mitchell was to join the ranks of the studios' saviours. Having previously worked at Elstree Studios as an associate producer on films including *The Young Ones* and *Summer Holiday*, now he had one aim in mind: to save Elstree Studios.

EMI hit the ground running with a big budget star-laden adaption of Agatha Christie's *Murder on the Orient Express*, directed by Sidney Lumet. Albert Finney starred as Hercule Poirot, and was joined by an impressive cast that included Lauren Bacall, Ingrid Bergman, Jacqueline Bisset, Sean Connery, John Gielgud, Richard Widmark, Anthony Perkins and Vanessa Redgrave.

ABOVE: Sean Connery and Vanessa Redgrave in the 1974 film, *Murder on the Orient Express*. The film was reported to have a budget of £554,100, which made it the most expensive film made at the studio at the time.

LEFT: Albert Finney as Poirot.

RIGHT: Jacqueline Bissett and Michael York.

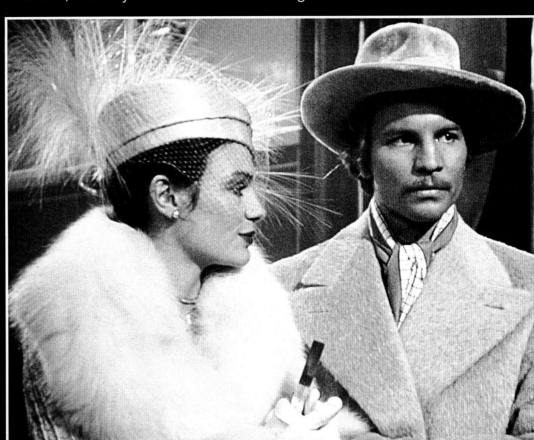

The film was a huge success, receiving six Oscar nominations, including a nod for Albert Finney. Ingrid Bergman won best supporting actress. And the film won three BAFTAs: one for Bergman, best supporting actor to John Gielgud and film music for Richard Rodney Bennett.

Ultimately, Elstree Studios' ongoing policy of being 'open to all' for hire, as well as its then involvement in film production and distribution, would be its continuing salvation during even the hardest times.

In 1974, producer Greg Smith made the first of four 'sex' comedies, starring Robin Askwith as window cleaner, Timmy Lea, with the *Confessions* title prefix. There is no doubt that the production of the *Confessions* series at Elstree Studios, which were funded by Columbia Pictures, helped to keep the studio in business at what was a very difficult time for the company. The X-rated *Confessions of a Window Cleaner*, which became the top-grossing British film of 1974, was directed by Val Guest who co-wrote the screenplay with Christopher Wood.

Robin Askwith remembers Elstree as a very congenial place to work. 'The atmosphere at the studio was tremendous,' he said. 'Whether it was Tom on the gate or Andrew Mitchell, the managing director, nothing was too much trouble. From the first

day, I was made to feel completely at home. There was always a great atmosphere in the bar, although I often used to go to the restaurant at lunchtime so I could learn my lines.'

During the making of *Confessions of a Window Cleaner*, the film version of the Thames Television sitcom hit *Man About the House*, which starred Richard O'Sullivan, was also being shot at the studio. 'One night, Richard stayed at my house,' remembers Askwith. 'And when we simultaneously departed to the studio the next morning, we unwittingly took each other's scripts. Thankfully, because we were both working at Elstree, it was just a case of getting a studio runner to surreptitiously swap the scripts.'

Following the success of *Window Cleaner*, a further three instalments were made: *Confessions of a Pop Performer*, *Confessions of a Driving Instructor* and *Confessions from a Holiday Camp*. Further success for *Window Cleaner* and the other *Confessions* films came thanks to their box-office success overseas. But distributing the films abroad came with its own headaches, as sometimes different versions had to be filmed and edited in order to placate the morality boundaries of different countries.

The proliferation of sitcoms being filmed for the big screen continued throughout the 1970s at Elstree. In 1974, there was *Man About the House*, the creation of writers Johnnie Mortimer and Brian Cooke, which starred Richard O'Sullivan, Paula Wilcox and Sally Thomsett playing young students sharing a flat, with Brian

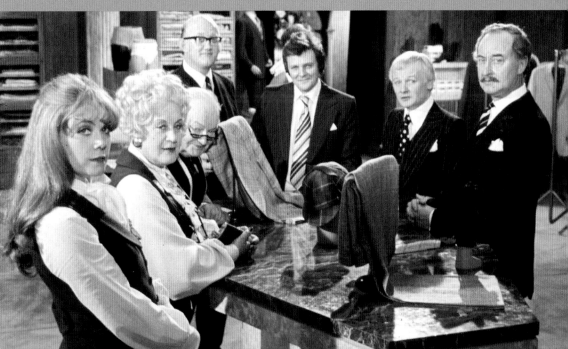

Murphy and Yootha Joyce playing their middle-aged, omnipresent landlords. In 1976, Rodney Bewes, James Bolam, Brigit Forsyth and Sheila Fearn took to the cinema screen in *The Likely Lads*, a spin-off film of the BBC sitcoms, *The Likely Lads* and *Whatever Happened to the Likely Lads?* by Dick Clement and Ian La Frenais.

And in 1977 there was to be a big-screen version of *Are You Being Served?* – an adaptation of a stage production of the BBC sitcom, which had originally run twice-nightly at Blackpool's Winter Gardens. David Croft and Jeremy Lloyd wrote the screenplay for the film, which starred John Inman, Mollie Sugden, Frank Thornton, Trevor Bannister, Wendy Richard, Arthur Brough, Nicholas Smith and Arthur English. As with many sitcom spin-off films of the time, *Are You Being Served?* was a more ambitious production, sending its characters on a holiday to Spain while the department store in which they all worked was being refurbished. Despite this storyline, save for a spot of location filming at Gatwick Airport, the cast didn't leave Elstree Studios.

The mid-1970s brought further cuts at Elstree. The studio's business had been getting better but was still losing money overall and in February 1975 EMI announced that six of the nine stages were to be closed, with a further loss of more than 200 jobs, leaving a skeleton staff of less than fifty people.

In August 1976, Elstree Studios' owners, EMI, purchased British Lion Films for the value of its archive. Titles included *In Which We Serve*, *A Taste of Honey*, *The Great St. Trinian's Train Robbery*, *Saturday Night and Sunday Morning* and *The Wicker Man*. The titles were added to Elstree Studios' already bulging vaults, which included films from the BIP and ABPC years (including those at Welwyn Studios), the Ealing Studios archive, purchased by ABPC after the studio closed, and those made by EMI since they'd taken control of the complex.

Although the 1977 film *Star Wars*, later renamed *Star Wars: A New Hope* and *Star Wars Episode IV: A New Hope*, went on to become a high-grossing, box-office success, the road to cinematic

success was not without its problems – particularly for its writer and director, George Lucas.

Lucas's inspiration for *Star Wars* and the subsequent films in the series can be traced back to his formative years. 'It's the flotsam and jetsam from the period when I was twelve years old,' the

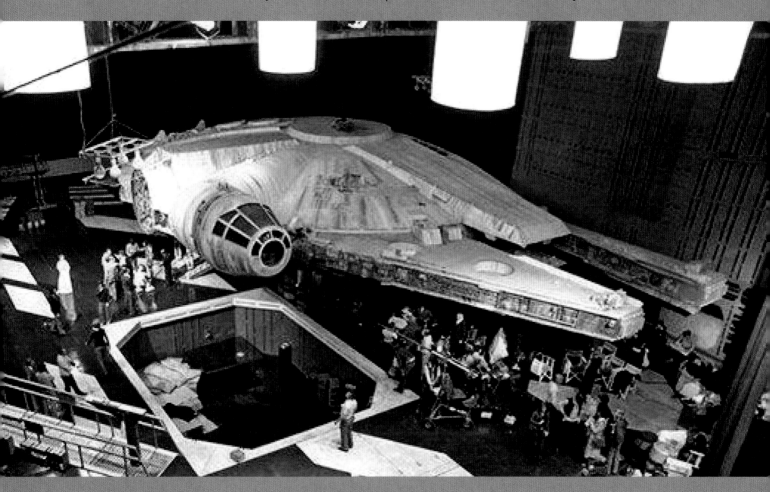

ABOVE: A behind-the-scenes photo taken in Stage 3 during the making of the 1977 film, *Star Wars*.

filmmaker recalled. 'All the books and films and comics that I liked when I was a child. The plot is simple – good against evil – and the film is designed to be all the fun things and fantasy things I remember. The word for this movie is fun.'

When United Artists and Universal Pictures rejected the first draft of the screenplay for *Star Wars*, Alan Ladd Jr of 20th Century Fox, despite not entirely understanding his vision, agreed to invest in George Lucas's talent and fund and distribute the film. The

original budget of $8 million was to eventually climb to around $11 million, and yet this figure was still considered relatively low for such a film at the time.

With permission to commence work on the film green lit, George Lucas set up a pioneering company, Industrial Light & Magic (ILM), in May 1975. ILM was developed to create the special effects required for the production, including a camera operating system that could effectively film and give life to the miniatures, such as the spacecraft, seen in the movie.

Back in the late seventies Robert Watts, the production supervisor on *Star Wars*, explained how the desire to use a studio with enough stage space was originally a frustrating process. 'Shepperton was out because they had torn down E, F and G stages, which effectively turned it from a large studio to only a medium-sized studio available to outside renters. I did go to Pinewood but they were unprepared to lease us all the stages.'

Former studio manager John Graham later explained how Elstree Studios was to become the original home of *Star Wars*. 'We had a visit from George Lucas and Gary Kurtz to discuss the renting of the stages for *Star Wars*. Andrew Mitchell, the then managing director and I, agreed a deal with George and Gary and the closed stages were re-opened. The rest is history.'

Shepperton Studios, however, did play its part in *Star Wars* as it housed the Great Hall set in Stage H.

Lucas was to cast Mark Hamill, Harrison Ford, Carrie Fisher, Peter Cushing and Alec Guinness in the lead roles which, following location filming, started shooting at Elstree Studios on Friday 9 April 1976 in the then Stage 3.

Kenny Baker, who plays R2-D2 in the *Star Wars* series, found that good fortune brought him into contact with George Lucas during casting of the film. 'I received a call to say that some American film people were in town. Rumour was that they were looking for a small person to fit into a robot. I went to the offices of 20th Century Fox

ABOVE: Mark Hamill, George Lucas, Carrie Fisher and Harrison Ford on the set of 1980 film, *Star Wars: The Empire Strikes Back*.

RIGHT: In civvies, some of the *Star Wars* cast: Harrison Ford, Dave Prowse, Peter Mayhew, Carrie Fisher, Mark Hamill and Kenny Baker.

in Soho Square, London, where I was introduced to George Lucas, who looked at me and immediately said: "You'll do"…!'

Baker found that socializing with cast and crew members was a rewarding way to spend the evening after a day's shooting on location. 'Most of the time filming was very uncomfortable for Anthony Daniels (C-3PO) and me,' admitted Baker. 'My best memory of Elstree Studios is that it had a good bar! I used to spend time after filming ended socializing with the lighting, sound and special effects technicians.'

Sculptor Brian Muir is known to all devoted *Star Wars* fans for his contribution to the series. But his association with the

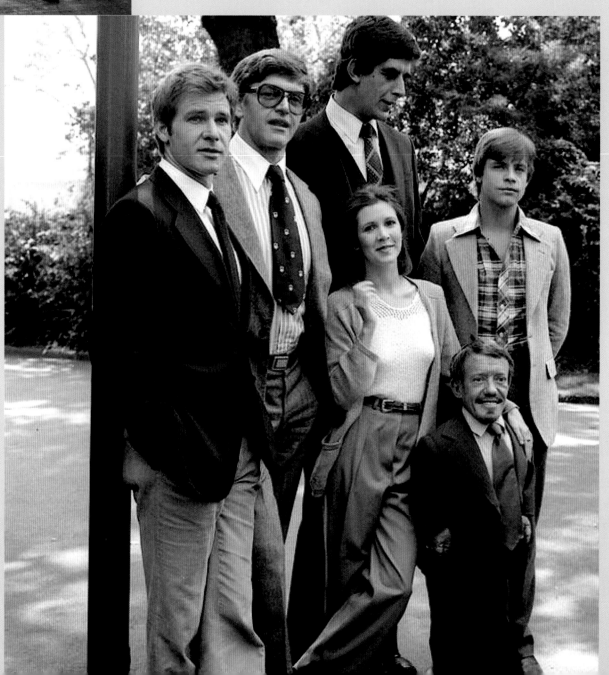

studio first began back in the late sixties. 'I was excited and a little apprehensive to be starting my indentured apprenticeship there in 1968 at the tender age of sixteen. Having been shown the impressive sculptural work stored in the stock room, I could see the standard of work expected of me. In 1972, when I had finished my apprenticeship, the film industry was very quiet in the UK. I moved on to work for an architectural company in London. A few years later I was very pleased to receive a call to start on a new film called *Star Wars*. Little did I know that I would be responsible for sculpting the most iconic villain of our time – Darth Vader. Most of my time during the five months I worked on the production were spent with my head down in the art department getting on with the Stormtrooper armour, Darth Vader of course, the Death Star droid, CZ3 and finishing work on C3P0.'

The first *Star Wars* film became an Oscar-winning blockbuster, grossing $500 million in box-office receipts across the world in its first three years. Not surprising then that a sequel would soon be in production and back at Elstree.

In 1978, co-produced by Lew Grade's ITC and the Italian broadcaster, RAI, *Return of the Saint* saw Ian Ogilvy take over the

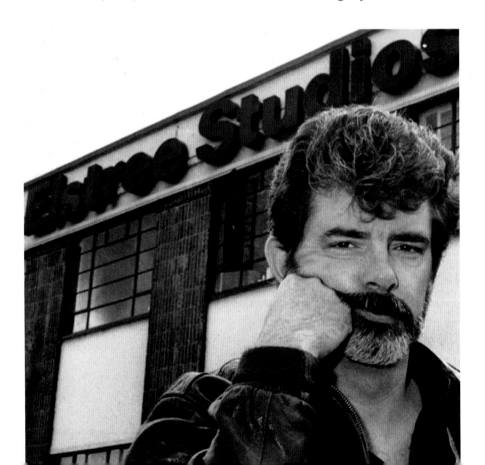

ABOVE TOP: Britt Ekland and Ian Ogilvy in a publicity photo for an episode of *Return of the Saint* entitled, 'Murder Cartel'.

ABOVE: Annette André and Ian Ogilvy in an episode of *Return of the Saint* entitled, 'Yesterday's Hero'.

LEFT: A photograph of George Lucas taken outside a former administration building at the studio.

ABOVE RIGHT: Ian Ogilvy as Simon Templar sits on the bonnet of what was now his trademark Jaguar XJ-S to publicize *Return of the Saint*.

role of Simon Templar from Roger Moore in 1978 for twenty-four episodes. The updated version also saw Simon Templar exchange his white Volvo P1800 for a Jaguar XJ-S. Unlike the original series, this one, with its bigger budgets and European production partner, saw filming abroad rather than simply in and around the studios. Despite being cast as Templar, working on the series wasn't always glamorous for Ogilvy. 'I remember working in the water tank on the backlot at Elstree. I spent a couple of days in scuba gear and got very cold and the stunt crew advised me to pee inside my wet suit because that would give me temporary warmth at least in the nether regions. A few days later, shooting at the Southall gas works, both my ears became painfully infected, which was hardly surprising given that, if I was peeing in my wetsuit, so were the stuntmen!'

The decade was drawing to a close. For Elstree, the seventies had been as dramatic as any production ever filmed on its stages. The pain of the changes necessary to ensure it would survive was balanced with the knowledge that the studios were still – very much as a consequence of the tough decisions taken – alive and home to some of the biggest productions in the world. Yet there was little time to breathe long sighs of relief. For change was on the cards yet again.

THE QUEST

FOR
STABILITY

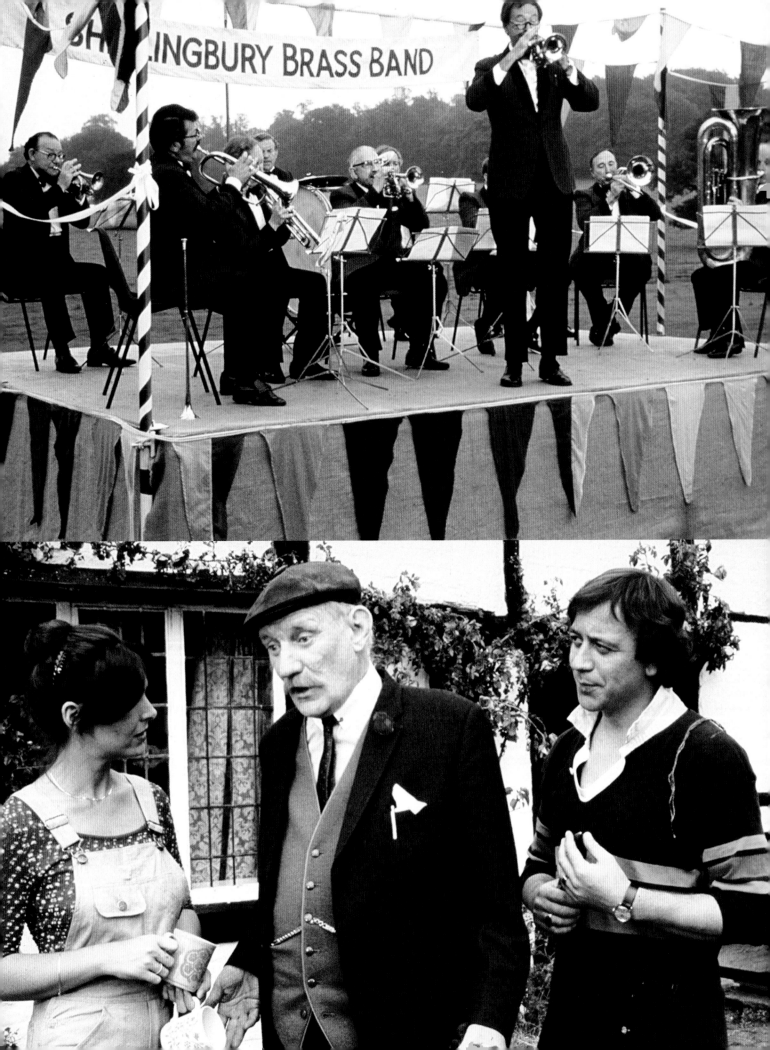

As the seventies gave way to the eighties, the UK saw a change of government and political direction for a country crippled by international oil price rises and industrial strife at home. Inflation rose above twenty per cent. Efforts to tackle the problem included increasing interest rates, higher taxes, spending cuts and money supply control. A severe recession hit the UK in 1981, and soon there were more than three million unemployed. Along with many businesses, the film industry would not be immune to the effects of these woes. For Elstree though, the decade started well.

The Shillingbury Blowers, a feature-length comedy drama pilot made by Greg Smith, was brought to Elstree for post-production work. The film starred Robin Nedwell, Diane Keen, Jack Douglas, John Le Mesurier and Trevor Howard. A six-part series – *The Shillingbury Tales* – followed. Both versions were directed by Val Guest, and were set in the fictitious village of Shillingbury. Although mostly made on location in the village of Aldbury in Hertfordshire, some filming did take place at Elstree Studios for the main television series.

Working at Elstree Studios was the fulfilment of a long-time ambition for Diane Keen. 'I used to dream about all the various studios, including Elstree Studios in Borehamwood, when I was a girl,' she said. 'That's where I wanted to make films – not America! The size of the lot at the studio is what I most remember. And the big, long corridors, which led to the make-up and costume rooms.

Elstree really had an aura of a film studio about it. I felt very at home and safe working there. We need to cherish studios like Elstree.'

Star Wars: The Empire Strikes Back (also known as Star Wars Episode V: The Empire Strikes Back) was released in 1980. Following location filming, shooting started at Elstree Studios on Tuesday 13 March 1979. George Lucas engaged Irvin Kershner to direct the film and Gary Kurtz returned to produce.

George Lucas later revealed his thought process for the story. 'It is a darker film. In the first act you introduce everybody and in the second act you put them in the worst possible position they can get into in their lives. They're in a black hole, never able to get out, and in the third act they get out. That's drama, that's the way it works. You don't have an exuberant, happy second act.'

When plans for Star Wars Episode V: The Empire Strikes Back were drawn up, Lucas made it known that he wanted to build a huge new stage at Elstree Studios. Bernard Delfont and EMI gave permission, and a new Stage 6 was born. It was built during the winter of 1978 and 1979, with construction delayed by bad weather. Stage 6 opened its doors to filming on Tuesday 22 May 1979. 'Completing the soundstage is the culmination of seven months of planning, building, and set preparation,' said Kurtz at the time. 20th Century Fox suggested that Prince Charles should be invited to open the stage, but a demanding filming schedule made this impossible.

Jeremy Bulloch, who first played the role of Boba Fett in this film, was pleased to return to the studio. 'It was wonderful to work at Elstree again and I remember how hot it was in my costume. It was very uncomfortable but enormous fun. I knew so many actors in the Star Wars films, so it was great to get back together and to talk about why we had been chosen to be in this massive trilogy.'

Stanley Kubrick's big screen adaptation of Stephen King's novel, The Shining, which had started filming at the studio in 1978 and took a year to film, was finally released in 1980. The filmmaker wrote, produced and directed the film, which stars Jack Nicholson, Shelley Duvall, Danny Lloyd and Scatman Crothers. Back in 1980, the UK

version of the film was cut by twenty-four minutes and given an 'X' certificate (suitable for over eighteens only). The full US cut was later given a 15 certificate for UK screenings on its reissue in 2012.

Kubrick had several sets built on stages at the studio. This allowed the production team the space and the time to shoot the scenes in chronological order. Meanwhile, the exterior set of the Overlook Hotel was built on the backlot at Elstree. Many of the events that took place during the making of *The Shining* were documented in a behind-the-scenes film made by Kubrick's daughter, Vivian Kubrick.

In the film, which Martin Scorsese once hailed as 'essentially unclassifiable, endlessly provocative and profoundly disturbing', a supernatural presence causes alcoholic novelist, and current caretaker of the Overlook Hotel, Jack Torrance (Jack Nicholson), to experience behaviour issues that later trigger a form of inexplicable madness. Torrance's violent outbursts become worse and worse, to the point that even the lives of his wife, Wendy (Shelley Duvall), and son, Danny (Danny Lloyd), are put in serious danger.

ABOVE: Jack Nicholson, Danny Lloyd and Shelley Duvall in the 1980 classic, *The Shining*.

LEFT: Thirty-five years after the release of *The Shining*, cast and crew members were among the guests to celebrate the film again at Elstree Studios in May 2015.

'I'm glad I was in *The Shining*. It was not a bad experience for me,' said Danny Lloyd, who was just five years old when he made the film. Although there were obviously financial rewards for Lloyd, some of his most enduring memories include riding his tricycle through the corridors of the Overlook Hotel set. 'I was five years old,' he said. 'To be able to ride your bike inside was this great thing.' Ironically, due to the nature of the content of the film, the boy actor didn't get to actually see *The Shining* for another decade, until he hit sixteen, although he admitted, 'I didn't find it scary because I saw it behind-the-scenes.'

Adam Unger first worked at Elstree Studios as an assistant editor on *The Shining*. 'Many of the sets were built on a large scale, utilizing the entire area of the stage. I particularly recall the ballroom set on Stage 5, which was matched by the lobby of the Overlook Hotel on Stage 3.'

Back on 24 January 1979, fictional drama gave way to scarier reality, which Unger still remembers clearly: 'Stage 3 was the scene of a dramatic fire towards the end of shooting, which destroyed the entire set and stage. It was a shock to see it all gone. Amazingly, the fire was neatly confined within the stage and, fortunately for the production, shooting had mainly been completed.'

With future bookings confirmed, the stage was rapidly rebuilt.

What many people watching *The Shining* won't realize is that music mogul Simon Cowell worked on the film as runner, one of his first jobs in the industry. His duties on the film were said to have included cleaning the famous axe used by Nicholson in his role as Jack Torrance.

Harrison Ford was to return to Elstree Studios to play archaeology professor Indiana Jones in the 1981 film, *Raiders of the Lost Ark*. Tom Selleck had been the original choice for the lead role, but his commitment to the television series *Magnum P.I.* – which made him the highest paid actor on American television at the time – meant his involvement was not possible. The *Indiana Jones* prefix was added to the film,

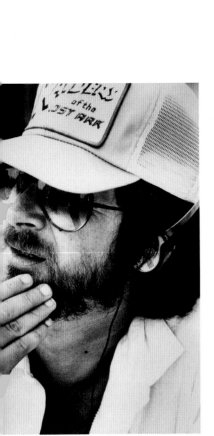

ABOVE: Director Steven Spielberg on the set of *Raiders of the Lost Ark*.

which was directed by Steven Spielberg, at a later date.

Following the production of *Star Wars: A New Hope*, George Lucas, the executive producer of *Raiders of the Lost Ark*, turned to director Steven Spielberg in the hope of his involvement. Spielberg agreed to direct the production, which was originally based on a story written by Lucas called *The Adventures of Indiana Smith*. Initially, Lucas had worked with Philip Kaufman to develop the story, but Kaufman departed to work on a Clint Eastwood film. Lucas, Spielberg and writer Lawrence Kasdan developed the concept, with Kasdan writing the screenplay. Paramount Pictures

eventually agreed to finance the film, which, despite the financial success of *Star Wars: A New Hope*, was turned down by a number of other studios.

As well as Harrison Ford, the final cast included Karen Allen, Paul Freeman, Ronald Lacey, John Rhys-Davies and Denholm Elliott. With casting complete, filming commenced on the seventy-three-day, $18 million movie on 23 June 1980, at La Rochelle in France, before moving to Elstree Studios, where filming began on 30 June 1980.

ABOVE LEFT: Harrison Ford as Indiana Jones in an iconic scene from *Raiders of the Lost Ark*.

ABOVE: Indiana Jones in a tight spot with the feisty Marion Ravenwood, played by Karen Allen.

During production at Elstree, the old Stage 3 was used to film the Well of Souls sequence. Initially, 2,000 snakes were brought in but Spielberg ordered an additional 4,500. In order to ensure safety, an ambulance was kept on standby, as were medical staff, with syringes filled with anti-venom serum in case any cast or crew member was bitten. The unit also wore protective clothing and stunt performers were on hand for Ford and Allen when necessary. Over 6,000 snakes went into Stage 3 – but it is said that only 5,000 came out. Many, it is believed, slithered away unseen down drainpipes and gulleys. Rumours abounded for years after that residents of Borehamwood, on entering their bathrooms, would always to lift their toilet seat, just to be sure.

The Dark Crystal, a fantasy film featuring a full cast of puppets, was released in 1982. Made by Henson Associates it was somewhat darker than *The Muppet Show*, and its subsequent spin-offs.

Although filming commenced in April 1981, Jim Henson, who wrote the screenplay with David Odell, started his journey on the film way back in 1976, when he spotted an image of Brian Froud's artwork. This inspired Henson to want to collaborate with Froud. But it wasn't until the August of the following year that a deal was signed for them to work together, the lengthy process in part due to Henson's work on *The Muppet Show*, which was made at what was the nearby ATV Centre (now BBC Elstree) in Borehamwood.

As of 1982, Elstree Studios was in a position to provide a number of enviable facilities to the industry – Stage 6 was the

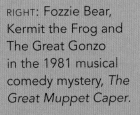

RIGHT: Fozzie Bear, Kermit the Frog and The Great Gonzo in the 1981 musical comedy mystery, *The Great Muppet Caper*.

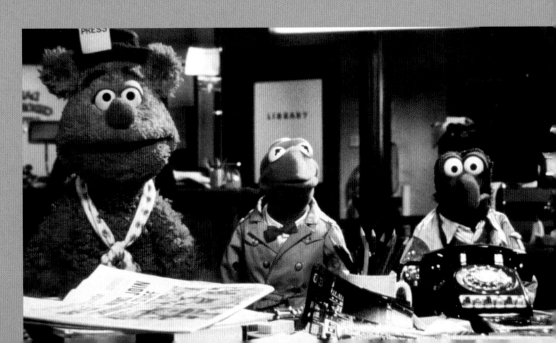

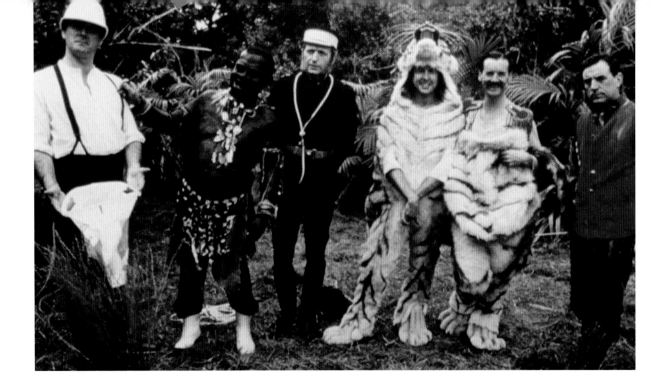

largest in Europe at the time and Stages 7, 8 and 9 offered the much-needed addition of television lighting grids. The site also offered state-of-the-art post-production facilities.

The Monty Python team based themselves at Elstree to make their 1983 film, *Monty Python's The Meaning of Life*. Before the main film began, a short stand-alone film by Terry Gilliam, *The Crimson Permanent Assurance*, was shown. Then *The Meaning of Life* launched into a series of sketches and musical numbers related to all the matters that habitually obsess human beings – from food and sex to money and death. Directed by Terry Jones, the film stars Graham Chapman, John Cleese, Terry Gilliam, Eric Idle, Terry Jones and Michael Palin.

Star Wars: Return of the Jedi (also known as *Star Wars Episode VI: Return of the Jedi*), which until December 1982 had the working title of *Revenge of the Jedi*, began principle photography at Elstree Studios on 11 January 1982 before being released in 1983. Filming on the stages at Elstree took seventy-eight days, with location filming then taking place in Arizona and California. At one time or another during its shooting at Elstree, the production used all nine stages.

During the filming, the large set of the Rebels' Main Briefing Room was built in the then Stage 5. By this point in its lifetime the

ABOVE: John Cleese, Terry Gilliam, Graham Chapman, Eric Idle, Michael Palin and Terry Jones in the 1983 comedy, *Monty Python's The Meaning of Life*.

stage had seen better days: it was notoriously cold and the lack of soundproofing meant that outside noise, including bad weather, would often interfere with filming. Worse still for the *Return of the Jedi* team was that, between filming, plastic sheets had to be employed to protect scenery from a number of pigeons that were living in the roof. Unbelievably, they made so much noise that a number of speeches made during filming had to be re-recorded in post-production, allowing some wag to exclaim, 'May the squawks be with you!'

Sean Connery's last outing as James Bond was in the 1971 film, *Diamonds Are Forever*, after which, Roger Moore took over the

BELOW: Back as Bond – James Bond – Sean Connery, with Kim Basinger in the 1983 film, *Never Say Never Again*.

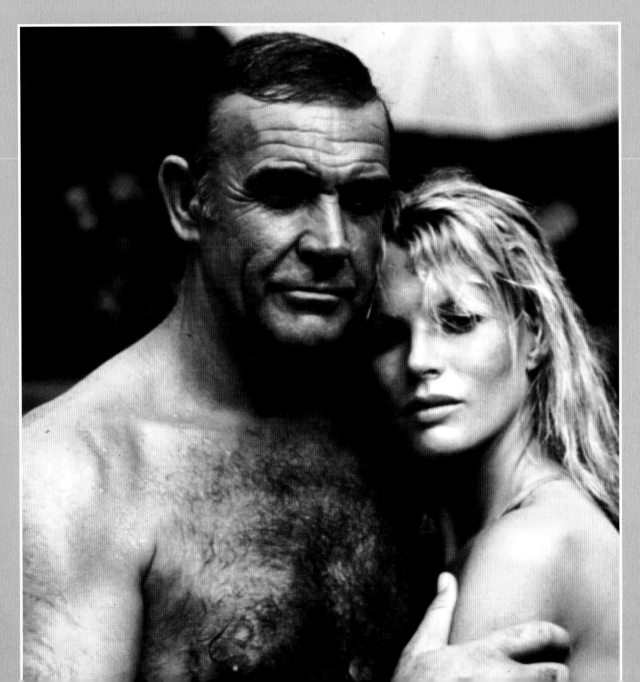

role, making his Bond franchise début in the 1973 film, *Live and Let Die*. And that was that for Connery, or so he thought. More than a decade later though, Connery found himself playing Bond once again, this time an older and more mature portrayal in a $36 million adaptation of Ian Fleming's novel *Thunderball*.

Connery had appeared in the 1965 version of the film, but this new adaptation, released under the title *Never Say Never Again*, was not made by the usual Bond team at Eon Productions. Indeed for legal reasons – there was a long and complicated legal dispute connected to this film – it had to be released as an 'unofficial' Bond film. Not only were casting changes required to appease the official series makers, but the iconic Bond theme, the gun barrel opening and the usual quintessential Bond title sequence were also off the menu.

Many Bond fans will know that the title of this film was said to be a tongue-in-cheek response to Connery's one-time declaration that he would never play the secret agent again. But what they might not be aware of is exactly who came up with the title. 'Sean's wife, Micheline Roquebrune, came up with the clever title, *Never Say Never Again*,' recalled Pamela Salem, who played Miss Moneypenny in the film. 'Micheline kept a list with her of ten or so ideas she thought up – after some company that had been hired for weeks to come up with a title with no success – and thereby saved the film a lot of money.'

First shown during the autumn of 1983, Euston Films' ambitious £4.5 million television series, *Reilly, Ace of Spies*, was partly filmed at Elstree Studios. The Thames Television offshoot company was most well known for making iconic television series *The Sweeney* and *Minder*. Verity Lambert acted as the executive producer on the series, which benefited from the directorial skills of Jim Goddard and Martin Campbell – who would later go on to direct two Bond films, *GoldenEye* and *Casino Royale*. Reilly was played by Sam Neill, and the other cast members included Leo McKern, Norman Rodway, Peter Egan, Jeananne Crowley and David Suchet.

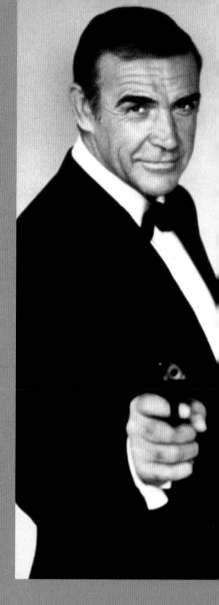

ABOVE: The ever-suave Sean Connery may have said, 'Never again,' but he did come back for one last outing as Bond in 1983.

Filming at Elstree Studios on *Indiana Jones and the Temple of Doom*, which had an estimated budget of $28 million, began on 5 May 1983, following location work in Kandy, Sri Lanka, and was released in 1984. Directed by Steven Spielberg, the film was written by Willard Huyck and Gloria Katz. For this outing, Harrison Ford was joined by Kate Capshaw, Amrish Puri, Roshan Seth, Philip Stone and Jonathan Ke Quan.

When Spielberg was asked to explain his philosophy behind the film, his reply was anything but pretentious. '*Temple of Doom* is a popcorn adventure with a lot of butter. A movie about a kind of life that is totally unattainable, where you wake up at one o'clock in the morning after seeing it and say, "That's impossible. I don't buy it." But you bought it when you were watching it, and that's all that's important.'

Sculptor Brian Muir remembers *Indiana Jones and the Temple of Doom* as a film on which he thoroughly enjoyed working. 'There was a relaxed and happy atmosphere on the film and I enjoyed the variety of work. We were working in the *Star Wars* prop room and it was quite strange to have Jabba the Hutt in the

BELOW: Sam Neill and Jeananne Crowley in the high-budget television drama, *Reilly: Ace of Spies*.

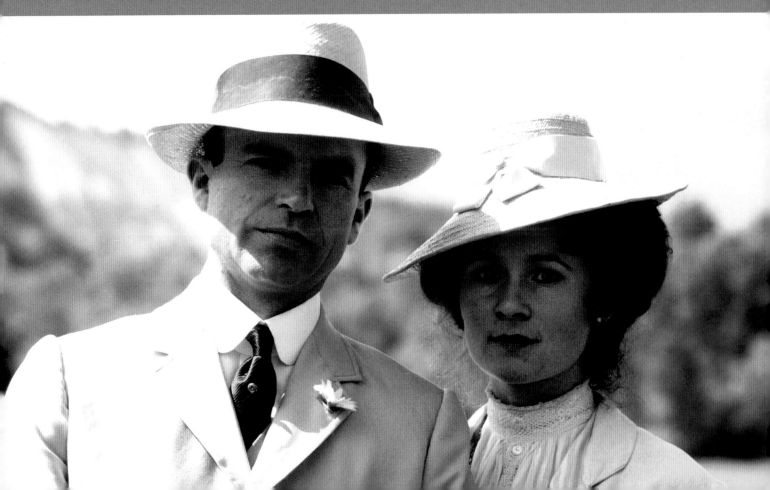

corner overlooking our endeavours. One of my many projects was the gong featured in Club OB1 in the opening sequence. Having spent two weeks sculpting a dragon around the perimeter of the gong with the Paramount Mountains in the centre, it was noticed by the art department that they had got the scale wrong. I then only had two days to sculpt what is seen on screen – but thankfully it still made for an effective start to the film.'

Princess Anne visited the studio on 17 January 1985 to officially open and tour the newly built John Maxwell Building, which replaced old workshops at the studio. The new building, located opposite the studio bar and Stages 7, 8 and 9, provided new, much-needed office and workshop space.

Directed by Muppet creator, Jim Henson (his last film) and produced by Eric Rattray, David Lazer and George Lucas, *Labyrinth* was a fantasy film released in 1986 with puppets from the Jim Henson Creature Shop taking many of the roles. David Bowie, Jennifer Connelly and Toby Froud were just some of the human performers appearing in the production. *Monty Python's* Terry Jones was brought in to write the first draft of the screenplay, with Brian Froud's sketches and designs said to be the inspiration for the story. Other writers, including one of the producers of the film, George Lucas, provided additional material for the final draft.

With a budget of approximately $25 million, the film started production at Elstree Studios on 15 April 1985. Stages used at Elstree Studios for the five-month shoot included the former Stage 6 – where the Goblin City set was built – and the current Stage 9.

ABOVE RIGHT AND LEFT: Jennifer Connelly as Sarah Williams and David Bowie as Jareth the Goblin King in the 1986 fantasy film, *Labyrinth*.

BELOW AND RIGHT: Christopher Reeve in his last outing as Superman in the 1987 film, *Superman IV: The Quest for Peace*.

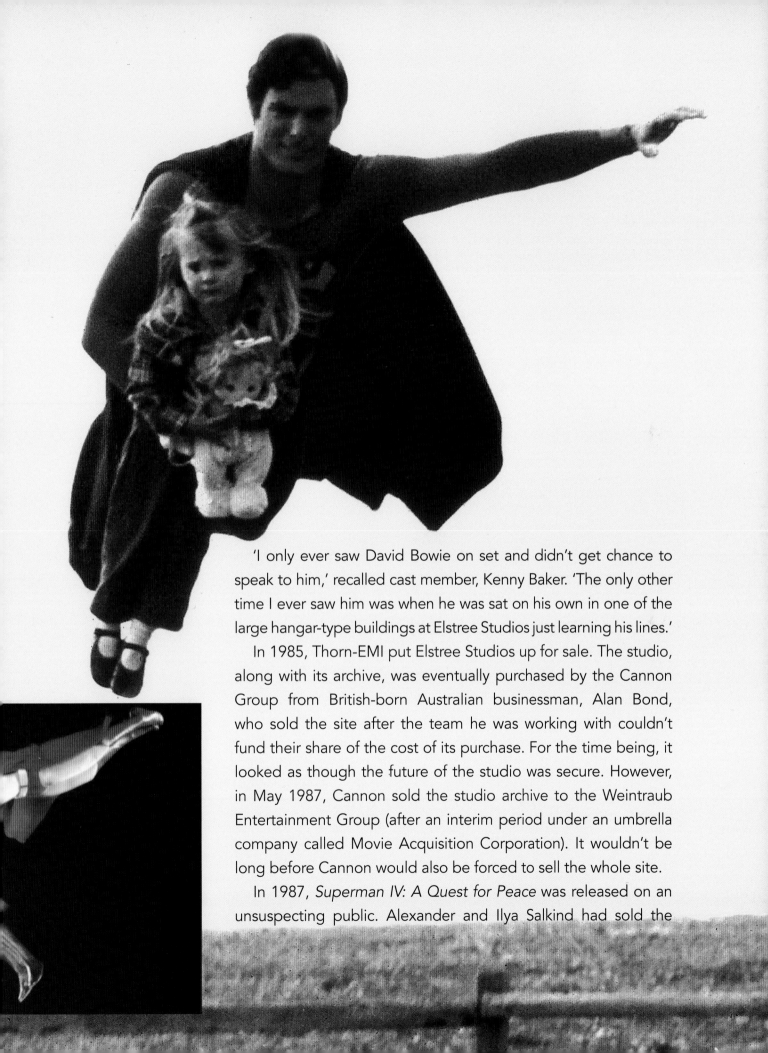

'I only ever saw David Bowie on set and didn't get chance to speak to him,' recalled cast member, Kenny Baker. 'The only other time I ever saw him was when he was sat on his own in one of the large hangar-type buildings at Elstree Studios just learning his lines.'

In 1985, Thorn-EMI put Elstree Studios up for sale. The studio, along with its archive, was eventually purchased by the Cannon Group from British-born Australian businessman, Alan Bond, who sold the site after the team he was working with couldn't fund their share of the cost of its purchase. For the time being, it looked as though the future of the studio was secure. However, in May 1987, Cannon sold the studio archive to the Weintraub Entertainment Group (after an interim period under an umbrella company called Movie Acquisition Corporation). It wouldn't be long before Cannon would also be forced to sell the whole site.

In 1987, *Superman IV: A Quest for Peace* was released on an unsuspecting public. Alexander and Ilya Salkind had sold the

Superman film rights to Cannon Films, believing that the public no longer had an appetite to see the adventures of Clark Kent and his alter ego on the silver screen. It was not the best of moves for the *Superman* franchise – and certainly not for Cannon. Financial problems were to see the original reported budget of $36 million slashed by half. This meant that the finished production did not share the same level of production values as the previous three *Superman* films. Practically every alleyway and corner of the studio lot was used for the building of exterior sets. Some of the studio buildings were also adapted to save money.

The production was directed by Sidney J. Furie and produced by Menahem Golan and Yoram Globus. Christopher Reeve played the title role for the fourth time, despite previously insisting he would not don the Superman outfit again. Reeve was joined by a cast that included Margot Kidder, Gene Hackman, Jackie Cooper, Marc McClure, Jon Cryer and Sam Wanamaker.

Despite good intentions, *Superman IV* did not perform well critically or financially. The film's outing would also mark the last time that Reeve would play Superman. Reeve was to sadly die in October 2004 at the age of just fifty-two.

Directed by former *Happy Days* actor Ron Howard and produced by George Lucas, the fantasy film *Willow* was released in 1988. Alan Ladd Jr came to Lucas's rescue once more after other distributors showed little interest in the film. The title was shot primarily at Elstree Studios and on location in Wales and New Zealand, and the cast included Val Kilmer, Joanne Whalley, Warwick Davis, Billy Barty and Jean Marsh.

As with the *Star Wars* series, *Willow* brings cinema-goers another good-wins-over-evil story. Despite being reluctant at first, Willow Ufgood (Warwick Davis), a dwarf farmer and amateur conjurer, finds himself entrusted with the task of looking after a baby and saving her from the evil Queen Bavmorda (Jean Marsh). George Lucas wrote the film specifically for Warwick Davis after meeting him on the set of *Return of the Jedi*. *Willow* did not do as well at the box

ABOVE: Eddie Valiant (Bob Hoskins) finds Roger Rabbit and wife Jessica Rabbit a bit tied up in the 1988 part-live-action fantasy comedy film, *Who Framed Roger Rabbit*.

office as its *Star Wars* counterparts, so there was to be no cinematic sequel, although Lucas continued the story in book form.

The same year was to see the part-animated, part-live-action fantasy comedy film *Who Framed Roger Rabbit* released. Directed by Oscar-winner Robert Zemeckis, the film starred Bob Hoskins, and featured Christopher Lloyd, Charles Fleischer, Kathleen Turner, Stubby Kaye and Joanna Cassidy. A year of post-production followed the principle photography and, harking back to a different era of animation, all of the characters were drawn by hand and there was not a single computer shot in the film.

The late Bob Hoskins made it known in an interview how his involvement in the film affected him. 'I think I went a bit mad while working on the film. Lost my mind. The voice of the rabbit was there just behind the camera all the time. You had to know where the rabbit would be at every angle. Then there was Jessica Rabbit and all these weasels. The trouble was, I had learnt how to hallucinate. My daughter had an invisible friend called Jeffrey and I used to play with her and this invisible friend until one day I actually saw the friend. I was following where she was seeing it. If you do that for eight months it becomes hard to get rid of.'

Who Framed Roger Rabbit, with its estimated budget of around $70 million, was the most expensive film produced that decade. There was considerable money and reputation riding on its success. Initial audience tests on eighteen- and nineteen-year-olds did not go well, with many of the audience walking out during the screening. Sticking to his guns, director Zemeckis refused to re-edit the film. The movie went on to win four Oscars including a special achievement award for animation direction.

Indiana Jones and the Last Crusade was the third in the Indy series and, again, directed by Steven Spielberg. Produced by Robert Watts and George Lucas, and with screenplay by Jeffrey Boam and an uncredited Tom Stoppard, the 1989 action adventure was filmed at Elstree Studios and on location in Spain, West Germany, Jordan, Venice, Texas, Colorado, New Mexico

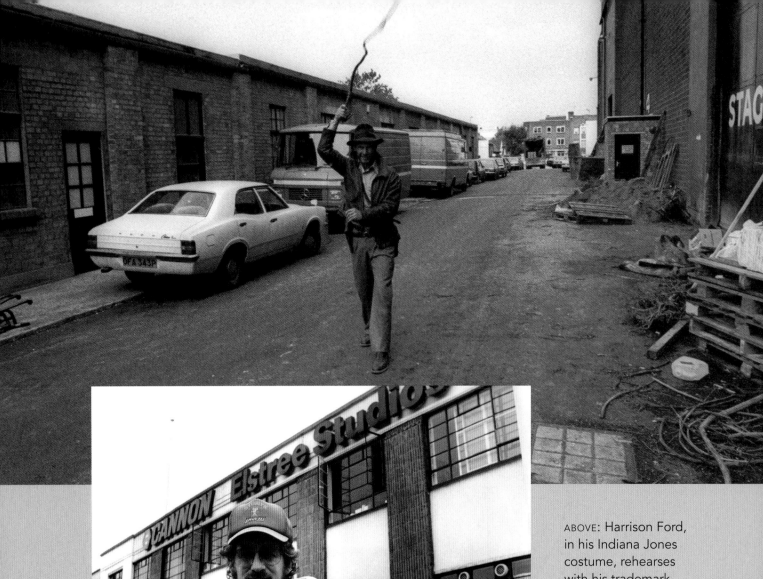

ABOVE: Harrison Ford, in his Indiana Jones costume, rehearses with his trademark whip outside Stage 4 at the studio.

LEFT: Steven Spielberg outside a former administration building after Cannon had taken over.

and Utah. This time, joining Harrison Ford were Denholm Elliott, Alison Doody, John Rhys-Davies and Julian Glover. Also starring was Sean Connery, as Indiana Jones's father Dr Henry Jones, as the two embark on a search for the Holy Grail.

Harrison Ford was delighted to be working with Connery. 'The third film benefits greatly from Sean Connery's presence, which kind of elevated everybody's game. I think it's by far the most sophisticated in many ways and was maybe the most fun of all of

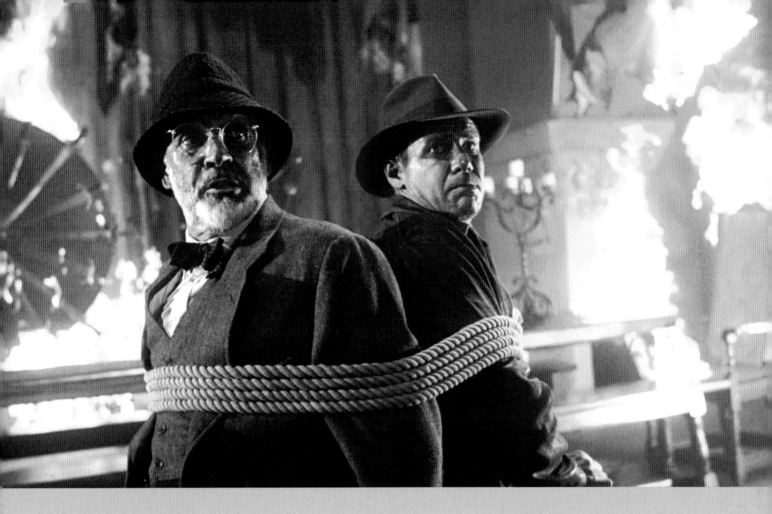

ABOVE: Sean Connery and Harrison Ford, as Professor Henry Jones and Henry 'Indiana' Jones, respectively, find themselves in peril in *Indiana Jones and the Last Crusade.* ·

them, because it had great locations, great physical sequences, it had a terrific leading lady, Alison Doody, with a really intriguing story to tell. The woman who had a relationship both with my father and me and the complications that ensued. And I had great fun with it.'

By 1988 Elstree's owners Cannon were in big financial difficulties, not helped by the failure of *Superman IV* to do the business at the box office, as well as having bought Thorn EMI's Screen Entertainment two years before. The company was massively overstretched and facing bankruptcy. Cannon was taken over by Pathé Communications and a corporate restructure began. Elstree Studios was put up for sale.

Borehamwood film historian, Paul Welsh, whose father had worked at the studios, recalled how he heard the news: 'Andrew Mitchell, the then managing director of Elstree Studios, called me to say that Cannon were planning to sell. I offered to start a campaign to save the studios, but the production manager of *Indiana Jones and the Last Crusade*, Pat Carr, had already taken the initiative

and I was invited to become chairman. This was the start of a few very hectic months. The campaign attracted a great deal of media attention from around the world. Both Steven Spielberg and George Lucas became our supporters and Richard Attenborough our honorary president. I organized a public meeting attended by around 800 local residents and the likes of George Baker and Sylvia Syms and we collected over 25,000 signatures.'

Former boxer turned successful businessman George Walker, founder of Brent Walker, purchased the studios on the understanding that his company would be allowed to develop part of the site in return for investing money into rebuilding and modernizing the remaining studio buildings.

In 1991, buildings including Stage block 1-4, Stages 5 and 6, the long administration block at the front of the site, offices, archive rooms and workshops were all subsequently demolished. This site would later become a supermarket, petrol station and car park. Even the former studio manager's house on part of the surviving studio land, which had once housed offices for Hammer Films, was razed to the ground.

And it soon became clear that modernizing Elstree Studios was the last thing on Walker's mind. 'The campaign had been stood down by this point and melted away,' recalls Paul Welsh. 'But I stayed on as chairman in order to keep the pressure on all interested parties and to keep the studios in the public eye. By 1993, Brent Walker had given up pretending they intended to modernize and declared they were closing the studio and wanted permission to redevelop the site.'

John Shepherd, who was by then the studio manager, shared his take on Brent's management of the site. 'The Brent Walker days started well, but it soon became apparent that they were property developers. The eventual demolition of the major part of the studios was very upsetting and seeing the front administration building coming down was especially sad.'

'Elstree suddenly became like a ghost town,' producer Greg

ABOVE: These sad photographs show demolition work taking place at the studio in January 1991. In time, this area would be taken over by a supermarket.

Smith later remembered. 'In the past, it had been a vibrant studio, and it was soul destroying to see what happened, especially when part of the site was demolished.'

Assistant editor on *The Shining*, Adam Unger, was equally distressed at the way the studio was being treated. 'I was very sad to see what was essentially the core of the studio demolished. It had serviced so many famous films in the past and included some of the oldest buildings on the site. The loss of the large stages meant a reduction in filmmaking capability in the UK. On a human level, many of the long-serving staff lost their jobs.'

Former PA to the Children's Film Foundation, Pamela Poll, remembers vividly how life at Elstree Studios changed with the arrival of Brent Walker. 'We moved out of London to Elstree in 1982. Our offices were located over one of the large stages. When half the site was sold off for development and all the large film stages and associated buildings were demolished we, together with other small tenants, moved into Portakabin offices. And then when all the staff at the studios were made redundant and all services withdrawn, we met with representatives of Brent Walker, and it was agreed certain facilities would be provided – electric heaters in occupied offices, lighting, cold water in kitchens and toilets and twenty-four-hour security … We now had an office at the front of the building, along with Paul Sattin's script-copying company, Sapex Scripts. After some months Paul, a staunch supporter of the "Save Our Studios Campaign" realized that he'd been spending too much time and money trying to stay put and, needing to protect his company's future, he moved out. There's no doubt that Brent Walker were trying to get us all out.'

Elstree Studios was on its knees. Half of it had been sold and now the rest was being asset stripped. A prime piece of real estate just twelve miles from the centre of London was being prepared for development. By now everyone knew what George Walker was up to. But could anyone stop him?

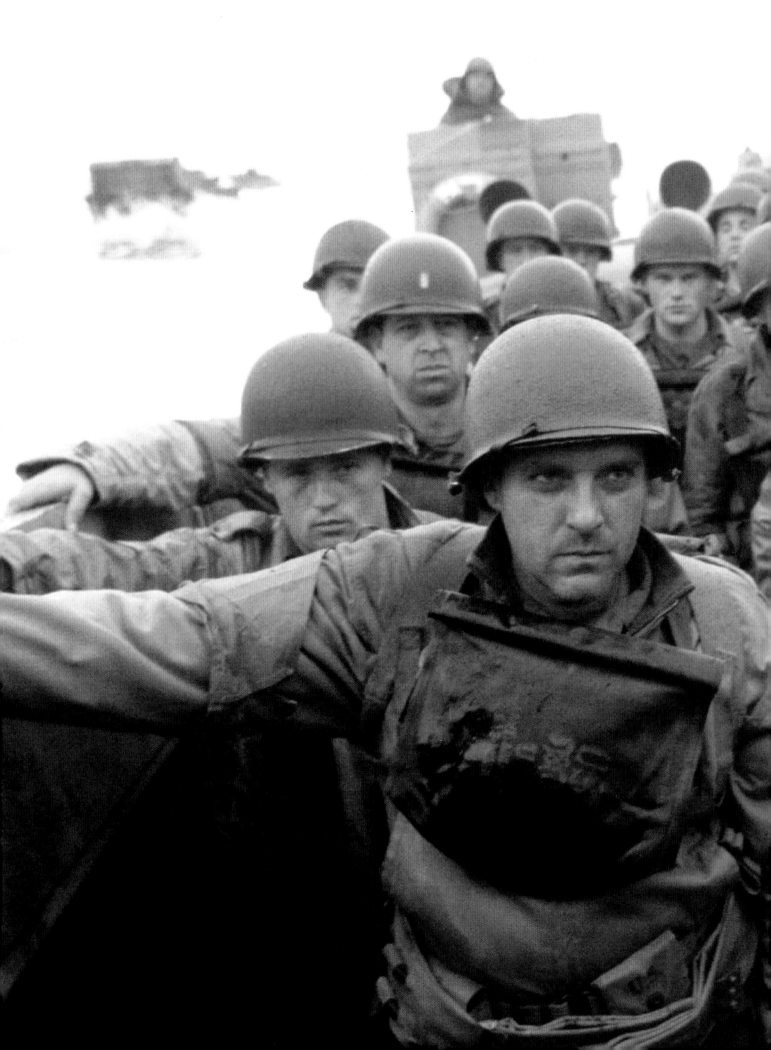

A PHOENIX

CHAPTER SIX

RISES

The borough of Hertsmere sits at the southeast tip of Hertfordshire, just where the county joins London. The name Hertsmere was created for the new district by combining the common abbreviation of 'Hertfordshire' (Herts) with 'mere', an archaic word for boundary. The name is reflected in the council's coat of arms, which shows a hart on the battlements of a boundary wall. When translated from Latin, its motto reads: Do Well and Fear Not, and as the planning authority that can grant or refuse applications, it's biggest challenge to live up to that motto was now staring it smack in the face.

With the support of the Save Our Studios campaign and the wider film industry, the council had been persuaded that it was the correct thing to do to allow the selling off of half of the Elstree Studios site, to allow the profits of the sale to be plumbed back into rejuvenating and saving what was left of the site. Now though, it had become clear that George Walker's plans were just the opposite – to make the claim that such a small studios would no longer be able to operate in the world of filmmaking and that, when it proved to be unviable, his company should be allowed to sell off the rest of the land for commercial and/or residential development.

Save our Studios chairman Paul Welsh lobbied Hertsmere Borough Council and they agreed to continue to fight to save the site. An ace up the sleeve of the local authority was that Brent Walker had put in place a £10 million bond on the site as surety once half had been sold off. By 1996, knowing that the company and its owner

PREVIOUS SPREAD: Tom Hanks starred in the highly acclaimed 1998 war drama, *Saving Private Ryan*, directed by Steven Spielberg.

LEFT: Bruce Forsyth and Tess Daly brought *Strictly Come Dancing* to the studios from BBC Television Centre for the first time in the autumn of 2013.

were now on the verge of bankruptcy, Hertsmere called their bluff and took them to court to claim the value of the bond.

Paul Welsh remembers when the news everyone had hoped for came through. 'It was on a February night in 1996 when Sir Sydney Samuelson, the then film commissioner, and I were both attending an event in London, we got a call to say that Brent Walker had decided to settle out of court and sell the studios to the council.'

Neville Reid, who at the time worked at Hertsmere, had the task of convincing the council of Elstree Studios' future viability once it had been wrestled from the grip of Brent Walker. 'It was a very grey and miserable February morning when I first visited the studios in 1996. There were torn-up film stills lying around the buildings, the underground car park was sealed off, the projector had been removed from the Preview Theatre, the heating was ruined and there was no running water and no power. But as I walked around the stages, I got a feeling that it was very much like a sleeping beast, and one that I just knew could be brought to life again. When I reported back to the council I said, "we can make it work".'

Fortuitously for the studios, the borough council had sold off its housing stock two years earlier to housing associations that now took care of that service for them. Thus, for the first time in its twenty-year history, the borough had sizable funds sitting in the bank, which it was in a position to invest in facilities for residents such as leisure centres and town centre renovation. It was unanimously agreed cross party by the council that money should be spent on the failing studios site to give it a fair chance of showing whether it could survive.

There followed a huge renovation programme at the studio – including an immediate injection of £1 million – which soon sparked renewed interest within the film industry. In the summer of 1996, despite the fact that the studios were not really ready for business, members of a production team for a Warner Brothers film called *Watch That Man* (which subsequently became *The Man Who Knew Too Little*) came to the front gate and asked if they could see the facilities.

RIGHT AND BELOW: Bill Murray starred as Wallace Ritchie in the action crime comedy film, *The Man Who Knew Too Little*.

He's on a mission so secr

BILL
the Man who

e doesn't know about it.

Y IS
ew too Little

Providing facilities for the production at that stage added additional challenges but Neville Reid and his team worked to solve them. 'They wanted to look at their "dailies" in the Preview Theatre, but it wasn't ready. We didn't want to say no, so found some cinema seats in Paris and the old projectors were donated back by Ronan Wilson, who was based down the road at Millennium Studios. A new sound system and screen were installed and, as promised, we had the Preview Theatre ready for them in literally a week.'

The Man Who Knew Too Little was directed by Jon Amiel and the comedy espionage cast was headed by *Groundhog Day*'s Bill Murray alongside Joanne Whalley, Alfred Molina, Richard Wilson and Geraldine James. It was perhaps fitting that this, the first film to come to Elstree's remaining stages, was an affectionate parody of a Hitchcock film – the great Hitch having made this country's first talking picture at Elstree back in 1929. Yes, Elstree was back in business.

As the industry gradually became aware that Elstree Studios was up and running again, new film and television productions were to take to its stages. A production village of industry-related tenants also began to grow again.

Welcoming television productions to the site once again became a priority for the studio in the late nineties. Neville Reid recalled, 'I felt we had to bring in more television to safeguard the income of the studios when there were the inevitable downturns in film production.'

Dramas filmed at Elstree included *Love Hurts*, *Kavanagh QC* and *Playing the Field*, while sitcoms taped included *Birds of a Feather* and *Drop the Dead Donkey*. Comedy dramas benefiting from the re-opened facility included *My Summer with Des*. Meanwhile, the award-winning sketch shows *The Fast Show* and *Smack the Pony* also moved in.

Steven Spielberg's critically acclaimed war film *Saving Private Ryan*, starring Tom Hanks, Edward Burns, Matt Damon and Tom Sizemore, moved into the studio. Spielberg was adamant about

coming back to the home where he'd filmed the first three *Indiana Jones* films. 'When I needed an English studio base there was no question in my mind where I wanted to be. It had to be Elstree.'

It soon became apparent that in order for the studios to be given the opportunity to run effectively and to prove to the industry that this revival was more than just a flash in the pan, the site needed more stage space. Without it, the business would surely flounder. A business plan was drawn up along with plans for the construction of two new large stages to be built on the former backlot.

The council agreed the plans and the cost of £5 million to build the new Stages 1 and 2 (later to be named The George Lucas Stage), and just eighteen months later, on 29 January 1999, the two tallest stages in Europe were opened by His Royal Highness Prince Charles.

Sculptor Brian Muir remembers the royal visit with great pride, 'It was exciting to be told that Prince Charles was coming to the opening of the stage and that he was going to visit my workshop.

ABOVE LEFT: Steven Spielberg was adamant about basing *Saving Private Ryan* at the studio.

ABOVE MIDDLE: John Goodman and Mark Williams in the 1997 children's film, *The Borrowers*.

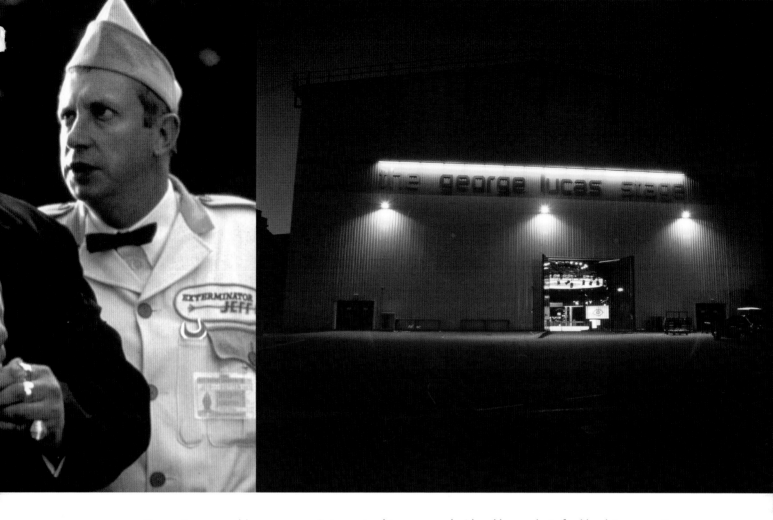

ABOVE RIGHT: Stage 1 of The George Lucas Stage. Both stages 1 and 2 of the complex were opened by His Royal Highness Prince Charles on 29 January 1999.

He was very interested in my work. I had been briefed by his security team that, as they were on a tight schedule, I would be told when to end it. After feeling several tugs from behind I thought I'd better tell Prince Charles we had to finish, but he insisted on seeing more and left in his own good time.'

Workshop space in the John Maxwell Building was then converted and became Stages 5 and 6, thanks to Jim Henson Productions signing a deal to make the children's television show *The Hoobs* in Stage 6 for an initial period of two years.

In September 1998, Celador began production of a new television quiz show for ITV called *Who Wants to Be a Millionaire?* Created by David Briggs, Steve Knight and Mike Whitehill, the series was originally made at Fountain Studios in Wembley. The show's host, Chris Tarrant, takes up the story. 'The reaction to the show was so massive that ITV, and the world, wanted as many shows as possible to be made the following year. However, the studio in Wembley was already heavily booked and just couldn't

give us all the dates that the television companies needed. So we went on a desperate hunt for a new studio that could take us en bloc for the future. For us, Elstree Studios was perfect, they could give us the technical back up and full facilities that this huge new television phenomenon required. And they agreed to custom build everything. So Elstree Studios became almost my second home in early 1999. We were to spend fifteen very happy years at Elstree, making show after show. There were many, many joyous evenings in the bar after the programme!'

During its run at Elstree, three production companies were to control the rights to make *Who Wants to Be a Millionaire?* – Celador, 2waytraffic and Victory Television. The production kept the set permanently standing in Stage 9 for over a decade.

Publically sending out a message that the studios were available for production of both big- and small-screen work and under new governance arrangements by which the council allowed an arm's length company to run the site which it oversaw, in 2000 the studio was to change its name to Elstree Film & Television Studios Limited.

Stage 1 of The George Lucas Stage was used for the filming of the main show of *Big Brother* and the spin-off, *Big Brother's Little Brother*. The reality gallery, production offices and edit suites were also based in the stage. Workshops close to the compound were used as extra studio space for another spin-off show, *Big Brother's Big Mouth*. Runs of the shorter *Celebrity Big Brother* series were also commissioned by Channel 4 and made at the studio. For many years, a live feed of action in the house was broadcast on Channel 4 and E4 from the studio, twenty-four hours a day. At the time, this was a unique and popular aspect of the series – and was ground breaking for a television show in the UK.

In 2011, after Channel 4 decided not to renew its deal with Endemol, Channel 5 purchased the rights to screen *Big Brother* and *Celebrity Big Brother*. Channel 5's presentation of the series saw a number of changes – the biggest from the studio's perspective being that Endemol stopped using Stage 1. Instead, a temporary

ABOVE: Both television hits *Who Wants to Be a Millionaire?* and *Big Brother* have been based at Elstree Studios.

stage and production village were erected next to the compound and in adjoining workshops, which allowed Elstree to rent out its largest stage space to other clients once again. Additional filming and office space was moved to Stage 6, towards the front of the studio, for a spin-off show called *Big Brother's Bit on the Side*.

Back in 2004, the modern, romantic drama *Closer* was released. Directed by Mike Nichols, the film was written by Patrick Marber and based on his award-winning play of the same name. Distributed by Columbia Pictures, complicated relationships, attraction and betrayal are all explored in this thought-provoking film, which involves four articulate lovers played by Jude Law, Julia Roberts, Clive Owen and Natalie Portman.

Celia Costas, the executive producer of *Closer*, found her Elstree experience a positive one: 'I will never forget the gracious reception that I received from Elstree in my many preliminary phone calls from America. They made me feel confident that whatever my needs or particular problems were, they would give them the utmost consideration. The experience of preparing to film in London

RIGHT: Clive Owen, Natalie Portman, Julia Roberts and Jude Law in the 2004 romantic drama, *Closer*. Stage 1 of The George Lucas Stage complex at the studio was used during the making of the production.

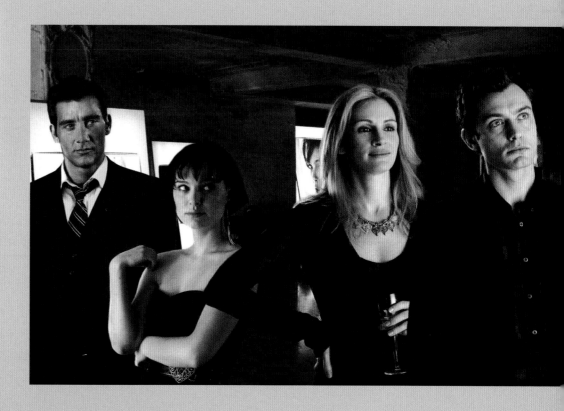

improved exceptionally once we made the decision to shoot at Elstree. Stages 1 and 2 are among the best available in London. I have shot all over the United States and in several foreign countries and can say I have never been happier nor been treated better.'

Released in 2005, *The Hitchhiker's Guide to the Galaxy* was directed by Garth Jennings and the screenplay was written by Douglas Adams and completed by Jennings and Karey Kirkpatrick after Adams passed away in 2001. The film starred Martin Freeman, Sam Rockwell, Zooey Deschanel, Bill Nighy, Anna Chancellor and John Malkovich. Martin Freeman recalls his time playing Arthur Dent: 'Filming at Elstree was a real pleasure. Not only was it near for me as a north Londoner but the whole atmosphere was professional and friendly. The dressing rooms are a treat too – nicer than most hotels!'

For producer Nick Goldsmith, filming at the studio was the fulfilment of an ambition that had begun during his childhood. 'After growing up in Elstree and visiting the studios as a kid, it was really special to come back and actually shoot our first film here.

BELOW: Bill Milner as Will Proudfoot and Will Poulter as Lee Carter in the 2007 comedy drama, *Son of Rambow*, directed by Garth Jennings.

Hitchhikers was an amazing experience for us, and Elstree Studios became our home for most of that year. So much so that, when we made our next film, *Son of Rambow*, it didn't take much time to decide to base ourselves at Elstree once again!'

The third instalment of the *Star Wars* prequels, *Star Wars Episode III: Revenge of the Sith*, included filming at Elstree. Once again George Lucas was at the helm, and the film had a reported budget of $113 million. Ewan McGregor, Natalie Portman, Hayden Christensen, Ian McDiarmid, Samuel L. Jackson, Christopher Lee, Anthony Daniels, Kenny Baker and Frank Oz all featured.

Although filming took place at other studios during the making of *Revenge of the Sith*, including Shepperton Studios, Lucasfilm were still keen to return and use Elstree Studios to shoot certain scenes. 'We could have shot anywhere in the world, but Elstree is our home,' said producer Rick McCallum. 'What distinguishes one studio from another is the people who run it. Elstree Studios provided us with the most efficient, organized and dedicated team, who were always able to adapt and respond immediately to our complex and technically challenging production requirements.'

Back on the small screen, *Dancing on Ice*, ITV's hugely successful Sunday night celebrity skating show, originally hosted by Phillip Schofield and Holly Willoughby, began in January 2006. When Willoughby left the series in 2011, presenter Christine Bleakley took her place. A host of judges, including Karen Barber, Jason Gardiner, Nicky Slater, Robin Cousins, Ashley Roberts and Louis Spence appeared on the series over the years. Celebrity contestants who won the series included Gaynor Faye, Suzanne Shaw, Hayley Tamaddon and Beth Tweddle.

Apart from in 2011, when, due to space problems at Elstree, the show was made at Shepperton Studios, *Dancing on Ice* was based in Stage 2 at the studio during each of its winter runs. Stage 5 was also used to house a training rink. The final series, which ended in 2014, was an impressive All Stars version and featured past winners and favourites from the previous eight series. Professional skaters

Jayne Torvill and Christopher Dean, who had been skating coaches on the series from the start, also celebrated the thirtieth anniversary of their famous *Bolero* dance.

'Both Chris and I had sort of quietly retired as a skating duo in 1998, following a performance we gave in Canada,' recalled Jayne Torvill. 'We kept it to ourselves, but it was very emotional. Then in 2005, ITV contacted us saying they wanted to make *Dancing on Ice* – which had a working title of *Skating on Thin Ice*. An independent production company also contacted us and said *they* wanted to make a similar version for the BBC. At the time, Chris was living in America, but we used to call each other every other day. We were excited at the prospect of working on the series, but concerned at having to teach all of the celebrities in such a short time. In the end, we decided to work with ITV.

'We felt we knew how to make it work, although we thought it would only run for one series. The viewing figures for the first series surprised everyone. After the first show went out, ice rink

LEFT: ITV's *Dancing On Ice* flying high in Stage 2.

MIDDLE: Jayne Torvill and Christopher Dean.

BELOW: A host of celebrities and their professional skating partners take to the ice.

attendances were up at public sessions, and some ran out of skates to hire! Pleasingly, adults as well as children wanted to try skating after watching the celebrities learning to skate.'

For the first two series there was no training rink at Elstree, and rinks around London had to be used to train the celebrities. Everyone agreed it would be far more beneficial and time efficient to train the celebrities at a training rink at the studio that was the same size as the rink in Stage 2. The show had the training rink from October until the end of each series, when it was removed to accommodate other booked productions.

At the start of 2007, with the initial tender period of seven years reaching its end for Elstree Film & Television Studios Ltd, Hertsmere Borough Council decided to revert to running the site as an in-house concern from April of that year, initially on a *pro tem* basis.

In the ten years since the studios had been taken over by

ABOVE FROM LEFT:
Olivia Coleman,
Jim Broadbent, Karl
Johnson, Simon Pegg,
Paddy Considine and
Nick Frost appeared
in the 2007 comedy
caper *Hot Fuzz*,
directed by Edgar
Wright.

the council, the face of British studios had been changing. Leavesden in Hertfordshire, originally a Rolls-Royce factory, has been used by various productions, including the 1995 Bond outing *GoldenEye* and then Steven Spielberg's television series of *Saving Private Ryan*, before the producers of the *Harry Potter* franchise moved in to make all of its films there. Now, Warner Brothers were planning to turn Leavesden into the biggest studio in the country. Pinewood and Shepperton, meanwhile, had merged and were no longer in competition with one another for business but working together to vie for big-budget home grown and international productions.

Hertsmere council, aware that the site needed investment and a longer-term strategy if it was to thrive, felt that now was perhaps the right time to test the waters and see just how interested in Elstree the industry was – and who might be willing to take over the business. The studio was renamed Elstree Studios to clarify that the facility was available for use by both film and television production companies, as well other media-related industries.

Market testing was undertaken and expressions of interest sought for the long-term running of the site. The council was wary of entertaining ideas of selling the studios. Firstly, the local authority didn't need the money in the bank as it was, by then, relatively

capital rich but revenue poor, so keeping the arrangement of an income stream coming into the coffers each year to pay for local services was appealing. More worryingly, losing control of the site could see the studio back to square one and under threat from asset strippers and developers once again.

In the event, no deal came forward that gave the council confidence that the studios would attract the necessary investment while also protecting the revenue stream essential to the district's finances. It was agreed to allow the studios to continue to be run by an arm's length company, of which the local authority was the only shareholder, and to ensure expertise from the industry to run it. To that end, a new managing director, Roger Morris, was appointed in January 2009. Morris had forty years' experience in the media production industries and had at one time both owned and run the similar-sized Teddington Studios.

With a new energy and sense of direction, Elstree was powering forward once again. As the studio headed towards the end of the first decade of the new millennium, director Daniel Barber shot scenes for his vigilante thriller *Harry Brown* at the studio. Released in November 2009, the film saw Michael Caine – returning to Elstree for the first time since *Get Carter* in 1971 – in the lead role of a retired widower who takes matters into his own hands and seeks justice for a friend who has been murdered by a local gang after the police fail to find enough evidence to make any arrests or convictions.

RIGHT: Michael Caine as Harry Brown in the 2009 vigilante thriller of the same name.

The King's Speech, starring Colin Firth, was also partly shot at the studio. Made with a budget of around just £8 million, this historical drama was to bring in more than £250 million at the box office worldwide. The 2010 film was directed by Tom Hooper and stars Colin Firth, Geoffrey Rush, Helena Bonham Carter, Guy Pearce, Timothy Spall, Derek Jacobi, Jennifer Ehle and Michael Gambon.

Although a great deal of location work took place on The King's Speech, the scene that is set at Buckingham Palace with Colin Firth, as the King, standing delivering a speech at a BBC microphone, was filmed in a stage at Elstree Studios.

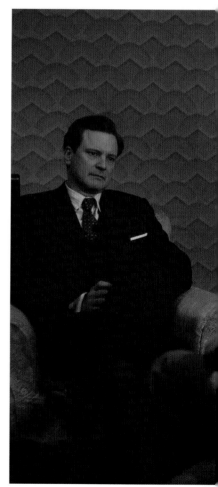

With four Oscars and seven BAFTAs, along with many other gongs to its name, The King's Speech is, to date, the most awarded and nominated film in Elstree Studios' history.

When the directors of the BBC continuing drama EastEnders, which has been made at nearby BBC Elstree since it started in 1985, devised a plotline in which its public house was to catch fire as part of 'Queen Vic Fire Week', the producers realized they needed an additional – and larger – stage space to film crucial and dramatic interior scenes. The four episodes were broadcast between 6 and 10 September 2010, and the plot culminated in the popular

LEFT: Robert Downey
Jr, Stephen Fry and
Jude Law in the
2011 action mystery,
*Sherlock Holmes: A
Game of Shadows*.

BELOW Colin Firth
as King George VI,
and Geoffrey Rush
as speech therapist
Lionel Logue in *The
King's Speech*.

character of Peggy Mitchell, played by Barbara Windsor, leaving the series. 'When we filmed the Queen Vic fire scenes I was hoping the programme wasn't going to kill my character off, because I didn't know. You see, they don't tell you!' confided Windsor. 'We recorded the interiors in a stage that's part of The George Lucas Stage complex. They made me wear all this special, protective clothing. I thought to myself, if I'm going to up in flames, it might as well be here!'

Returning to the studio brought back many happy memories for the actress. 'I love Elstree Studios very much. It's very homely and much cosier than other studios. Don't get me wrong, I love the other studios like Pinewood, but they all seem so vast. At one point, I thought it was going to go. So I was so thrilled and surprised when Hertsmere Borough Council saved it, as the greatest movies have been made there.'

With the reopening of the Elstree Studios by Hertsmere Borough Council, film and television production recommenced with renewed vigour. It should not be forgotten that pop video production has also seen a renaissance at the studio. Back in 2007, Peter Kay, Matt Lucas and David Walliams recorded the popular Comic Relief video for their version of The Proclaimers' song 'I'm Gonna Be (500 Miles)' at Elstree. Filmed in Stage 5 in just two days, the video included The Proclaimers themselves and a host of television personalities. Other performers who have shot their videos at the studio in more recent times include Enya, Girls Aloud, Mika, Katie Melua, Matt Cardle, Connor Maynard, Emeli Sande, Little Mix, Tinchy Stryder and One Direction.

The George Lucas Stage complex is a particular asset for production companies that need the space to rehearse for large or smaller tours of concerts and musicals. The musical artistes who have taken to Elstree Studios in past years include Queen and Paul Rogers, Mika, Anastacia, Madonna, Robbie Williams, Katherine Jenkins, Spandau Ballet, Cheryl Cole, Kylie Minogue, Will Young, Leona Lewis and West Life. While theatrical productions include the 'live' versions

of small-screen hits *Balamory*, *Doctor Who*, *Thomas the Tank Engine*, *Bob the Builder* and the touring ice show *Disney on Ice*.

In 2012 a new musical talent show format arrived on television screens with BBC One's *The Voice*, in which a group of hopefuls take part in a series of auditions and performing rounds in an attempt to win the series and walk away with £100,000 and a recording deal. Elstree played host to the live knock-out rounds. The presenting line-up has so far included Holly Willoughby, Reggie Yates, Emma Willis and Marvin Humes, while the judging panel on those rotating chairs has so far included Will.i.am, Tom Jones, Jessie J, Danny O'Donoghue, Ricky Wilson, Kylie Minogue and Rita Ora. Although a busy stage schedule for the studio meant that *The Voice* couldn't return in 2013, the series returned for selected editions in 2014 and 2015.

With the closure of the iconic BBC Television Centre in White City for redevelopment and with BBC Elstree in Borehamwood already busy with a host of shows including *EastEnders* and *Holby City*, the BBC began to move their operations – and shows – into Elstree Studios. There was refurbishment to the ancillary block, including dressing rooms and offices, new television floors and permanent galleries added to Stages 8 and 9. Additionally, the BBC's arrangement with Elstree Studios has also seen the use of Stages 1 and 2 for large-scale productions.

Elstree Studios received a royal visit when the Duke of York visited the site on 12 June 2013. His Royal Highness was given a tour by managing director, Roger Morris, and toured the set of Sky 1's *Yonderland* as well as being scanned in 3D by the award-winning team at special effects company Lifecast.

Continuing its role as a major player in the film industry, the studio provided stage space for the 2013 science fiction comedy *The World's End*. Directed by Edgar Wright, the film stars Simon Pegg, Nick Frost, Paddy Considine, Martin Freeman, Eddie Marsan and Rosamund Pike.

Despite working successfully in Hollywood, Simon Pegg has

great affection for Borehamwood: 'Working at Elstree Studios was a real honour for me. Growing up as a fan of *Star Wars* and *Raiders of the Lost Ark*, I was very aware of Elstree as the place where my favourite films were made. As I matured into a fan of cinema, I discovered the illustrious list of classic films that were created at the legendary studio complex. Elstree is and ever will be an essential part of the British Film Industry's DNA.'

A glitter-filled welcome was given by Elstree Studios to the BBC light entertainment show *Strictly Come Dancing* in 2013 – the number one hit programme that sees celebrities paired with professional dance partners. Although the series has had occasional outings to Blackpool and Wembley, it has primarily been based in TC1 at BBC Television Centre since it started back in 2004. So, this move marked a major development for the programme. It wasn't the first time that ballroom glitz and glamour had been seen at the studios as, back in 2009, BBC Three's *Dancing on Wheels* was recorded at Elstree, in which celebrities joined forces with wheelchair users in a unique dancing competition.

For *Strictly*, veteran entertainer Bruce Forsyth remained at the helm on the Saturday editions of the 2013 series, alongside co-host Tess Daly, while the Sunday night editions were co-hosted by Daly and Claudia Winkleman. In 2014, Daly and Winkleman became the

BELOW: The celebrity line-up for the first run of *Strictly Come Dancing* at the studio in 2013.

main hosts of *Strictly Come Dancing*, with Bruce Forsyth returning to present the Children in Need and Christmas specials.

Robin Windsor, one of the professional dancers on the series, shares the sheer excitement of working at the studio felt by so many. 'It's been incredible making *Strictly Come Dancing* at Elstree Studios, knowing which iconic film and television productions have been made there over the years. It makes me proud that all of us at the show have been given the chance to be part of that history.'

'Making *Strictly Come Dancing* in Stage 1, and more recently Stage 2, has allowed the show to grow visually and become much grander in scale,' said series director, Nikki Parsons. 'The extra space might not be obvious on television, but it has allowed us to expand the set and increase the audience seating capacity. We now also have the luxury of being able to keep the set standing for the whole run of the series, whereas we had to build and strike the set each week at BBC Television Centre. This gives the professional dancers the opportunity to rehearse the group numbers on the set during the week, as opposed to before where they had to use a rehearsal room. The last couple of years, in particular, have been very important to the show. The viewing figures have continued to climb, and the programme has become even more of a talking point. I love directing the show at Elstree Studios, everyone is very helpful.'

The autumn of 2013 saw Sky 1 HD broadcast *Yonderland*, a family fantasy-comedy that was shot in Stages 5 and 7. A hugely

RIGHT: When Bruce Forsyth gave up his main hosting duties on *Strictly Come Dancing*, Claudia Winkleman joined Tess Daly as co-host on the series.

FAR RIGHT: On-screen cast members of Sky 1 HD's family fantasy-comedy, *Yonderland*.

popular programme for children and adults alike, the show was an instant success and was immediately recommissioned for a second series. Directed by Steve Connelly the television series, which inspired one critic to say 'It's basically *Labyrinth* meets *Monty Python*', was written, co-created by and stars performers from CBBC's hit children's series, *Horrible Histories*. The show features puppets made by Baker Coogan, long-time collaborators with the Jim Henson Company.

In late 2013, the veteran comedy double act Vic Reeves and Bob Mortimer recorded five episodes of the first series of BBC Two's sitcom, *House of Fools*, at the studio. The following year saw, among other television productions, the BBC Two series *Episodes*, with Matt LeBlanc, Stephen Mangan and Tamsin Greig, and the ITV2 comedy panel show, *Celebrity Juice* both take to its stages.

The first big-screen version of *Paddington* was released in November 2014, having used Elstree Stages 1, 2 and 7 in the production. The comedy, based on Michael Bond's literary creation, was directed by Paul King, and stars Hugh Bonneville, Sally Hawkins,

Julie Walters, Jim Broadbent, Peter Capaldi, Nicole Kidman and Ben Whishaw as the voice of Paddington.

'When I first saw the finished film I was completely blown away by the quality of what they'd actually brought to life,' said Hugh Bonneville, who plays Mr Brown in the film. 'It was no longer a beautiful three-dimensional image, it was – sorry, hope it doesn't sound too ridiculous – a living, breathing bear as far as I was

BELOW: Children's favourite Paddington successfully made his way onto the big screen in 2014. A number of scenes featured in the film were shot at the studio.

concerned and I completely forgot that I hadn't been acting with it. So watching it I was totally transformed, my disbelief was totally suspended and I was watching this bear and I cared about this bear.' Audiences of all ages seemed to agree and *Paddington* has become the highest grossing British children's film to date.

As Elstree began to look towards its ninetieth anniversary, and looking back at the past five years, as the world in general and the UK in particular suffered its worst recession since the 1930s, it was gratifying to note that Elstree had, under the expert guidance of its management and hard work of its small team of employees,

RIGHT: Bill Murray lives it up as President Franklin D. Roosevelt in the 2012 comedy drama, *Hyde Park on Hudson*.

managed to ensure the best years of profitability that the studios had seen in a generation.

Hertsmere Borough Council was equally as delighted to know that the faith it had put in keeping this facility running and the huge sums of local taxpayers' money that had been invested since it took control in the late 1990s had proved to be a wise move. The local authority was now receiving well in excess of £1 million a year from the studios, subsidizing the council tax for every home across the entire borough, not just Elstree and Borehamwood, to the tune of twenty per cent.

In addition to contributing over £1.4 million rental income per annum to the council's revenue budget, the studios had also become a key local employment hub, providing, it is estimated, more than 800 jobs via production companies and associated employers as well as assisting local economic regeneration. In light of these important factors, maintaining and enhancing the studios' earning potential was of paramount importance.

As the years progressed, both the studios and the local authority knew that Elstree could not just stand still as others around developed and enhanced their facilities – investment in the ageing site was crucial.

The biggest frustration had been that a quarter of the site was not in use. There was a mound of earth, covering almost four acres of land, situated at the rear of the site, that had remained unused for some twenty years due to the dumping of contaminated material there prior to the council gaining ownership of the site. In the intervening years, quotations had been sought to remove the mound in its entirety but, due to changes in legislation and landfill tax prices, the cost of removing the mound had increased considerably, making a commercial return less viable.

At the same time, over the past five years the studios had remained extremely busy, despite the economic climate, and the lack of available letting space had meant that major business opportunities had to be turned down. On a number of occasions

prestigious and lucrative productions were turned away due to the lack of studio space, resulting in large potential losses of revenue.

So, the studios and the local council made a bid to the Hertfordshire Local Enterprise Partnership (LEP) to help fund the clearance of the mound of earth. The LEP panel, which included successful business executives, saw the business potential of this initiative – the clearance of the mound could, for example, see the land used to build an additional stage, or the installation of workshops, possibly the erection of a backlot for exterior filming, and so on.

The work to remove the mound started in September 2013 and was completed in the spring of 2014 – on time and on budget.

Of course, Elstree Studios can only be expanded so far. It is not a huge site like Pinewood, which has 100 acres, and it is fairly landlocked all around. Realistically, Elstree knows it will as often as not only ever get the films with lower budgets, as well as continuing to be a niche studio for television as there are only so many productions that can be accommodated at any one time.

So what could be done to help attract more production business? Well, attracting feature films is a highly competitive business. Despite world-class studios, post-production facilities and diverse locations, the UK must compete for US studio filming projects – and competition is fierce.

One of the big issues that production companies experience when filming on location is the need for speedy road closures. Requests to close roads for filming historically required a minimum of six to eight weeks' notice, which is far from practical when filming schedules are tight; sometimes, through no fault of the production, changes must be effected quickly.

In view of the competitive nature of the filming industry, London introduced legislation to allow its boroughs to effect road closures more easily. Like Hertfordshire, Kent has historically benefited from high levels of location filming too. Kent took the initiative to introduce legislation and therefore had an advantage over Hertfordshire.

ABOVE: 'Nice to see you . . .' Minister of State for Culture Ed Vaizey MP with Sir Bruce Forsyth, Elstree MD Roger Morris and Studio Chairman Morris Bright on a Government visit in September 2014.

It was following a trip made in 2011 by American producers to visit studios and locations in the UK that Elstree Studios agreed to spearhead the way to seek to raise the local advantage by introducing road closure legislation in Hertfordshire, which would have the benefit of making it less complex and time-consuming to make roads available for filming. Hertfordshire's authorities clubbed together with Elstree Studios to fund the £70,000 needed to secure the passage of a Private Bill in Parliament. This Private Bill was intended to enable the closure of roads to facilitate filming on the highway in Hertfordshire and enable the licensing of temporary placing of film production apparatus on the highway across the county. The Hertfordshire County Council (Filming on Highways) Bill received Royal Assent and became an Act on 31 January 2014. It is believed to be the first time that a studio has helped create an Act of Parliament. Another first for Elstree.

BELOW: HRH The Duke of York takes a tour of the studio with Studio Chairman Morris Bright and Elstree MD Roger Morris.

Elstree Studios is a small player in the market, yet continues to punch above its weight and is respected for what it is doing not just to improve and support the creative industries but also for what it does for the local economies around it. Elstree is unique in that it is owned entirely by a local authority, so profits are returned straight back to the public coffers to pay for services for local people. It is truly a studio of the people, for the people.

From its peak in the 1950s where Hollywood greats including David Niven, Sophia Loren, Gregory Peck, William Holden and Errol Flynn graced its stages in movies such as *Moby Dick* and *The Dam Busters*, to the great lows when the studios were shut for production in the early nineties, to its rebirth and fight to survive and thrive in the twenty-first century, there is no doubt that Elstree's story is as dramatic as any production ever filmed on its stages.

And with new business booking out its stages and plans to develop the back of the site coming to fruition, it looks very much as if Elstree Studios will be having a very happy ninetieth birthday indeed. After all that it's been through, if any studio deserves to celebrate such a milestone, it is Elstree. To be continued . . .

PRODUCTION CREDITS

The following lists contain just some of the many film productions that have had all or some form of pre-production, production and/or post-production at Elstree Studios, under its various names and ownerships, since it originally opened. All titles are listed in alphabetical order and in the decade in which they were released. In addition, a selection of music video and rehearsal credits have been included.

FILM CREDITS

1920s

Adam's Apple
Alf's Carpet
Alpine Melodies
The American Prisoner
An Arabian Knight
Atlantic
Black and White
Blackmail
Champagne
Chelsea Nights
Cocktails
Emerald of the East
The Farmer's Wife
The Flying Scotsman
The Hate Ship
High Seas
The Informer
Jazztime
Kitty
The Lady from the Sea
Lily of Killarney
A Little Bit of Fluff
Madame Pompadour
The Manxman
Me and the Boys
Memories
Moulin Rouge
Musical Medley
Musical Moments
Not Quite a Lady
Notes and Notions

Odd Numbers
An Old World Garden
Paradise
Piccadilly
The Plaything
Poppies of Flanders
Pot-Pourri
The Ring
A Romance of Seville
The Silver Lining
Song-Copation
A Song or Two
Those Who Love
Tommy Atkins
Toni
Under the Greenwood Tree
Up the Pond
The Vagabond Queen
Weekend Wives
The White Sheik
Widecombe Fair

1930s

Abdul the Damned
Across the Sahara
After Office Hours
Alf's Carpet
Almost a Honeymoon
Aren't Men Beasts!
At the Villa Rosa
Bachelor's Boy
Bill and Coo

Black Eyes
Black Limelight
The Black Hand Gang
Blossom Time
Brother Alfred
Bulldog Drummond at Bay
Cape Forlorn
Children of Chance
Choral Cameos
Claude Deputises
Compromising Daphne
The Compulsory Husband
Creeping Shadows
Crime on the Hill
Cupboard Love
Dandy Dick
Dead Man's Shoes
Doctor's Orders
Drake of England
The Dominant Sex
Dr. Josser, K.C.
Dual Control
An Elastic Affair
Elstree Calling
Facing the Music
A Feast of Harmony
The Feather Bed
Fires of Fate
The Flame of Love
The Flying Fool
For the Love of Mike
Freedom of the Seas

Gipsy Blood
The Girl in the Night
Girls Will Be Boys
Give Her a Ring
Glamorous Night
Glamour
Goodbye to All That
Happy
Harmony Heaven
Hawley's of High Street
Heads We Go
Heart's Desire
His Wife's Mother
Hobson's Choice
Hold My Hand
The House Opposite
Housemaster
How He Lied to Her Husband
I Give My Heart
I Spy
The Indiscretions of Eve
The Innocents of Chicago
Invitation to the Waltz
It's a Bet
Jamaica Inn
Jane Steps Out
The Jolly Farmers
Josser in the Army
Josser Joins the Navy
Josser on the River
Juno and the Paycock
Just William

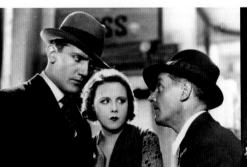
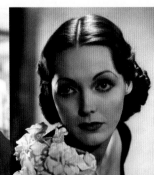
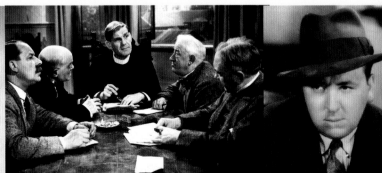

Keepers of Youth
Kiss Me Sergeant
Lame Duck
The Last Coupon
Leave It To Me
Let Me Explain Dear
Let's Fall and Laugh
Let's Make a Night of It
Letting in the Sunshine
Living Dangerously
Loose Ends
Lord Camber's Ladies
Lost in the Legion
The Love Habit
Love Lies
The Love Nest
Love Race
Lucky to Me
The Luck of a Sailor
Luck of the Navy
Lucky Girl
The Maid of the Mountains
The Man At Six
The Man from Morocco
Marigold
Master and Man
McGlusky the Rover
Men Like These
The Middle Watch
Mimi
Money for Nothing
Money Talks
Mr. Bill the Conqueror
Mr. Cinders
Murder!
Murder in Soho
Music Hath Charms
My Old Duchess
My Song Goes Round the
 World
My Wife's Family
Night Birds

Not So Quiet on the Western
 Front
Number Seventeen
Oh Boy
O.K. Chief
The Old Curiosity Shop
Old Soldiers Never Die
Old Spanish Customers
On Secret Service
Ourselves Alone
Out of the Blue
The Outsider
Over She Goes
The Perfect Lady
Please Teacher
Poison Pen
A Political Party
Poor Old Bill
Potiphar's Wife
Premiere
The Pride of the Force
Queen Cargo
Radio Parade of 1935
Raise the Roof
Realities
Red Wagon
Rich and Strange
Royal Cavalcade
The Scotland Yard Mystery
Sensation
The Shadow Between
 Shadows
She Couldn't Say No
The Skin Game
Sleepless Nights
Someone at the Door
Song of Soho
The Song You Gave Me
A Southern Maid
Spring Handicap
St. Martin's Lane
A Star Fell from Heaven

Strip, Strip Hooray
The Student's Romance
Suspense
Tam O'Shanter
Tell Takes
The Tenth Math
The Terror
Their Night Out
Those Were the Days
Timbuctoo
Tin Gods
Tonight's the Night
Two Worlds
Uneasy Virtue
Vessel of Wrath
The W Plan
We Take Off Our Hats
What a Night!
Wishes
Why Sailors Leave Home
The Woman Between
Yellow Sands
Yes, Madam?
You Made Me Love You
Young Woodley

1939–1947

Film production
temporarily ceased for the
Second World War and the
subsequent rebuilding of
the studio.

1948–1949

The Hasty Heart
Landfall
Man on the Run

1950s

Alive and Kicking
Angels One Five
Captain Horatio

Hornblower R.N.
Castle in the Air
Chase a Crooked Shadow
The Dam Busters
The Dancing Years
The Devil's Disciple
Duel in the Jungle
The Elstree Story
Father's Doing Fine
For Better, For Worse
Girls at Sea
The Good Beginning
The Good Companions
Green Grow the Rushes
Guilt is My Shadow
Happy Ever After
Happy Go Lovely
High Hell
The House of the Arrow
Ice Cold in Alex
Indiscreet
Intent to Kill
Interpol
Isn't Life Wonderful?
It's Great to Be Young!
It's Never Too Late
The Key
King's Rhapsody
Knave of Hearts
The Lady is a Square
A Lady Misled
Laughter in Paradise
Law and Disorder
Let's Be Happy
Lilacs in the Spring
Look Back in Anger
The Magic Box
The Man Inside
The Master of the Ballantrae
Moby Dick
The Moonraker
The Naked Earth

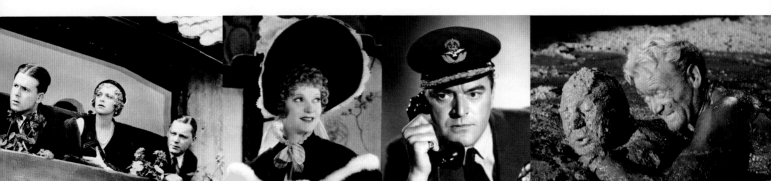

Night of the Demon
No Time for Tears
No Trees in the Street
Now and Forever
Oh … Rosalinda!!
Operation Bullshine
Portrait of Clare
Rob Roy – the Highland Rogue
The Sea Wife
She Didn't Say No
The Siege of Pinchgut
The Silent Enemy
The Silken Affair
The Small Hotel
So Little Time
South of Algiers
Stage Fright
Tarzan and the Lost Safari
The Traitors
These Dangerous Years
Tommy the Toreador
Tons of Trouble
Top Secret
Trouble in the Glen
Twenty-Four Hours in a Woman's Life
Two-Headed Spy
Valley of Song
The Weak and the Wicked
Where's Charley?
Will Any Gentleman …?
Woman in a Dressing Gown
The Woman's Angle
The Woman with No Name
Wonderful Things
Yangtse Incident
The Yellow Balloon
Yield to the Night
You Can't Escape
The Young and the Guilty
Young Wives' Tale

1960s

The Anniversary
The Bargee
Billy Budd
Bottoms Up!
The Boys
The Cracksman
Crescendo
Crooks in Cloisters
Crossplot
The Devil Rides Out
Don't Bother to Knock
The Double Man
Dr. Crippen
Follow That Horse!
French Dressing
The Full Treatment
Go to Blazes
Guns of Darkness
Hammerhead
Hand in Hand
Hell is a City
His and Hers
Jigsaw
Lolita
The Long and the Short and the Tall
The Lost Continent
Man in the Middle
The Masque of Death
Mister Ten Per Cent
Moment of Danger
Mrs Gibbon's Boys
The Naked Edge
The Nanny
Night of the Eagle
Nothing But the Best
One Million Years B.C.
Operation Snatch
Petticoat Pirates
The Pot Carriers
The Punch and Judy Man

Rattle of a Simple Man
The Rebel
The Roman Spring of Mrs Stone
Sands of the Desert
The Scarlet Blade
School for Scoundrels
Secret Ceremony
The Servant
She
Slave Girls
Sparrows Can't Sing
A Story of David
Summer Holiday
The Sundowners
A Taste of Fear
The Theatre of Death
The Third Secret
The Trials of Oscar Wilde
The Vengeance of She
We Joined the Navy
West 11
What a Crazy World
Wonderful Life
World Ten Times Over
The Young Ones

1970s

The Abominable Dr. Phibes
Adolf Hitler: My Part in His Downfall
The Alf Garnett Saga
Alien
And Soon the Darkness
Are You Being Served?
The Battle at the Villa Fiorita
Baxter
The Best Pair of Legs in the Business
Blood from the Mummy's Tomb
The Boyfriend

The Brigand of Kandahar
Captain Kronos Vampire Hunter
Confessions from a Holiday Camp
Confessions of a Driving Instructor
Confessions of a Pop Performer
Confessions of a Window Cleaner
The Curse of the Mummy's Tomb
Demons of the Mind
Digby, the Biggest Dog in the World
A Doll's House
Dr. Jekyll and Sister Hyde
Dr. Phibes Rises Again
Dracula A.D. 1972
Dulcima
Endless Night
Fanatic
Father, Dear Father
Fear in the Night
For the Love of Ada
Frankenstein and the Monster from Hell
Frankenstein Must Be Destroyed
Get Carter
The Go-Between
Great Expectations
The Greek Tycoon
Hanover Street
Henry VIII and His Six Wives
Hoffman
Holiday on the Buses
The Horror of Frankenstein
I am a Dancer
Julia
The Legend of Hell House
The Likely Lads

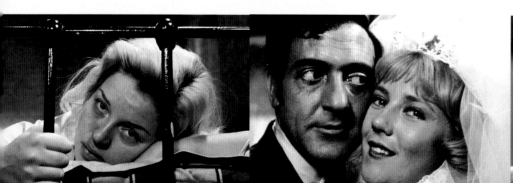
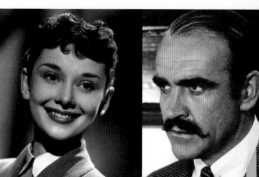

The Little Prince
Love Thy Neighbour
Lust for a Vampire
Man About the House
The Man Who Haunted
 Himself
Moon Zero Two
Mr. Forbush and the
 Penguins
Mr. Jericho
Murder on the Orient
 Express
Mutiny on the Buses
The National Health
Neither the Sea Nor the Sand
Night Watch
Not Now, Comrade
Not Now Darling
On the Buses
Our Miss Fred
Out of Season
Percy
The Raging Moon
Rentadick
The Railway Children
The Satanic Rites of
 Dracula
Scars of Dracula
Some Will, Some Won't
Spanish Fly
Stand Up Virgin Soldiers
Star Wars Episode IV: A
 New Hope
Straight on Till Morning
Swallows and Amazons
Take Me High
Tales of Beatrix Potter
Taste the Blood of Dracula
To the Devil a Daughter
Up Pompeii
Up the Chastity Belt
Up the Front

Valentino
The Vampire Lovers
Villain
Voyage of the Damned

1980s
The Boys in Blue
Clockwise
The Dark Crystal
Death in Venice
Duet for One
Empire of the Sun
Fourth Protocol
George and Mildred
Give My Regards to Broad
 Street
The Great Muppet Caper
Greystoke: The Creation
 of Tarzan and His Epic
 Adventures
Half Moon Street
Haunted Honeymoon
Indiana Jones and the Last
 Crusade
Indiana Jones and the
 Raiders of the Lost Ark
Indiana Jones and the
 Temple of Doom
Labyrinth
Lady Chatterley's Lover
Monty Python's Meaning
 of Life
Never Say Never Again
Plenty
Return to Oz
The Shining
Star Wars Episode V: The
 Empire Strikes Back
Star Wars Episode VI: Return
 of the Jedi
Superman IV: A Quest for
 Peace

Who Framed Roger Rabbit
Whoops Apocalypse
Willow
Young Sherlock Holmes

1990s
The Borrowers
Final Curtain
The Man Who Knew Too Little
Saving Grace
Saving Private Ryan
Sorted
Wives and Daughters

2000s
A Number
The Albert Walker Story
Ashes and Sand
Batman Begins
Breaking and Entering
Capture the Castle
Closer
Colour Me Kubrick
Derailed
Enigma
Exam
Flyboys
44" Chest
1408
The Gathering
Harry Brown
Hitchhikers Guide to the
 Galaxy
Huge
The Importance of Being
 Earnest
Is Anybody There?
The King's Speech
The Lost Prince
My Zinc Bed
Nicholas Nickleby
No Ordinary Trifle

Notes on a Scandal
The Other Boleyn Girl
Proof
Shanghai Knights
Son of Rambow
Star Wars Episode III:
 Revenge of the Sith
Star Wars Episode II: The
 Attack of the Clones
Troy
Vanity Fair
Young Rambow

2010s
Batman Begins: The Knight
 Rises
Bonded By Blood
Cuban Fury
The Danish Girl
Devil's Playground
The Hooligan Factory
Hot Fuzz
Huge
Hummingbird
Hyde Park on Hudson
Jack the Giant Slayer
Kick-Ass
King of Soho
The Last Days on Mars
The Look of Love
Paddington
Page 8
Plastic
Sherlock Holmes: A Game of
 Shadows
Street Dance Juniors
U Want Me 2 Kill Him?
Under the Skin
The Wedding Video
The World's End
World War Z
X-Men: First Class

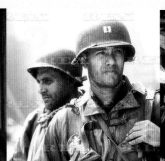

TELEVISION CREDITS

1950s
Churchill
Crime Club
Dial 999
The Flying Doctor
Glencannon
The Human Jungle
International Detective
Invitation to Murder
Mantovani
Tales from Dickens
The Target
Trader Horn

1960s
The Avengers
The Baron
The Champions
Department S
Gideon's Way
Randall and Hopkirk
 (Deceased)
Sir Francis Drake
The Saint
The Winter's Tale

1970s
Here Come the Double
 Deckers
Jason King
The Protectors
Return of the Saint

1980s
The Ginger Tree
Oliver
Reilly – Ace of Spies
Rude Health
The Hammer House of
 Murder and Suspense

Inspector Morse
The Shillingbury Blowers
The Shillingbury Tales
The Storyteller – Greek Myths

1990s
The Art of Touch
Big Bad World
Big Women
Birds of a Feather
Bodger and Badger
Close Relations
Coming Home
David Copperfield
Deceit
Drop the Dead Donkey
The Fast Show
Jack and the Beanstalk
Jane Eyre
Kavanagh QC
Kind in the Corner
Last of the Summer Wine
Little Napoleon
Love Hurts
Madame Bovery
My Summer with Des
Nancherrow
Playing the Field
Smack the Pony
Tom Jones
Who Wants to Be a Millionaire?
Wuthering Heights

2000s
All About Me
Are You Smarter Than a Ten
 Year Old?
Big Brother (and spin-off
 shows)
Bunny Town
Celebrity Big Brother (and
 spin-off shows)
Celebrity Hijack (and spin-off

shows)
Daddy's Girl
Dancing on Ice (and spin-off
 shows)
Dancing on Wheels
Dead Set
Gigglebiz
He Knew He Was Right
The Hoobs
Jackanory
Jim, Jam & Sunny
Lord of the Dance
The Lost Prince
Loveland
Morning Glory
Most Haunted Live
New Year's Day
The People Versus
Robot Wars
Secret Diary of a Call Girl
Smack the Pony
Space Pirates
Tough Love
The Tweenies
The Vice
Who Wants to Be a
 Millionaire?
Your Place or Mine?

2010s
Bad Bad World
Big Brother (and spin-off
 shows)
Big Fat Quiz
The Box
Call the Midwife
Celebrity Big Brother (and
 spin-off shows)
Celebrity Juice
The Chase
Dancing on Ice
EastEnders
Episodes

The Exit List
Fake Reaction
Father Figure
Fifteen to One
Friday Download
The Game Show Story
Gigglebiz
Grandma's House
Great British Hairdresser
House of Fools
The IT Crowd
Lee and Jenny
Let's Dance for Sports Relief
Lewis
Little Crackers
Little Howard
Live at the Electric
London Spy
Michael Buble: Home for
 Christmas
Never Mind the Buzzcocks
OK! TV
Peep Show
Piers Morgan's Life Stories
Pointless
Push the Button
Red or Black?
Room 101
Sadie J
The Slammer
Strictly Come Dancing
Sweat the Small Stuff
Top of the Pops (specials)
The Trapped
Tumble
Two Tribes
VIP
The Voice
Who Wants to Be a
 Millionaire? (and celebrity
 editions)
Yonderland
Your Face Sounds Familiar

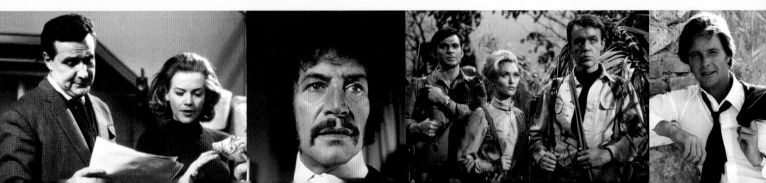

MUSIC VIDEOS
Break of Dawn
Matt Cardle
Cat's Eyes
Comic Relief (Peter Kay, Matt Lucas, The Proclaimers etc.)
The Delays
Enya
Girls Aloud
Little Mix
Connor Maynard
Katie Melua
Mika
Mimi Twilight
Muse
One Direction
Queen (Bohemian Rhapsody)
Rhydian
Emeli Sande
Sonny J
Tinashe
Tinchy Stryder
Laura White

TOUR REHEARSALS
Anastacia
Balamory: Live
Biffy Clyro
Blake
Bob the Builder: Live
Susan Boyle
Brainiac Live
Sarah Brightman
CBeebies Live
Chemical Brothers
Dancing on Ice: Tour
Disney on Ice
Diversity Live
Dr. Who Live
Paloma Faith
Florence and the Machine
Foo Fighters
Foreigner
Here Come the Girls
Il Divo

Iron Maiden
Yusuf Islam (Cat Stevens)
Jay-Z
Katherine Jenkins
Alicia Keys
King Crimson
Beverley Knight
Leona Lewis
Madonna
Mika
Kylie Minogue
McBusted
Muse
The Nolan Sisters
Pendulum
Pet Shop Boys
Pink Floyd
Placebo
Pop Idols: Live
Postman Pat: Live
Queen and Paul Rodgers
Radiohead
Cliff Richard
Rihanna
Frank Sinatra Jnr.
Scissor Sisters
S Club 7
Sinatra
Spandau Ballet
Star Wars: The Musical Journey
Take That
Teletubbies: Live
Thomas the Tank Engine: Live
Tokio Hotel
Tweenies: Live
The War of the Worlds – Alive on Stage
West Life
Wings
Robbie Williams
Will Young
Jay Z
Led Zeppelin

SOURCES

BOOKS
The Confessions of Robin Askwith, Robin Askwith, Ebury Press (1999)
Elstree: The British Hollywood, Patricia Warren, Elm Tree Books/Hamish Hamilton (1983)
Hammer Films: The Elstree Studios Years, Wayne Kinsey, Tomahawk Press (2007)
Harry H. Corbett: The Front Legs of the Cow, Susannah Corbett, The History Press (2012)
Marlene, Marlene Dietrich, Open Road Media (ebook, 2012)
Mr Carry On: The Life and Work of Peter Rogers, Morris Bright and Robert Ross, BBC (2000)
Star Wars: The Empire Strikes Back, Alan Arnold, Sphere Books (1980)
Star Wars: The Making of Return of the Jedi, Edited by John Phillip Peecher, Del Rey Books (1983)
Up in the Clouds, Gentlemen Please, John Mills, Gollancz (2001)

NEWSPAPERS & MAGAZINES
Daily Express
Kinematagraph
New York Daily News
The Times
Western Mail (Perth, WA: 1885–1954)

WEBSITES
Alfred Hitchcock Wiki – http://the.hitchcock.zone/wiki
Avengerland – avengerland.theavengers.tv
BFI – Screenonline – www.screenonline.org.uk
British Lion – www.britishlion.com
British Pathé (YouTube Channel) – www.youtube.com/user/britishpathe
TheRaider.net – www.theraider.net
TelegraphVideo – www.youtube.com/user/telegraphtv
YouTube – The Making of Indiana Jones and the Last Crusade (copyright owner unknown)
YouTube – Bob Hoskins interview, Bogart, Danish TV

ACKNOWLEDGEMENTS

That Elstree Studios remains as successful as it does is down in no small part to the huge efforts of its great management team and supportive Board of Directors. Our thanks for their efforts, for both the studios in general and for this publication in particular, go to Roger Morris, Tricia Newman, Jo Veal, Joely Hertz, LouLou Carter, Paul Clark, Mike Scales, Nayan Gudka, Matthew Bradley, George Hudson, Lee Driscoll and Justin Page of Elstree Studios and recent Board members past and present, Paul Morris, Caroline Clapper, Pervez Choudhury, Charles Goldstein, Sajida Bijle and Ann Harrison.

Our thanks go to Tom Hooper for finding time during a busy shoot and edit on *The Danish Girl* to write the introduction to this book, and to his PA, Chloe Dorigan, for her assistance. We would like to thank the following people for sharing their recollections of working at the studio: Annette André, Robin Askwith, Kenny Baker, Alexandra Bastedo, Jeremy Bulloch, Susannah Corbett, Celia Costas, Jim Dale, Angela Douglas, Bryan Forbes, Martin Freeman, William G. Stewart, Nick Goldsmith, John Graham, Melvyn Hayes, Diane Keen, Suzanne Lloyd, George Lucas, Rick McCallum, Brian Muir, Ian Ogilvy, Nikki Parsons, Simon Pegg, Pamela Poll, Dave Prowse, Neville Reid, Wendy Richard, Pamela Salem, Janette Scott, Alan Simpson, Roy Skeggs, Madeline Smith, Steven Spielberg, Chris Tarrant, Jayne Torvill, Adam Unger, Reg Varney, Paul Welsh, Barbara Windsor and Robin Windsor.

We owe a special debt of gratitude to Massimo Moretti of Studiocanal Films Limited, whose enthusiasm for this project was matched by his many hours sifting through the their archive to ensure that this book was able to display some great images, many previously unseen, from productions made at the studios, especially in its formative years.

Thanks are also due to: Stephen Atkinson (Rex), David Barnes, Howard Berry of The Elstree Project, Mary Kirkland, Martin Lakin, Tessa Le Bars, Scott Mitchell, Lindsay Muir, Laura Paxman, Damien Slattery and also the Estate of Dinah Sheridan and the Estate of Greg Smith.

The authors and publishers would like to thank: Ana Bjezancevic, Ron Callow at Design 23, Sue Gard, Kate Inskip and Judith Palmer for their sterling work in making this book.

PICTURE CREDITS

INDEX

Page numbers in italic type indicate photographs

THE RANK ORGANISATION PRESENTS

PATRICK CARGILL

FATHER DEAR FATHER

...A PYNE · ANN HOLLOWAY
NOEL DYSON

...WELLS · JOYCE CAREY · JILL MELFORD
...CHARD OSULLIVAN as Richard

...REID & DONALD SINDEN

...ATE WICKTHALL & BRIAN COOKE
...OHN L. STEWART · PETER J. THOMPSON
...ESSWOOD FILM PRODUCTION

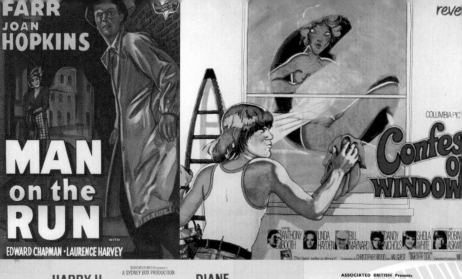

FARR
JOAN HOPKINS

MAN on the RUN

WITH

EDWARD CHAPMAN · LAURENCE HARVEY

reve...

Confes...
of
WINDOW...

COLUMBIA PIC...

...CARMICHAEL
TERRY-THOMAS
JANETTE SCOTT
ALASTAIR SIM

School for Scoundrels

DENNIS PRICE

OR
ERAL
BITION

Distribution by WARNER BROS.

A STEVEN SPIELBERG FILM

tom hanks
saving private ryan

edward burns · matt damon · tom sizemore

the mission is a man.

A SYDNEY BOX PRODUCTION

HARRY H. DIANE
CORBETT · CILENTO

RATTLE OF A SIMPLE MAN

MICHAEL THORA
MEDWIN · HIRD

Screenplay by GEORGE H. BROWN and PATRICK KIRWAN
Produced by GEORGE H. BROWN · Directed by CHARLES DYER · WILLIAM GELL · Directed by MURIEL BOX

ASSOCIATED BRITISH Presents

TOMMY ST...
JANET MU...
in

TOMM...
TOREAD...

WITH

SIDNEY JAMES · VIRGILIO
PEPE NIETO · GUEST ARTISTE NOEL P...

COLOUR BY TECHNICOLOR

Screenplay by GEORGE H. BROWN and PATRICK KIRWAN
Produced by GEORGE H. BROWN · Directed by JOHN PA...
A FANFARE FILM in association with NAT COHEN and STUA...

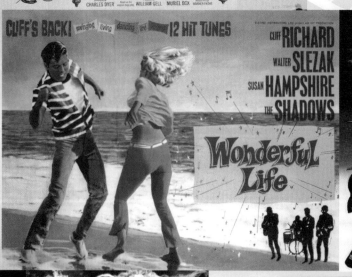

CLIFF'S BACK! swinging living dancing and 12 HIT TUNES

CLIFF RICHARD
WALTER SLEZAK
SUSAN HAMPSHIRE
THE SHADOWS

Wonderful Life

WHOO...
APOCALY...

LONDON

WANTED ON VOYAGE

FROM THE PRODUCER OF HARRY POTTER

THE PADDINGTON TRAIL

JUDI DENCH CATE BLANCHETT

ONE WOMAN'S MISTAKE IS ANOTHER'S OPPORTUNITY.

...L MIGHTY
NOTES ON A SCANDAL

FROM THE BOYS THAT CREATED SHAUN OF THE DEAD

A NEW COMEDY

THEY'RE BAD BOYS.
THEY'RE BIG HARDS.
THEY'RE LETHAL WEAPONS.
THAT ARE...

HOT FUZZ

SIMON PEGG NICK FROST

www.hotfuzz.com

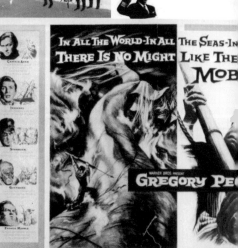

IN ALL THE WORLD—IN ALL
THERE IS NO MIGHT

THE SEAS—
LIKE THE...
MOB...

GREGORY PEC...

RICHARD BASEHART · LEO GENN in
ORSON WELLES

JOHN H...
MO...